FOUNDATIONS
of DRAWING

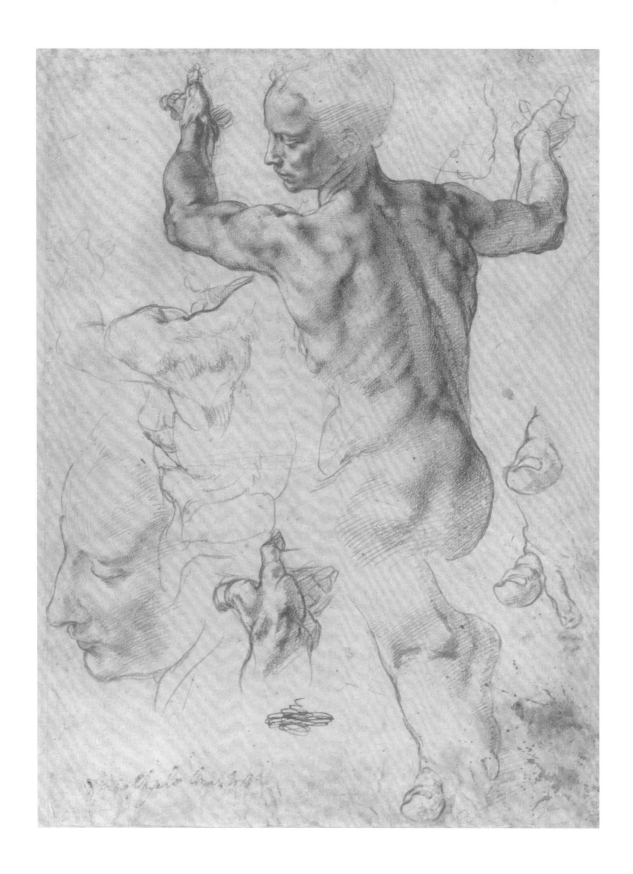

AL GURY

FOUNDATIONS of DRAWING

A practical guide to art history, tools, techniques, and styles

WATSON-GUPTILL PUBLICATIONS
California | New York

PAGE ii Michelangelo Buonarotti, *Studies for the Libyan Sibyl*, 1508–1512, red chalk on unknown surface, 11⅜ x 8⁷⁄₁₆ inches (28.9 x 21.4cm). The Metropolitan Museum of Art (New York, NY). Art Resource, NY.

OPPOSITE Holly Trostle Brigham, *Judith and Flora*, 2003, watercolor on paper, 29½ x 29½ inches (74.93 x 74.93 cm). Private collection.

Published in the United States by Watson-Guptill Publications, an imprint of the Crown Publishing Group, a division of Penguin Random House LLC, New York.
www.crownpublishing.com
www.watsonguptill.com

WATSON-GUPTILL and the WG and Horse designs are registered trademarks of Penguin Random House LLC

Library of Congress Cataloging-in-Publication Data

Names: Gury, Al, author.

Title: Foundations of drawing : a practical guide to art history, tools, techniques, and styles / Al Gury.

Description: First edition. | California ; New York : Watson-Guptill, 2017. | Includes bibliographical references and index.

Identifiers: LCCN 2017001750 (print) | LCCN 2017003614 (ebook)

Subjects: LCSH: Drawing—Technique. | Drawing—History. | BISAC: ART / Techniques / Drawing. | ART / Techniques / General. | ART / Study & Teaching.

Classification: LCC NC730 .G89 2017 (print) | LCC NC730 (ebook) | DDC 741.2—dc23

LC record available at https://lccn.loc.gov/2017001750

Trade Paperback ISBN: 978-0-307-98718-1
eBook ISBN: 978-0-307-98719-8

Printed in China

Design by Tatiana Pavlova

10 9 8 7 6 5 4 3 2 1

First Edition

CONTENTS

Drawing done by the author at age five.

PREFACE: a Life of Drawing

The ideas, thoughts, and concepts contained in this book are filtered through my own experience and that of the many teachers of drawing who have influenced my development as an artist and teacher. In this book, I try to recreate the atmosphere of my drawing classroom and the rich conversations with my students on materials, concepts, aesthetics, and history. For thirty years, I have taught drawing to students ranging from complete beginners—including children, teenagers, the elderly, and the learning impaired—to very experienced artists at the Pennsylvania Academy of the Fine Arts. PAFA has produced some of the finest artists in American history, including Thomas Eakins, Mary Cassatt, Maxfield Parrish, Cecilia Beaux, Daniel Garber, Sidney Goodman, and Vincent Desiderio, and drawing has always been at the core of the school's curriculum—an umbrella for its educational mission. The drawing curriculum at PAFA is strong and balanced and addresses the great tradition of academic fine-arts education as well as important issues of contemporary artistic discourse and art-making. Beginning with cast drawing, life drawing, anatomy, still-life drawing, interior drawing, and perspective, PAFA students are guided through lessons in the formal elements of drawing (shape, form, line, light and shade, perspective, composition, and so on) with the goal of developing a solid knowledge base and an expressive, personal language and vision. Upper-level classes add the concerns of drawing in the modern world: content, narrative, aesthetics, diverse mediums, and personal statement.

Thomas Toner, *Sketches*, date unknown, pencil on paper, 8 x 12 inches (20.32 x 30.48 cm). Collection of the author.

Tom Toner did numerous preparatory sketches in pencil, like this one, for his large oil paintings. He loosely sketched the shapes of the figures and faces with a sharp 6B pencil, then added shading with short hatch lines following the direction of the light. Toner's drawing technique is derived from approaches used in the fifteenth and sixteenth centuries in Italy and northern Europe by artists such as Pontormo and Albrecht Dürer.

Cast Corridor, Pennsylvania Academy of the Fine Arts (PAFA), Philadelphia.

The Cast Hall and Corridor at PAFA were designed as drawing studios by the building's architects, the Philadelphia firm of Furness-Hewitt. The building, a national landmark, was opened in 1876 for America's centennial celebration. Its cast collection, including more than 160 full-size replicas of Greco-Roman and Renaissance figures, busts, and reliefs, serves a central component of the drawing curriculum at the school.

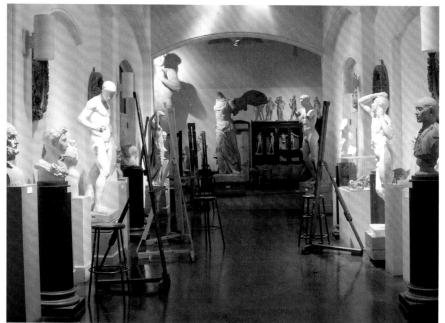

Michelangelo Buonarroti,
A Seated Nude Twisting Around,
circa 1504–1505, pen and brown ink
with wash and lead white on paper,
dimensions unknown. British Museum,
London. © the Trustees of the British
Museum/Art Resource, New York.

This Michelangelo drawing, probably
done from a model, is first sketched
in with fine line in brown ink and pen.
The modeling of the forms uses short
hatching lines in brown ink following
the direction changes of the surfaces
of the figure's anatomical structures.
Strokes of white hatch lines on
the very tops of the swelling forms
complete the sense of form and light.
The tan paper provides a unifying
middle tone for the forms of the figure.

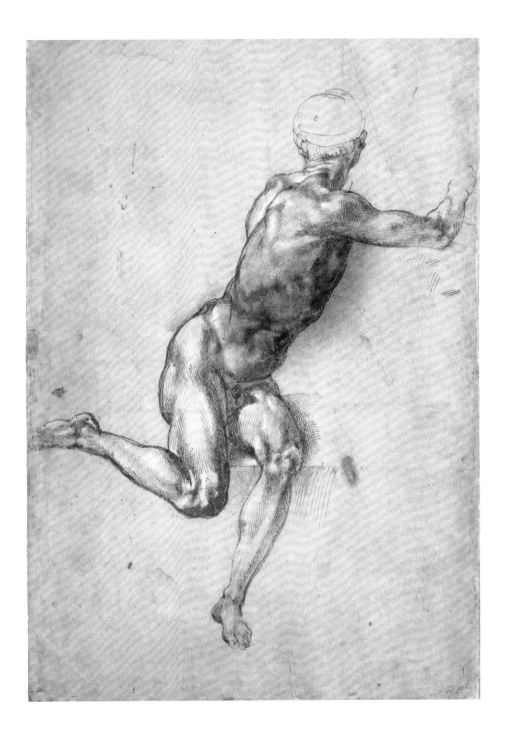

INTRODUCTION

Foundations of Drawing is a guide for teachers, students, artists, and the general reader to the traditions and practice of drawing in Western culture. This overview of the history of drawing and of drawing materials, concepts, and techniques provides a practical look at the art of drawing and will be a useful text for anyone who is interested in learning about drawing, returning to drawing, studying drawing, or teaching drawing as well as for longtime practitioners of the art. The book takes the point of view that clear information on the history, materials, and techniques of drawing creates the ability to understand drawing, make choices, and chart one's development in drawing with a sense of confidence.

Foundations of Drawing focuses on classic drawing mediums such as pencil and charcoal while also presenting an overview of a broad range of other materials, including chalk and oil pastels, watercolors, and acrylics. Not all materials are discussed in depth, but the essential ones are presented. Traditional materials and methods are illustrated through examples of old master and contemporary drawings as well as through demonstrations of basic concepts. The essential elements and concepts of core drawing genres—still life, interiors, portraiture, life drawing, and landscape—are presented for foundational drawing study and portfolio-making. More experienced artists can use *Foundations of Drawing* as a sourcebook and a point of departure for further personal growth and artistic exploration.

Drawing is an essential part of a portfolio for art school admittance. Drawing shows whether or not the applicant has a basic ability to understand visual organization and use the formal principals of shape, form, line, light, and perspective. It also shows whether or not the applicant can visualize creative ideas and concepts.

What Is Drawing?

For many centuries, drawing has been a practical approach to visualizing and planning everything from human figures in an oil painting to designing machine parts, buildings, and textiles. Simple materials such as graphite

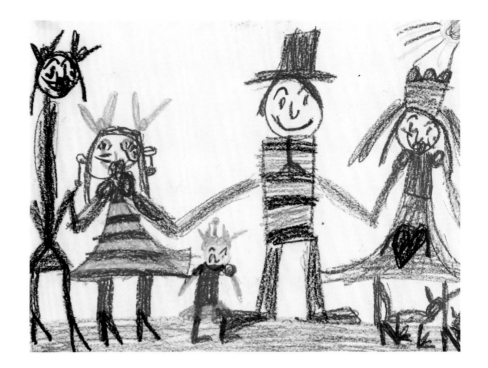

First grade student, *My Family*, 2012, crayon on manila drawing paper, dimensions unknown.

Drawing provides insight into the inner world and perceptions of the child.

pencils, charcoal, and ink have been the primary means for doing the great majority of drawings.

The term *drawing* now encompasses a wide range of traditional and nontraditional mediums, approaches, and aesthetics. Modern technology has created new versions of old materials and has sometimes even replaced them. For example, fine-point marker pens have added to or replaced older dip pens and ink bottles for some artists. Some artists rely on and cherish traditional materials and methods, while others draw only on computer screens. And some artists draw experimentally using materials their Renaissance ancestors would think very strange: blood, tar, food, and computer drawing pads.

Also, the aesthetics of drawing, which traditionally focused on a figure, an object, or a scene, now include abstract and conceptual forms having little to do with nature and more to do with how the artist personally interprets the world. Once thought of as the province of trained artists or skilled amateurs, drawing is now recognized as part of the language of children, the mentally disabled, and self-taught or outsider artists. Prisoners and victims of social injustice draw in order to document their social and political experiences.

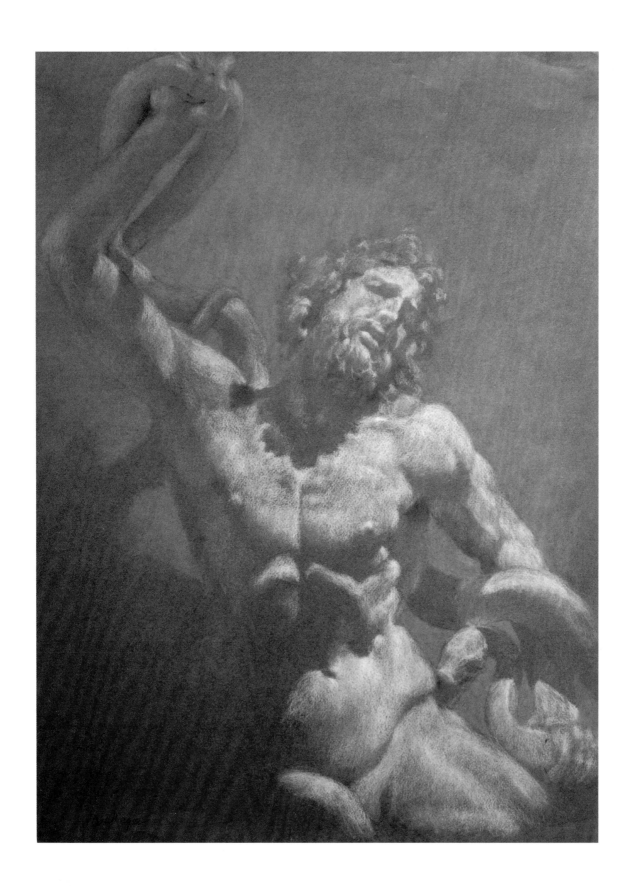

TOP Here, a student is drawing from a cast-plaster replica of the ancient statue *Laocoön and His Sons*, the original of which is in the Vatican Museum, in Rome. The north-facing skylights in the Cast Hall at PAFA provide perfect light for drawing.

BOTTOM This student is making quick gesture sketches of a model with vine charcoal on newsprint. He has lined up the figures sequentially to compare and correct size, proportion, and movement—and to aid him in learning consistency in scale, line weight, and shape. Such gesture sketches are also called *croquis*, an old French academic name for quick sketches of a model.

OPPOSITE Student drawing of *Laocoön and His Sons*, c. 1990s, white and black pastel on colored charcoal paper, 24 x 18 inches (60.96 x 45.72 cm). School Collection, Pennsylvania Academy of the Fine Arts.

In this student drawing, the structural shapes and gesture lines of the figure of Laocoön were lightly laid out using vine charcoal. The light on the sculpture was first described with loosely scumbled (roughed in) strokes of white pastel to establish a strong contrast between light and shade. Highlights within the light mass were added by building up loose strokes of white pastel. The strokes follow the direction of the forms. Shadows were deepened with vine charcoal, with a few edges and creases emphasized with a stronger, sharper touch of the charcoal. The overall effect is one of soft light and shade and atmosphere.

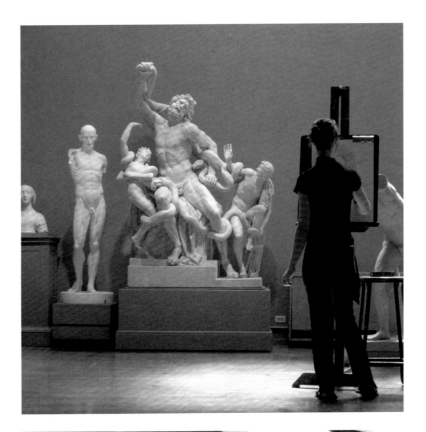

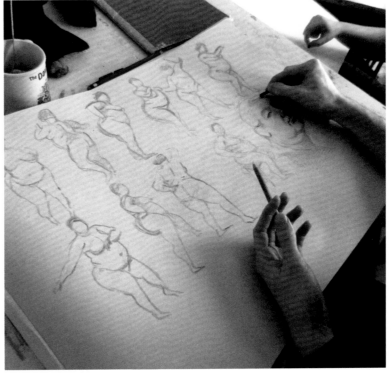

Anyone Can Learn to Draw

With the right tools, clear guidance, and encouragement, anyone can learn to draw. Many people consider taking a drawing class because they remember that they enjoyed it in elementary school; it was something personal that gave them pleasure. This is one of the best reasons for anyone to begin drawing.

Any person can learn the basics of shape, form, line, shading, perspective, and composition—the foundational, or "formal," elements of drawing. Foundational elements are the gateway; some individuals stop there, having achieved their primary goal of being able to sketch simple things for enjoyment and relaxation. Others, however, may feel that the lessons have opened up a new world of interest and will want to continue the journey— even to a career as an artist. Any reason for drawing is a good one.

"Why Can't I Draw a Straight Line?"

Being unable to draw a straight line may be very frustrating for someone learning to draw. But we are not physically designed to draw straight lines. Two anatomical structures in our arms dominate the actions needed to draw: the shoulder and its joint structure and muscles and the wrist and its connection to the forearm. The bones all have S-curved shapes, and the joints are all diagonal and oval ball-and-socket structures. They're designed to make our limbs move in a curving fashion, which is more economical than straight, angular movements. So when you first try to draw a straight line, you may find it very difficult because your body wants to make curved, diagonal lines. You must learn to align your hands, your arms, and their movements to create a straight movement. Like shooting a basketball, this takes practice and the ability to control the movements of your hand and arm.

Al Gury, *Why Can't I Draw a Straight Line?*, 2014, marker on paper, 8 x 10 inches (20.32 x 25.4 cm).

Drawing a straight line is a learned action.

Al Gury, sketchbook pages, year unknown, marker and ballpoint pen on white paper, 8 x 5 inches (20.32 x 12.7 cm).

The freedom and immediacy of drawing in a journal or sketchbook creates a world of personal exploration.

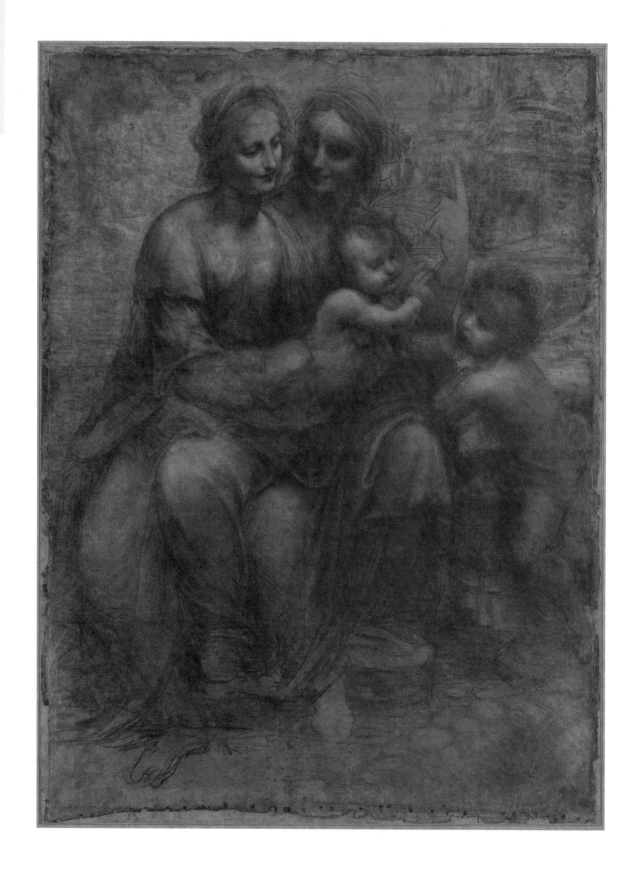

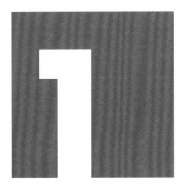

ESSENTIAL HISTORY OF DRAWING

The Roman historian Pliny the Elder (AD 23–79) credited drawing's invention to the daughter of the Corinthian sculptor Butades (fl. c. 600 BC). As Pliny's charming story goes, Butades's daughter—whom he refers to only as the Maid of Corinth—is anxious over her beloved's imminent departure for war and casts the young man's shadow on a wall with a lamp, then traces the shadow's outline. Her father uses the outline to sculpt a portrait bust of the young man—connecting drawing's origin to that of sculpture, as well. In reality, drawing began much farther back in time.

BEGINNINGS IN PREHISTORY

The history of drawing in Western culture begins with mysterious shapes and symbols drawn, scratched, and painted on cave walls and rock faces in what are now Spain and France. Why and by whom these drawings were made we may never know for sure; nevertheless, these simple, elegant images reveal a desire on the part of our ancestors to describe and organize the experience of their lives and their beliefs and fears.

Incised lines and dots are among the oldest such images, dating from around 700,000 BC, during the Lower Paleolithic period.

It was during the Upper Paleolithic period, from 40,000 to 10,000 BC, that many of the finest Stone Age drawings were produced. Drawn with charcoal from burned wood and colored with ocher clays and chalks, these mysterious yet beautiful images of animals, hunts, hand prints, magical, and fertility symbols tell us of the impulses of the Neanderthals, a group of early humans closely related to modern Homo sapiens. From 35,000 BC onward, physiologically modern humans began creating more complex artworks with surprisingly naturalistic images of animals and humans.

These primitive works became a great influence on artists of the early twentieth century, who yearned to return to a simpler and more direct drawing language. Their goal was to free themselves from the constraints of the conventions of art-making maintained by the art academies. For example, the Swiss-German artist Paul Klee (1879–1940) utilized childlike symbols and lines in his paintings and drawings. The primitive animal shapes and curving and geometric line patterns in his work recall prehistoric symbols and animal drawings. He felt this visual language not only freed him to be purely creative but also touched something deep in the psyche of the viewer.

The Spanish artist Pablo Picasso (1881–1973) was likewise influenced by the art of indigenous cultures, especially those of Africa. A strong visual connection can be seen between African masks and Picasso's abstractions of the human face. And Picasso may also have been influenced by his visit to the Lascaux caves in France soon after their discovery in 1940. His many lyrical and deceptively simple drawings of bulls and other animals suggest a connection with cave paintings. Interestingly, both Klee and Picasso were academically trained and later made conscious decisions to adopt alternative methods of drawing and art-making.

Joseph-Benoît Suvée, *The Invention of Drawing*, c. 1791, black and white chalk on brown paper, 21½ x 14 inches (54.6 x 35.6 cm). The J. Paul Getty Museum, Los Angeles.

Suvée's drawing of the story of Butades's daughter is one of numerous depictions by many artists of the romantic myth about drawing's origin.

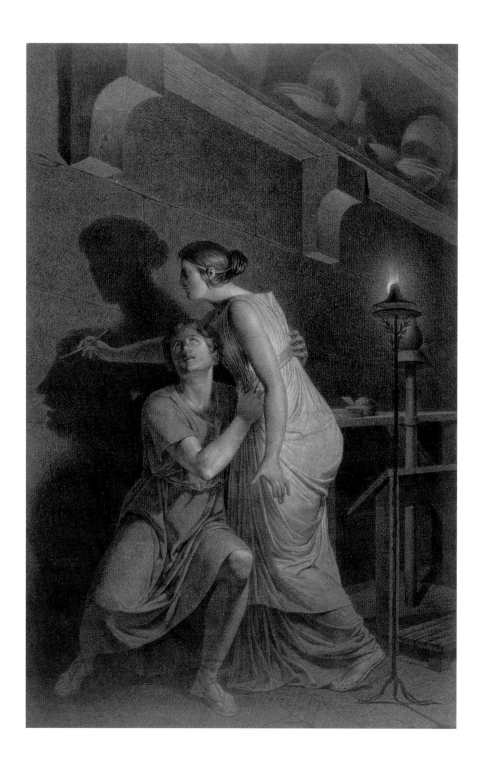

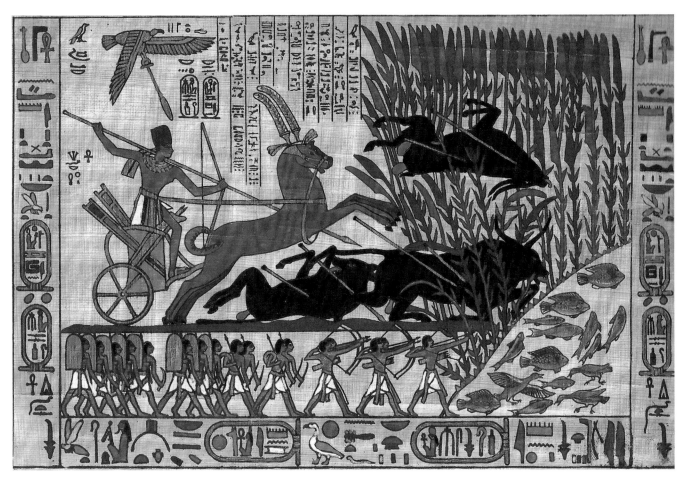

Modern copy of an ancient
Egyptian drawing, water-based
ink and pigments on papyrus,
15 x 20 inches (38.1 x 50.8 cm).
Collection of the author.

Flat shapes and black outlining
characterize the symbolic imagery
of ancient Egypt.

THE ANCIENT WORLD

The development of written language in Mesopotamia around 3200 BC
introduced a wide array of drawing and writing tools, many still in use.
Sharpened sticks used to draw symbols in wet clay tablets, quill and reed
pens, a variety of inks and brushes, and parchment (made from animal
hides) and papyrus (made from the fibers of the papyrus plant) were all
readily available in Egypt in the fourth millennium BC. Ancient Egyptian
scribes, because of their ability to read and write, were the recorders of laws,
history, and literature. Some of the oldest Egyptian examples of illuminated,
or illustrated, texts date from the Old Kingdom, around 2900 BC, and were
illustrated by scribes using simple drawing materials like pens, brushes, inks,
and water-based colors. Their training in the use of writing tools gave them
the skills needed to draw and paint, combining text with illustrations and
hieroglyphs, or picture words.

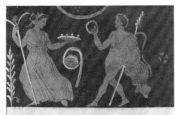

Engraving of images on an ancient Greek vase, 1800s, ink on laid paper. Collection of the author.

Greek drawing was line oriented and varied between flat outlines and more organic thick and thin lines, to create a sense of form. The Classical Greeks of the fifth and fourth centuries celebrated the supremacy of line over color and expression, thinking that color and expression reflected Dionysian emotional chaos while line exhibited the intellectual control of Apollo.

While training in drawing was primarily reserved for scribes and artisans in ancient Egypt, the ancient Greeks considered drawing a discipline important to the education of a well-rounded male citizen and to the achievement of the good life. By the third century BC, aristocratic Athenian youths were receiving training in drawing as well as music, literature, and gymnastics. Citizens of ancient Rome continued the Greek practice of training upper-class youths in the art of drawing as part of a well-rounded education.

In his *Natural History*, one of the most complete compilations of knowledge in the ancient world, Pliny the Elder puts forward his thoughts on painting and drawing as well as on colors, art materials, art history, and famous works of art. Copied and transmitted to later generations, Pliny's book provided a record of knowledge in the arts for medieval monks, Renaissance scholars, nineteenth-century Romantics, and modern artists to follow.

THE MEDIEVAL WORLD

The ancient tradition of training in drawing and calligraphy continued with the production of Bibles and prayer books in early Christian and medieval Europe. The oldest to survive date from the fifth through seventh centuries. The earliest known complete European book is the St. Cuthbert Bible from the seventh century, produced in what is now northern England.

In a world increasingly degraded by a poor economy, lack of stable government, and constant warfare, the Church, particularly through the monasteries, became the main preserver of book illumination, scholarship, and the arts in general. Monks working in monastic *scriptoria*—workrooms devoted to the study, copying, and preservation of documents—produced handwritten manuscripts of biblical and theological materials, stories of saints and heroes, and copies of ancient Greco-Roman literature. They kept classical culture and literature alive by transcribing surviving classical texts on papyrus, vellum, and, later, paper made from cotton and linen fibers and then gathering the pages into leather-bound books. Elegant and complex illustrations and decorations done in pen and ink and colored with water-based pigments were created to illuminate these precious handmade books. In addition, the monasteries produced fine, usually small-scale, icons for personal devotion. These were drawn and painted on wood panels and colored with water-based or egg-based tempera pigments.

In their manuscript illuminations, artist-monks not only told Bible stories and heroic tales clearly and simply but also created an elaborate and beautiful decorative vocabulary of plants and animals, imaginary landscapes, and

This is an example of minuscule script,
a type used for small devotional books
for personal rather than liturgical use.

intriguing pictures of daily life to embellish the borders of the manuscript
pages. These added visual delight and even humor to their works. The style
of these drawings ranged from naturalistic and volumetric work reminiscent of
the thick-and-thin, form-describing, volumetric line of Greek and Roman art
to simple, flat, childlike drawings with color filled in between the outlines, not
unlike a modern coloring book.

Training in drawing was essential to the depiction of holy figures
in Bibles and prayer books, and to expedite that training, pattern books
were developed—collections of designs for faces, scenes, bodies, and
objects that could be copied and embellished. One of the oldest to survive,
the *Macclesfield Alphabet Book*, prepared in England around 1490,
presents fourteen alphabet styles and many decorations and images for
embellishing book pages. Medieval images often depicted artistically

stylized sacred characters, and these stylized forms were used over and over. The forms, characterizations, and symbols of holy figures and saints were deeply embedded in the visual culture of Christian Europe and were easily recognizable by viewers. A pattern for the face of a saint—or that of a sinner, soldier, or king—could be copied from a pattern book and then embellished as the monk or artisan saw fit. The tradition of the pattern book has continued into the modern era in books of decorative patterns and alphabets that users can copy.

An improved economy and the rise of universities in the eleventh and twelfth centuries in Europe heightened demand for books of all kinds, and texts of classical literature and philosophy illustrated by beautifully drawn woodcuts or hand-done illuminations were increasingly sought from the monastic scriptoria. Meanwhile, training in drawing was still a part of the education of a gentleman or lady and became a hobby for the upper classes. Strong drawing skills were a necessary tool for artisans and builders, and the ability to design and draw buildings, furniture, maps, and other useful things continued to be—as it had been since ancient times—a commercially desirable skill. For the working classes, drawing was part of job training rather than a hobby, and practical training in drawing was offered not only in the monasteries but also under the auspices of master craftsmen in the commercial guilds.

THE RENAISSANCE

By the fifteenth century, the increased production of paintings for private consumption demanded finer and more complex training in drawing, especially in the forms and aesthetics of classical Greco-Roman art. The early Renaissance's fascination with the classical world encouraged the study of perspective, anatomy, and color, and the medieval world's focus on the heavenly realm shifted to the sensual beauty of the natural world. Artists of all kinds now desired to depict the world as seen through the lens of Greek naturalism and the sfumato, or hazy atmosphere, of Leonardo da Vinci (1452–1519).

In response to the need for better and more exacting training in drawing of natural and classical subjects, the Italian Renaissance saw, by the mid-sixteenth century, the rise of academies of art and, within them, formal drawing programs. While the monasteries continued to produce manuscripts and icons, the academies provided art training for secular painters and sculptors. The first, the Accademia e Compagnia delle Arti del Disegno (Academy and Company for the Arts of Drawing), was established

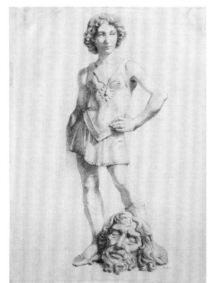

ABOVE Lyndall Bass, student drawing of cast of Andrea del Verrocchio's *David*, 1970s, sanguine on toned paper, 24 x 18 inches (60.96 x 45.72 cm). School Collection, Pennsylvania Academy of the Fine Arts (Philadelphia, PA).

This fine example from the cast drawing classes of the Pennsylvania Academy of the Fine Arts is done with delicate light-directional hatching lines. The figure's edges and details are finished with organic closed-form lines.

RIGHT Unknown artist, page from fifteenth-century incunabulum, ink, watercolor, and gilding on laid paper, 8 x 5 inches (20.32 x 12.7 cm). Collection of the author.

This page from a book of the feast days of the Roman Church reflects the Renaissance interest in classical contrapposto, fine line drawing, and perspective.

in Florence in 1563. The academies promoted drawing from original Greco-Roman statues or plaster copies of them, as well as from the life (that is, nude) model, considered by the academicians to be the most noble and beautiful of subjects. These practices—drawing from antique statuary and the study of anatomy—along with debates over differing aesthetics, or ideas of beauty, have come down to the modern era as time-honored elements of drawing curricula.

Leonardo da Vinci, *Seated Figure (drapery study on linen ground)*; 1452–1519; gray tempera highlighted with white tempera, applied with a brush, on linen; 10²/₅ x 9⁹/₁₀ inches (26.5 x 25.3 cm). Louvre (Paris). Photo credit: Scala/Art Resource, NY.

Leonardo has worked out the light and shade and the subtleties of form in this study—a preparatory work for a painting. The light and shadow masses are the primary tonal descriptions. Reflected lights in the shadows and tonal variations in the light do not diminish the strength of the primary light statement.

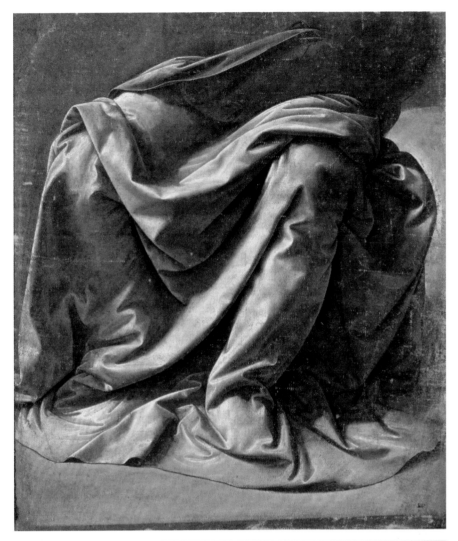

Robert Byrd, *Smiling Lady* (illustration for Byrd's *Leonardo: Beautiful Dreamer* [New York: Dutton Children's Books, 2003]), sepia pen line over HB pencil with watercolor and colored inks on watercolor paper, 10 x 22 inches (25.4 x 55.88 cm). Courtesy of the artist.

Robert Byrd combines history, storytelling, and strong character development with a whimsical and expressive drawing style. His version of the creation of the *Mona Lisa* invites the viewer into a day in the life of Leonardo da Vinci, complete with studio cats.

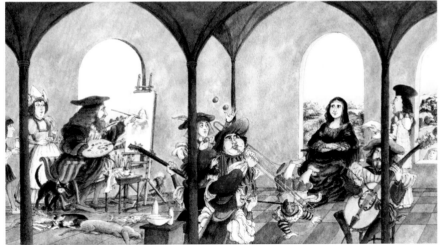

be replaced by trade schools and schools of design. For example, design schools such as the École nationale supérieure des beaux-arts de Lyon in Lyon, France, and the Royal College of Art in South Kensington, England, provided training in drawing skills for adults taking jobs as tapestry designers, furniture makers, potters, and the like. A culmination of this trend can be seen in modern design schools and especially in the German Bauhaus School, which was highly influential on twentieth-century design. While life drawing was part of design and trade schools' arts curricula, more practical drawing skills—two-dimensional design, perspective, and copying of patterns—were emphasized. The goal of these schools was to prepare artisans who would uphold high standards of design and craft and to promote the national and ethnic design arts traditions.

For young American artists at this time, especially after the Civil War, the lure of the European academies was strong. American students flocked to the École des beaux-arts in Paris and other European academies not only to receive training from famous masters like Gérôme but also to experience the artistic and cultural richness of the European capitals. For example, Thomas Eakins and George Bridgman (1865–1943) both studied with Gérôme at the École. Mary Cassatt (1844–1926) studied privately with Gérôme because women were not admitted to the École until late in the nineteenth century. Both Eakins and Cassatt had received their preliminary training at the Pennsylvania Academy of the Fine Arts in Philadelphia, which modeled its drawing program on that of the French school.

BEGINNINGS OF THE MODERN ERA

By the third quarter of the nineteenth century, the influence of classicism and the dominance of academic curricula began to be challenged. These challenges came from sources both within and outside the official art world. Artists such as Gustave Courbet (1819–1877) passionately espoused personal freedom and founded the French Realist School, creating art that reflected the social and political realities of the day. The Barbizon School of French landscape artists, influenced by the English landscape painter John Constable (1776–1837) and the French painters Jean-Baptiste-Camille Corot (1796–1875) and Jean-François Millet (1814–1875), and their emphasis on brushwork and atmosphere had a profound influence on emerging young artists like Pierre-Auguste Renoir (1841–1919) and Claude Monet (1840–1926). These influences opened up ideas about how to describe form, space, texture, and mood. Broken lines, mixtures of mediums and techniques, and an

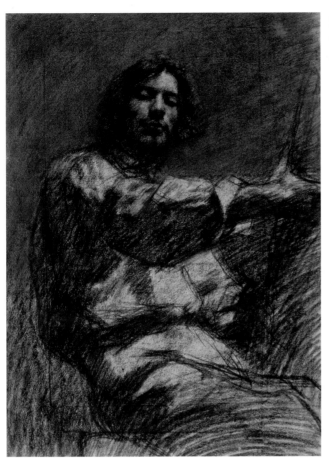

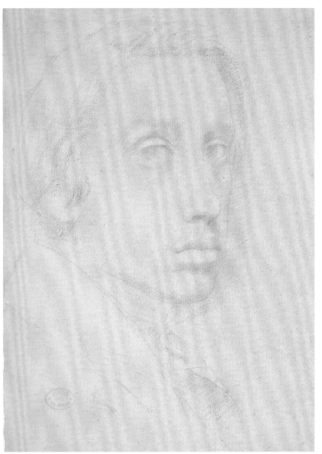

emphasis on light and atmosphere and personal expression all challenged the classical academic definitions of what art was and how drawing could be used to create it.

Throughout the first three-quarters of the nineteenth century, especially in France, other aesthetic voices were also challenging the supremacy of official taste. For example, the Symbolist painter, lithographer, and draftsman Odilon Redon (1840–1916) created imagery derived from dreams, poetry, and mysterious symbols, laying the groundwork for the development of Surrealism in the early twentieth century. Also outside the mainstream of the academies was the Pre-Raphaelite movement in England. Founded in 1848 by Dante Gabriel Rossetti (1828–1882) and others, the Pre-Raphaelite Brotherhood focused on literary themes from the Bible and Shakespeare as well as on their romanticized ideas of medieval art, producing drawings and paintings that the academics considered overly sensual and stylized.

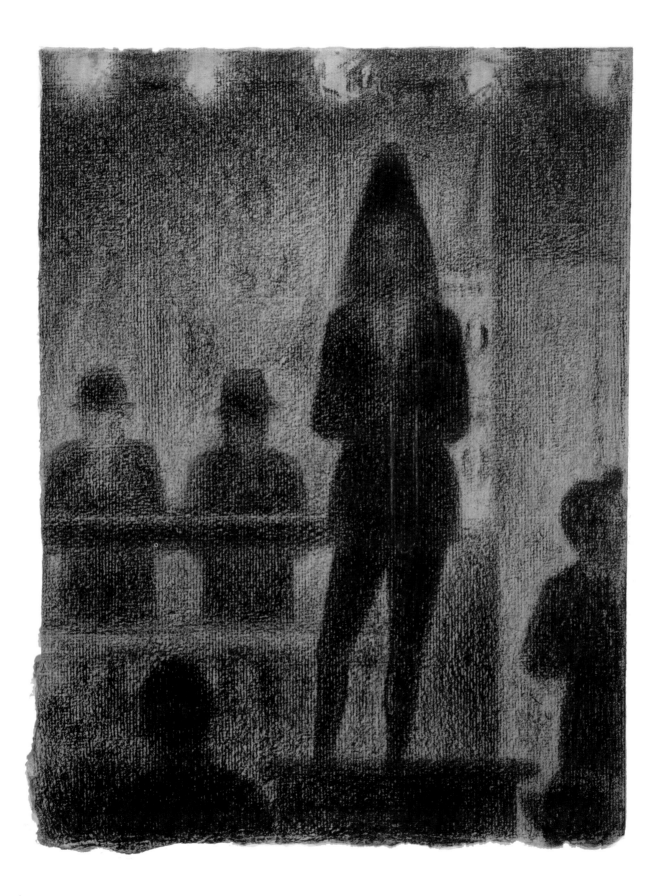

By the time of the opening of the first Impressionist exhibition in Paris in 1874, new trends and aesthetics—Impressionism, Postimpressionism, Symbolism, and many others—already existed in France and elsewhere and would soon overturn the supremacy of the academic traditions, changing the art world forever.

Even so, at the end of the nineteenth century training in drawing was still considered essential to the development of a well-schooled artist. While the academies had required art students to "classicize" their subjects, however, a trend toward naturalism was emerging—even in the academies. In the 1860s, a typical drawing of a life model would be "adjusted" to give the model the appearance of a Greek statue, but by the 1890s, drawings of models portrayed their subjects' actual bodies. The common denominator remained the study of body structure, line and tone, technique, and anatomy; although the aesthetic goals had changed, these organizing concepts continued to be important.

Other attitudes had changed, as well. Ordinary daily scenes and activities had, earlier in the century, been considered subjects only suitable for practice—not worthy of fine, finished works of academic art. By the late nineteenth century and the turn of the twentieth, however, city streets, taverns, ordinary interiors and still lifes, and working people had become commonly accepted subjects for the Impressionists, Post-Impressionists, Expressionists, and Fauves. These simple subjects provided ample material for exploring the modern interest in shape, pattern, and atmosphere; new techniques; and abstraction. For example, the French artist Georges Seurat (1859–1891), whose paintings were composed of small dots of paint evenly distributed over the canvas, created drawings in which charcoal, dragged over the grain of the paper, produced an effect similar to that of his paintings. Drawings by the French painter Henri Matisse (1869–1954) focused on flat line, emphasizing the contours of his subjects.

THE MODERN WORLD

At the dawn of the twentieth century, classicism, Romanticism, realism, Impressionism, Postimpressionism, Fauvism, modernism, and many other "isms" were jostling with and influencing one another. Artwork of all kinds reflected changes in the understanding of beauty and of what was worthy of being called art.

In the United States, the Ashcan School of painters, which included Robert Henri (1865–1929), William Glackens (1870–1938), and John Sloan

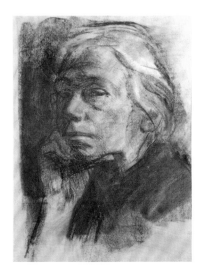

Käthe Kollwitz, *Self-Portrait*, 1908, charcoal on paper, 15 x 12 inches (40.5 x 31.1 cm). Graphische Sammlung Albertina, Vienna, Austria; photo: Erich Lessing/Art Resource, NY; © ARS, NY.

Kollwitz uses drawing to create images of the human soul. Her direct and unflattering approach to her subjects creates a feeling of empathy between subject and viewer. Here, she uses her classical training well in her use of toning, hatching, blending, and line.

OPPOSITE Mary Cassatt, *Woman Arranging Her Veil*, c. 1890, pastel on paper, sheet: 25½ x 21½ inches (64.8 x 54.6 cm). Philadelphia Museum of Art, bequest of Lisa Norris Elkins, 1950.

Cassatt's drawing technique is very close to her painting approach. A variety of marks, including hatching, line, blending, and scumbling, add up to a vigorous and immediate image.

(1871–1951), depicted gritty urban scenes. Their graphic and literal drawings of urban life were influenced by newspaper illustrations, and, in fact, most Ashcan School members created such illustrations to earn their living. Their tough realism depicted factories and workers, crowded city tenements, and the harsh street life of America's growing urban centers.

At the same time the Ashcan School painters were depicting urban America, the Fauves, or "Wild Beasts" (a name coined at the 1905 Salon d'Automne in Paris by the critic Louis Vauxcelles), were exploring the purity of color, line, and brushwork. In their drawings, the Fauves, led by Matisse and André Derain (1880–1954), utilized childlike lines and marks, echoing their goal of a return to a simplicity and directness in art-making unmediated by the complexities and technical emphasis of academic art training. These works ignored accepted ideals of beauty in favor of the exploration of the formal artistic elements of shape, line, color, and personal interpretation as subjects in and of themselves.

For the first time, artists of the early twentieth century used drawing as a major part of their thought process and of their finished work. Earlier artists used drawing in preparatory studies for major works or for teaching purposes, but in the twentieth century drawing was recognized and presented as a major aspect of an artist's formal work. Drawings were exhibited as finished art to be appreciated for their own sake. For example, the French Cubist painter Georges Braque (1882–1963) drew in charcoal and pencil directly on his canvases and left the resulting design exposed as part of the finished work. He followed a similar process in his collages. These drawings and mixed-media works were exhibited as finished art, scandalizing conservative audiences who saw them as unfinished and crude. Picasso likewise explored drawing, in both sketches and finished works, throughout his life.

While drawing was a facet of the output of artists like Henri, Derain, Picasso, and Braque, it was the creative focus for German artist Käthe Kollwitz (1867–1945). Her dark, powerfully emotional charcoal, pencil, and ink drawings of oppressed workers and the poor in Germany between the world wars represent a high point in her career. Though she was also a skilled printmaker, Kollwitz stands as a modern master of drawing and serves as a role model for artists pursuing drawing as a serious artistic endeavor.

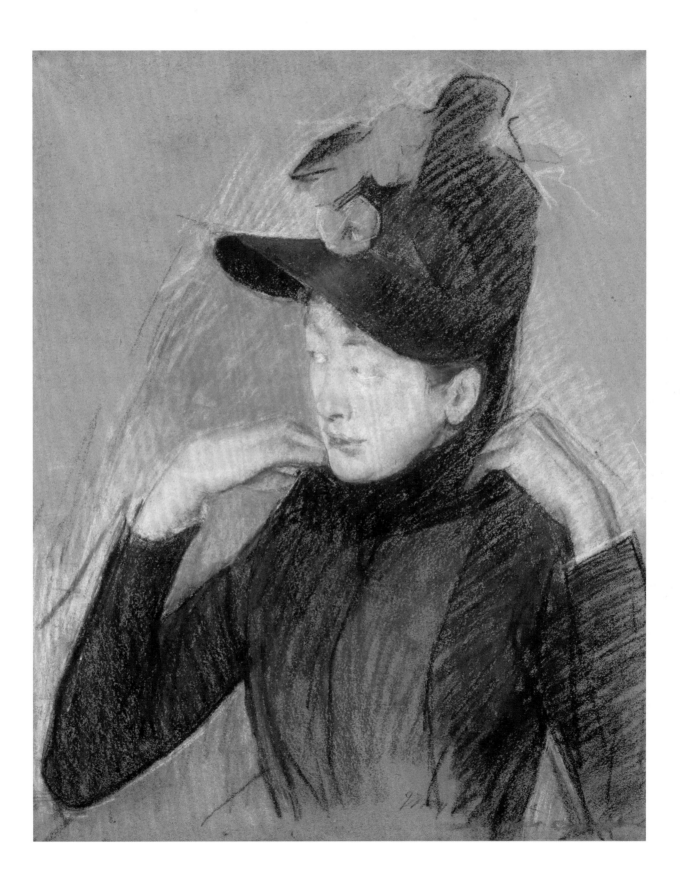

Drawing's Journey

Drawing's long journey—from being thought of as notes and preparatory sketches to being seen as serious works of art worthy of being collected and exhibited—actually began in the Renaissance. For centuries, drawing was seen as a means to an end. Drawing helped the artist think through and visualize an idea, but the real goal was a finished work in oil or marble. Michelangelo destroyed many of his drawings, thinking of them as merely steps in planning his sculptures and paintings. Though he did some finished drawings as illustrations for his poetry, he mostly considered drawing a means to an end.

Some Renaissance collectors and connoisseurs, however, began to think of drawings by famous masters as objects of beauty in and of themselves. Many Renaissance drawings survived because collectors believed the drawings allowed them to glimpse the creative process of important artists like Michelangelo, Leonardo da Vinci, and Raphael. Other collectors were simply interested in the methods and materials of drawing. For example, the Italian artist and author Giorgio Vasari (1511–1574) preserved thousands of drawings by his contemporaries. His writings, particularly *Lives of the Most Eminent Painters, Sculptors, and Architects* (1550), helped elevate the status of the crafts of drawing and printmaking.

Not until the eighteenth century in Europe do we begin to see drawings commonly commissioned as finished works. The French artist Jean-Baptiste-Siméon Chardin (1699–1779) received many commissions for portraits in pastel. By the end of his career, they were highly valued. Because portrait drawing in pastel was also considered a desirable part of a noblewoman's education, painters such as Rosalba Carriera (1673–1757) and Louise Élisabeth Vigée Le Brun (1755–1842) were able to gain acceptance and popularity as fine artists.

In the nineteenth century, pastels as finished works became a common part of many artists' output. For example, the American expatriate Mary Cassatt and her great friend and admirer Edgar Degas (1834–1917) further elevated drawings, in particular pastels, to the status of finished works by exhibiting and selling them as stand-alone artworks.

In 1916, American photographer and gallerist Alfred Stieglitz exhibited the charcoal drawings of Georgia O'Keeffe (1887–1986) at his Gallery 291 in New York. Describing the drawings as "pure, fine and sincere," Stieglitz not only launched O'Keeffe's career but also gave her drawings the same status as the works in oil he exhibited by other artists.

Drawing's importance as an independent art form is shown today by a steady stream of exhibitions of drawing of all types, by drawing majors in schools of art, and by the work of countless contemporary artists who see drawing as an important part of their work or as their whole artistic focus.

CONTEMPORARY GROWTH AND CHALLENGES

After World War II, drawing faced both highs and lows in Europe and America. On the one hand, some artists and critics, demoralized by the tragedy of the war, declared the traditional realist or representational arts, including drawing, to be dead. Art could be anything or nothing, and traditional means could not approach the complexity of the modern experience. By the 1960s, under the influence of reports of the "death of drawing," some university art departments discontinued drawing as part of their students' training and many artists gave up traditional mediums in their work, some turning to mediums such as video or installation art. Others gave up art-making altogether, sometimes returning to it after a thoughtful hiatus. For example, the American artist Marcia Hafif (b. 1929) gave up painting in the late 1960s but returned to art through drawing, which she saw as a way of beginning again with a clean slate. Hafif used pencil and paper to make simple marks. This allowed her to connect with traditional materials and ultimately to return to painting.

On the other hand, drawing was also being reconsidered as a primary language and vehicle for personal exploration. The German artist Gerhard Richter (b. 1932) explores drawing with a variety of mediums and material—often very experimental, including attaching a pencil to an electric drill.

Also, representational imagery in a variety of mediums, including drawing, has regained prominence since the 1980s. Exhibitions such as *Contemporary American Realism since 1960*, curated by Frank H. Goodyear and mounted at the Pennsylvania Academy of the Fine Arts in 1981, helped artists, students, and viewers refresh their view of representational art, including drawing. If subjects such as the human figure were to be described and interpreted in contemporary ways, drawing could be the vehicle for this exploration. From the mid-twentieth century on, artists as diverse as Richard Diebenkorn (1922–1993), Sidney Goodman (1936–2013), and Sarah McEneaney (b. 1955) have used drawing in vigorous ways to describe their personal journeys and visions—Diebenkorn through line and semiabstraction, Goodman through tonality and urban subjects, and McEneaney in the documentation of her daily life and private world.

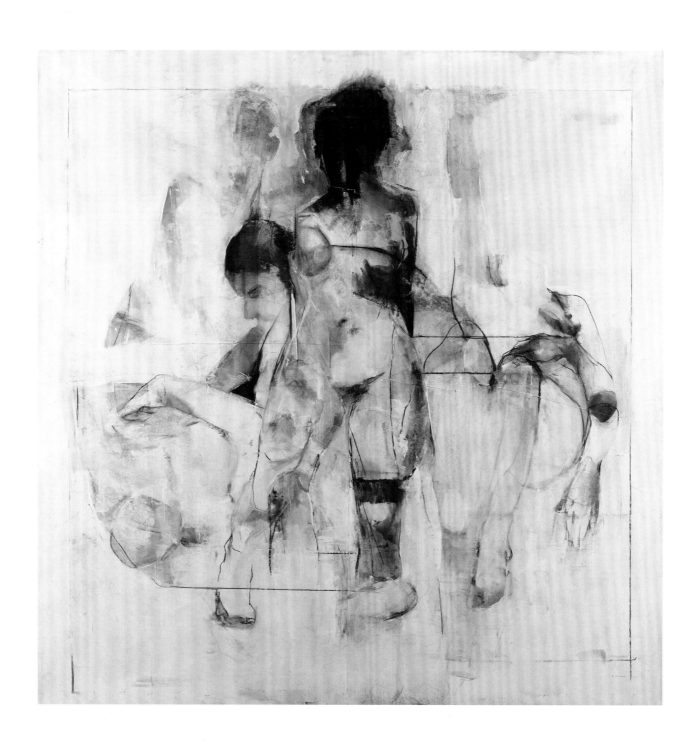

LEFT Marcia Hafif, *November 15, 2007*, 2007, Faber-Castell pencil 4B on Arches 250 lb. paper, 30 x 22 inches (76.2 x 55.88 cm). Courtesy of the artist and Larry Becker Contemporary Art (Philadelphia, PA). Photo credit: Larry Becker Contemporary Art, Philadelphia, by Zorawar Sidhu.

RIGHT Marcia Hafif, *November 12, 2009*, 2009, Faber-Castell pencil 4B on Arches 250 lb. paper, 30 x 22 inches (76.2 x 55.88 cm). Courtesy of the artist and Larry Becker Contemporary Art (Philadelphia, PA). Photo credit: Larry Becker Contemporary Art, Philadelphia, by Zorawar Sidhu.

Hafif responds to the pleasure of drawing through the touch of a pencil point on paper and minimal and precise marks. The intent is a pared down response to the physical act of mark-making.

OPPOSITE Sophie Brenneman, *We Made Our Own Lascaux*, 2016, charcoal, ink, and acrylic on parachute cloth, 56 x 56 inches (142.24 x 142.24 cm). Courtesy of the artist.

In this large drawing, Brenneman explores the interaction between the human figure and the abstract patterns and mark makings of modernist aesthetics.

TODAY

Now, a renewed interest in academic drawing has emerged as a way of exploring both the craft of drawing and an idea indicted by critics of 1960s: beauty in art. Small ateliers, attempting to re-create the academic curricula of the nineteenth century, have flourished in the last twenty years. The Florence Academy (with locations in Florence, Italy; Mölndal, Sweden; and Jersey City, New Jersey), the Grand Central Academy in New York City, and numerous other small ateliers uphold the classic, traditional disciplines of drawing.

As many modern artists have reexamined drawing, art schools have reinstated or upgraded drawing in their curricula, often establishing drawing (or works on paper) as a major equivalent to other fine arts majors like painting, sculpture, and graphic design. Drawing—using traditional, experimental, and mixed media—has become a common part of university and art school curricula, as well as a fixture of commercial art galleries and museum exhibitions.

In art galleries and museums, exhibitions of drawing done with experimental materials—blood, cut paper, video—are exhibited alongside drawings by old masters.

Not surprisingly, the debates between the Apollonians and the Dionysians, the Poussinists and Rubenists, the traditionalists and the avant-garde continue today. In art history, university symposia, critical writing, and curriculum design, the role and importance of drawing continues to be vigorously explored by artists, teachers, and scholars.

ESSENTIAL DRAWING MATERIALS

A comprehensive study of drawing includes trying out as many drawing materials as possible, and so this chapter provides a practical guide to those that are most commonly used. The descriptions include basic history, available types, aesthetic properties, and recommendations for the use of each.

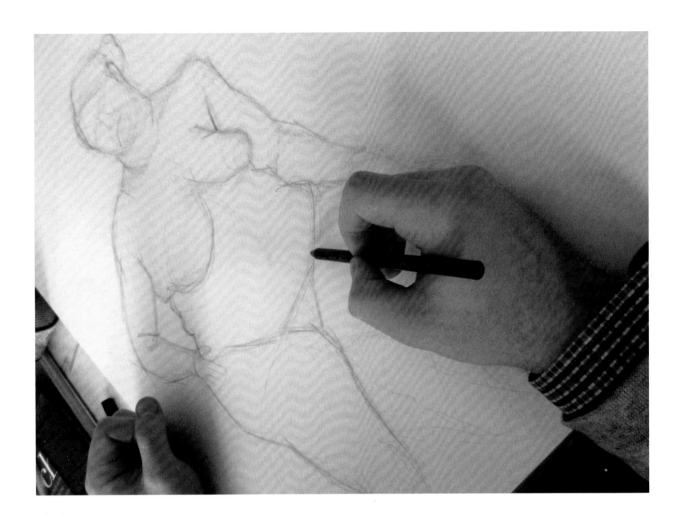

DRAWING MEDIUMS

A great variety of drawing mediums, in many different forms made by many different manufacturers, are on the market today. Some—such as charcoal, water-based paints, and chalks—have been in use for thousands of years and are still made the same way they have been since ancient times. For example, charcoal has been made by heating and burning wooden sticks since antiquity. Made from the branches of willow or other softwoods, today's vine charcoal sticks are light, soft, and ideal for quick, easy-to-modify drawings on any surface.

Modern versions of other ancient materials also exist. For example, early sanguine drawing sticks, so called for their reddish, bloodlike color, were made of naturally occurring clay or soft stone. Very popular since the Renaissance, sanguine easily lends itself to both line and tone and produces drawings characterized by a soft warmth of color. Modern sanguine is

Sophie Courtland, pencil sketch of a model, 2014, graphite on woven sketch paper, 11 x 8 inches (27.94 x 20.32 cm). Courtesy of the artist.

A most basic form of drawing is the small pencil sketch in a pocket sketchbook. This compositional study uses a great range of marks to evoke a variety of textures, tonalities, and spatial relationships.

OPPOSITE Student drawing with a graphite pencil.

composed of a mixture of reddish chalk or clay and gum arabic compressed into a stick or pencil form. Today's sanguine drawing materials look like their Renaissance ancestors and produce much the same results but have a more consistent quality.

Other drawing mediums were not invented until the nineteenth or twentieth century, like ink markers and oil pastels. These modern additions have extended the range of possibilities available to artists, especially in mixed-media works.

Graphite Pencils and Powder

Typically, the modern pencil is a rod of graphite encased in wood. Graphite is a naturally occurring form of carbon. The name graphite derives from the ancient Greek word meaning "to write."

In Italy, as early as the sixteenth century, cut graphite sticks were encased in carved wooden holders. Graphite quickly replaced the harder, more difficult to use rods of lead or silver in use since ancient times. Pencils are still often called "lead pencils," though lead has long since been replaced as a common writing material. Silverpoint, on the other hand, is still used by artists today (see the section on metal point, page 62).

The graphite used today in pencil or stick form is a compound of graphite and clay. This mixture is compressed in molds to form the desired shape, and the hardness or softness of the pencil is determined by the amount of clay and the force of the compression. (Softer grades have more clay and less compression; harder grades have more graphite content and a greater degree of compression.) Graphite rods are placed in wooden shafts to form the familiar modern pencil, but graphite sticks, without a wood casing, are also available. Graphite sticks come in a variety of shapes, from thin rods to square sticks. The sticks can be used directly or placed in a holder. The most common holder is the mechanical pencil.

Graphite pencils are ideal for line drawings and light shading. Pencils come in a range of densities—harder or softer—each designated by a number and letter. H stands for hard and B for soft, and the full range extends from 6H (hardest) to 9B (softest). Artists choose different densities of graphite to produce specific aesthetic effects. Harder densities are desirable for clean, clear line and contour drawings. Shading with harder densities produces light gray tones as well as clearly delineated hatching marks. Softer densities more easily create dark lines and softer, more atmospheric shading effects and softer pencils are easier to blend. The common 2B pencil used in schools and offices is an intermediate density. A practical writing tool, it is also good for general sketching.

Brian Baugh, *Still Life With Skull*, 2005, graphite on paper, 22 x 14 inches (55.88 x 35.54 cm). Courtesy of the artist.

Essentially closed form, or contour line–oriented, this drawing utilizes a light touch to create delicate tone changes. Lightly dragging the pencil point over the grain of the paper—a technique called graining—is combined with light hatching and contour line.

Because of its mineral nature, graphite can have a shiny surface quality, especially when built up heavily on a drawing surface. Graphite marks are generally easy to erase and blend on all kinds of paper, though the harder the density, the more difficult it is to erase the marks because of the intense compression of the graphite. The hardest grades may even cut into and damage a soft or thin paper surface.

Graphite pencils can easily be combined with most other drawing mediums—but not all. You'll need to experiment to achieve a clear understanding of how pencil can or cannot be mixed with other mediums. For example, an ink wash can be used to color or shade a light pencil sketch, but a heavy dense layer of graphite from a graphite stick will repel water-based ink. Charcoal and pastel can easily be used over light pencil sketches, while pencil is generally too hard to be layered over charcoal or pastel. Graphite sticks work very well alone or with graphite pencils to create soft tones and broad marks. Soft versions are especially useful as an alternative to charcoal for shading and tonal work.

Graphite powder is also available. A mixture of graphite and clay in a loose, powdered form, graphite powder is often applied with a dry brush. The powder can also be easily blended and mixed with other mediums, such as pastel. Graphite powder can be manipulated much in the same way as pastels and chalks and may require a protective fixative. Because of their generally less dusty nature, however, pencil drawings (except those made with a very soft pencil grade) do not usually require protection by a fixative. (For more on fixatives, see page 57.)

Graphite pencils and sticks can be sharpened with a standard pencil sharpener or shaped with a blade. H-grade pencils will generally retain their properties of delicacy and grayness even when their points are worn down. B-grade pencils and sticks can be sharpened to fine points for details or used with a dull point to provide rich, dark, broad effects.

When deciding which graphite forms to use in your work, consider a number of factors: If a clean, light line drawing is desired, either for layout or finished art, one of the H-grade series might be desirable. The line will be gray, very clean, thin, and difficult to smear or blend—suitable for artists doing technical or highly detailed drawing or who like a light layout under a darker pencil finish. With their range of softer, darker marks, B-grade pencils are more easily blended. B pencils and sticks are more desirable for art with soft atmospheric effects and less so for more precise works and line-oriented works. Pencils in the range of 6B to 9B can make extremely dark, velvety marks, and B pencils of different grades are easily mixed to provide a variety

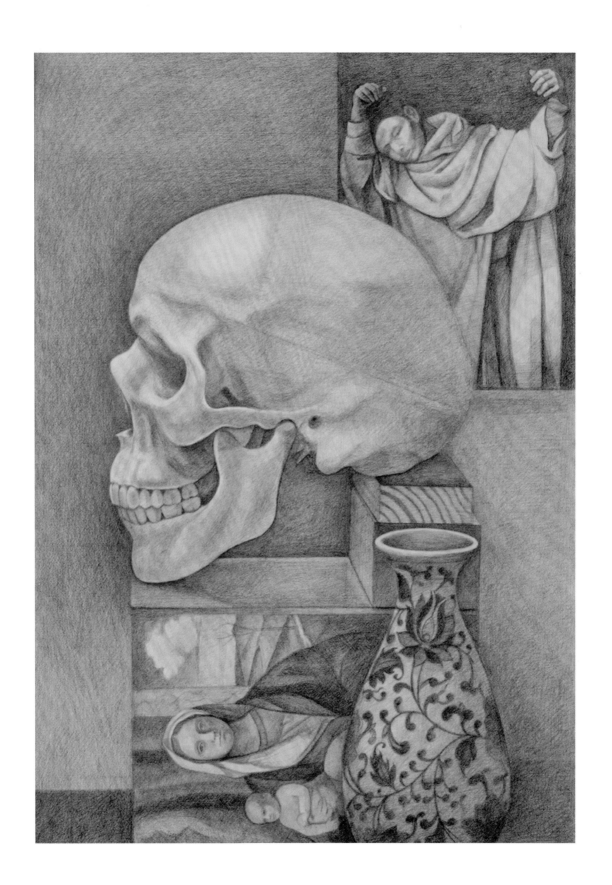

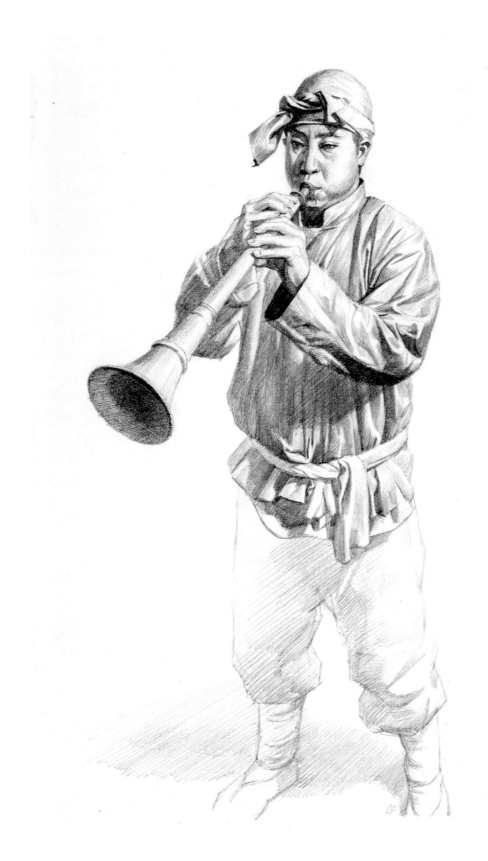

of tonal effects and shadings. Because of their relative softness, the B grades are easily smeared by accident and may require a fixative for permanence.

Another factor to consider when drawing with pencil or graphite is which paper to choose. Pencil marks are directly affected by the hardness, softness, and texture of drawing papers. B-grade pencils take poorly to very hard hot-pressed papers that have little texture or are very glossy. Generally speaking, H-grade pencils work best with smooth, hot-pressed papers where fine detail is required, while B-grade pencils perform best on more textured cold-pressed papers.

Yet another important consideration is the scale of the drawing you want to produce. For a drawing smaller than 16 x 20 inches, H-grade pencils and B and 2B pencils will provide fine detail and clarity that works well on a smaller scale because the small size of the drawing requires close-up viewing. As you scale up a drawing to a paper size that must be viewed from a few feet away, however, these finer pencil grades begin to look too thin, gray, and weak. For drawings larger than 16 x 20 inches, soft grades of graphite pencil, graphite stick, and graphite powder work well because of their darker values and their ability to describe broader atmospheric and tonal areas. Such pencil drawings look very strong from a viewing distance of several feet or more.

The finished effect of graphite powder is similar to that of soft vine charcoal, though smoother. Even so, there are important differences. The various grades of charcoal can provide vastly more expressive, darker effects than graphite. Even very soft graphite may begin to lose integrity on a large scale, and charcoal may be preferable.

Charcoal

Artist's charcoal is made by heating wood in a closed oven at a temperature high enough to quickly remove all moisture and completely char and soften the wood. Any burned wood could theoretically be used for drawing, but artists' charcoals are soft and consistent in texture and quality. Willow and other softwoods, like linden, are used in the manufacture of most artist's charcoal. Hardwoods like oak are rarely used because they are too dense and fibrous. The character of the wood can affect qualities such as smoothness, darkness, and response to paper surfaces.

There are two basic types of artists' charcoal: vine charcoal and compressed charcoal. Vine charcoal is made from charred sticks of soft wood, such as willow, and can be produced in softer or harder grades depending on the hardness of the wood chosen. Vine charcoal is usually very brittle and soft, and it can be easily blended or smeared. It allows for

a light touch and is easily erased, though it might leave a light ghost image on the page afterward. Its forms vary from actual willow sticks, which have all the irregularities of a plant branch, to square and round rods that have been cut and shaped by commercial saws. Available in soft, medium, and hard densities and in sticks of different sizes, the charcoal can appear dry and gray or velvety and very black. Many artists choose a favorite type and brand of vine charcoal and use it consistently. Some like to make their own, or they buy unusual forms of vine charcoal made from irregular chunks of wood.

Compressed charcoal is made by adding a binder like gum arabic to charcoal powder and then compressing the mixture under high pressure. Compressed charcoal comes in a variety of densities, or grades, from soft to hard, depending on the amount of gum added (the more gum, the harder the grade). It is more permanent and harder to erase than vine charcoal. Generally, compressed charcoal has a bolder, heavier feel and look than vine charcoal and can produce a broader range of deep darks and black tones than is possible with vine charcoal.

Both vine and compressed charcoal sticks can be used by placing their ends or their edges on the paper, and both can be sharpened to points for more precise lines. The sticks are too brittle for a mechanical sharpener, however, and must be sharpened carefully with a blade or fine sandpaper. When used on their sides, charcoal sticks of both kinds create broad areas of tone. And both kinds of charcoal can be blended with a paper blending stump (tortillon), a chamois cloth, a paper towel, or even your fingers.

Peter Van Dyke, *Evening Class*, 2009, charcoal on charcoal paper, 24 x 18 inches (60.96 x 45.72 cm). Courtesy of the artist.

A light, quick touch using broken line characterizes this figure study.

Charcoal powder is also available commercially; it has similar uses in developing tonality and blended effects. It can be used to create broad, soft, and dark tonal areas, especially when blended into the grain of the paper. Vine charcoal powder has a softer, less black effect than compressed charcoal powder, which is generally blacker and darker. Both types are often applied to paper with a soft brush and blended with a brush or stump.

Compressed charcoal is also made into rods for use in pencils bound in wood sleeves or in paper sleeves that are unraveled to expose more charcoal as it is used up. The pencils come in a variety of densities and are graded in the same way as the stick form: soft, medium, hard, and so on.

Because of the protective sheath around the charcoal rod, charcoal pencils can be sharpened with either an electric sharpener or a blade.

Knowing which kind of charcoal to use requires experimentation, practice, and an awareness of the aesthetic you want. Many artists use vine charcoal for quick sketching on a large drawing pad, such as a newsprint pad. Because vine charcoal marks can easily be changed or erased, it allows for experimentation and lots of reworking. Some beginning students making the transition from pencil to vine charcoal complain that the charcoal is messy and hard to control, but they generally become more comfortable with it. It lends itself to the exploration of big forms, gesture lines, and broad, simple tonalities and is excellent for sketching in beginning life-drawing and still-life classes because of its flexibility and the ease of correction.

The look of a quick vine-charcoal sketch can be graceful and light or dark and energetic. In a larger, more finished drawing, vine charcoal can provide a wide range of soft blended effects as well as strong, dark lines and tones. Because it can be used to create subtle value gradations and light lines, it is highly desirable for elaborate finished drawings. It is also an excellent material for doing an underdrawing to which compressed charcoal or pastel will be added. Many artists begin a drawing using vine charcoal for the layout, basic lines, and tonalities and then work over the layout with compressed charcoal, Conté, or pastel. Combined with these mediums, vine charcoal can enhance the subtlety of a drawing.

Compressed charcoal sticks and pencils require a more definite hand and a more deliberate decision-making process because their dark marks are not easily erasable. For this reason, many artists will lay out a drawing in vine charcoal and add compressed charcoal only when they feel the structure and look are correct. Utilizing the inherent qualities of compressed charcoal—the rich and velvety intensity of the darks, its boldly expressive qualities, and its permanence—can make a drawing very powerful.

The work of Sidney Goodman, the master Philadelphia figurative painter, exemplifies the word *painterly*. His use of charcoal and pastel evokes the feeling of atmospheric oil paint on canvas. Initially laid out in broad, loose lines, tonal masses are blocked in broadly with the side of the charcoal. Edges are clarified by sharper or softer contrasts and textural differences.

This lovely and romantic study utilizes tonal masses that are then blended and finished with hatching and line touches.

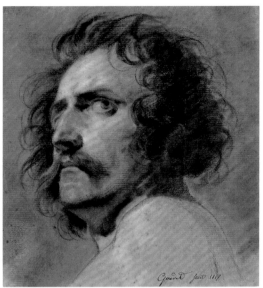

The choice to use compressed charcoal pencils depends on whether fine lines, hatching strokes, or careful details are needed in the drawing. A drawing done entirely in charcoal pencil will exhibit a strong and definite set of lines and marks. Like compressed charcoal sticks, charcoal pencil marks are relatively hard to erase, permanent, and dark. Some artists add sharpened charcoal-pencil lines to complete a drawing laid out in soft graphite pencil or vine charcoal.

My general recommendation to beginners is to experiment with vine charcoal of varying grades to get a feel for charcoal's range, then add compressed charcoal sticks or pencils into the mix. In a very short time, you will have a good sense of the possibilities drawing charcoal offers.

As with graphite drawings, paper choices are important. Charcoal works best on paper that has enough grain, or tooth, to hold the charcoal particles well. Papers that are smooth may resist the charcoal or cause the charcoal to slip around. Charcoal and pastel papers have a strong tooth and allow for extensive reworking through erasing, blending, and layering. Other suitable papers that work well with charcoal include the rougher grades of sketch paper, newsprint, and craft papers. Charcoal drawings are very susceptible to damage from accidental smearing. Fixatives are often used to preserve and protect the charcoal layer. Careful storage of charcoal drawings is also important. The drawings should be preserved from wear and tear by being layered carefully in a storage container, ideally between layers of acid-free glassine or tissue.

Holders for Charcoals, Pencil Leads, and Chalks

Before the development of wood-encased pencils, simple mechanical holders were often used to provide better drawing control. Drawings, engravings, and paintings from the fifteenth through eighteenth centuries show artists drawing with these simple tools. Common for centuries, simple holders are readily available today from art supplies vendors. These wood, metal, or bamboo holders allow the artist to hold a sharpened piece of charcoal, sanguine, graphite, or pastel much like a wood-encased pencil.

Many artists prefer this older device for its versatility and the variety of materials it can hold, including larger pieces of chalk.

Mechanical pencils, sometimes called filler pencils, are used for many forms of drawing, including mechanical drawing, as well as for writing. In use as early as 1822, mechanical pencils commonly hold thin rods of graphite or chalk. The pencil's mechanism allows for easy refilling. Artists who require a thin point for detail often prefer mechanical pencils.

Robert Bohne, *Cat and Snow*, 2014, charcoal and white chalk on pastel paper, 20 x 16 inches (50.8 x 40.64 cm). Courtesy of the artist.

The abstract shape and design elements of this drawing are very strong. The sense of depth is very much in tension with the patterns of light and dark.

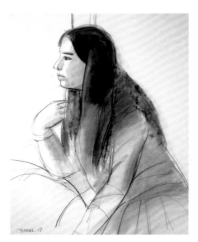

Elizabeth Osborne, *Leslie*, 1969,
Conté on paper, 28½ x 22½ inches
(72.39 x 57.15 cm). Courtesy of Locks
Gallery (Philadelphia, PA).

Conté

Conté sticks and pencils are made of dry pigments mixed with wax or clay and compressed into square sticks or thin rods that can be held in a metal or wooden holder or sheath. Conté typically comes in varieties of whites, grays, browns, and blacks and in a range of densities from soft to hard; the harder forms have more binder or wax and the softer less. Softer grades of Conté mix well with charcoal (vine and compressed) and pastel due to their lower wax content and more chalk-like nature; the harder grades, which have more wax binder, may not mix well with charcoals and pastels.

Modern red or brown Conté is often a replacement for the sanguine chalks used in many early master drawings. The iron-rich red clays and soft reddish stones used to make the early sanguine and red-chalk drawings are still available but have largely been replaced by modern equivalents such as Conté. Like compressed charcoal, Conté provides a strong, definite, and relatively permanent mark. For this reason, it is often added over an underdrawing of soft pencil or vine charcoal. Conté sticks and pencils can be used broadly and roughly or sharpened to a point with a blade or sandpaper. Like charcoal and pastel pencils, Conté pencils can also be sharpened in an electric sharpener for a fine point.

The aesthetic effects of Conté can be described as rich, bold, and definite. As with compressed charcoal, the choice to use Conté is driven by a desire for bold expressive properties and strong and clear lines, or both. Using brown, gray, or sanguine Conté in addition to black enables the artist to create a drawing that has warmth and variety without going into full color with pastel. (Conté is also less dusty and smear-prone than pastel.)

The best papers to use for Conté are cold-pressed papers and charcoal papers that have enough tooth to hold the Conté's chalk grains. Like charcoal and pastel, Conté works well on toned papers. Soft white Conté is an excellent choice for creating highlights in a charcoal or Conté drawing done on toned paper.

Sanguine

From the Renaissance through the nineteenth century, sanguine was a common drawing tool. If a drawing is described as having been done in red chalk, that often means it was created with sanguine. Contemporary drawing products labeled as sanguine as well as modern brown and red Conté and pastel simulate the effect of red sanguine chalk, creating a bit of confusion as to how sanguine is different from these products. Named for their blood-red or reddish-brown color, sanguine sticks and pencils are similar to Contés

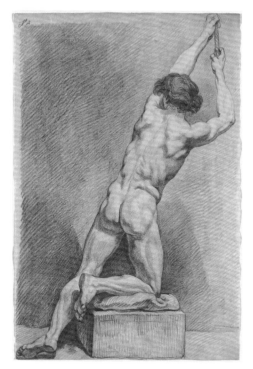

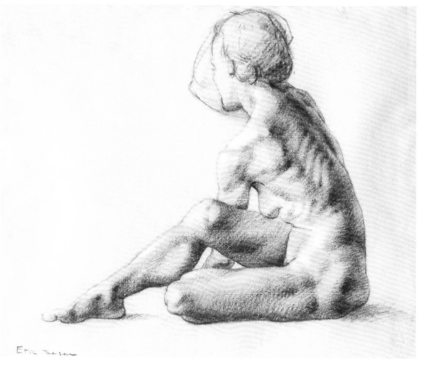

This graceful figure was probably
done in the life-drawing studio of a
local atelier. The pose, the structure
the model is sitting on, and the
relative naturalism of the model
suggest a drawing from life.

Inspired by the drawings of
eighteenth-century Rococo masters,
this work utilizes a fine-line contour.
Form, light, and shade are built by a
combination of directional contour
hatching and local contour hatching.

and pastels in composition—powdered pigment bound with wax and
compressed into a stick or pencil form.

Drawings done in sanguine are characterized by a warm, soft, reddish
glow. Preferred especially for figure and portrait drawings, sanguine provides
a fleshlike warmth that black and white drawings cannot. Such drawings are
often done entirely with sanguine, though it is very common for a touch of
black Conté or charcoal to be added for emphasis and additional darks. The
traditional *trois colours* ("three colors") drawing method refers to a sanguine
drawing enhanced by touches of black and white on toned paper. The reason
to use sanguine is similar to that for using brown or red Conté: The warmth
of the color may enhance the richness of the drawing, giving it a stronger
feeling of life. Using the trois colours method lets you achieve a rich range
from light to dark and warm to cool with minimal means.

Like Conté and pastel, sanguine requires a paper that has enough tooth
to hold the grains of the chalk. Traditional charcoal and pastel papers are
ideal. Because sanguine tends to be a middle tone in value, a light middle
tone or white paper is preferable. Adding black and white allows for a
greater range of values.

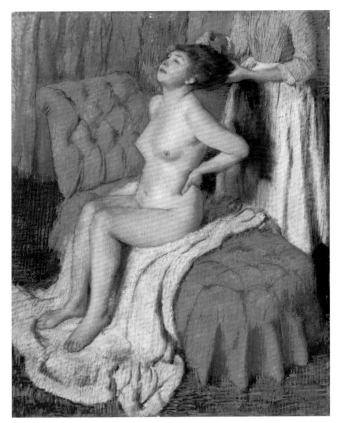

Edgar Degas, *Woman Having Her Hair Combed*, c. 1886–88, pastel on light green wove paper (now discolored to warm gray) affixed to original pulpboard mount, 28⅛ x 23⅞ inches (74 x 60.6 cm). Metropolitan Museum of Art (New York, NY). Bequest of Mrs. H. O. Havemeyer, 1929, 29.100.35. Photo credit: © The Metropolitan Museum of Art; Art Resource, New York, NY.

Even though this image has strong shapes, masses, and colors, it was made with a buildup of lines of varying lengths and directions. Degas's early training as a classical, closed-form draftsman informed his mature techniques.

Sidney Goodman, *Night Vision*, 1992–94, charcoal and pastel on paper, 83½ x 59 inches (212.09 x 149.86 cm). Private collection. Courtesy of the artist and his family.

Goodman utilizes one of the most classic pastel techniques in this image. He adds colors into a highly developed charcoal drawing. This way, the integrity of the tonal drawing is maintained while it is enriched with areas of color. The colors match the tonalities and structures created by the charcoal.

Jill A. Rupinski, *Circle of Change*, 2004, pastel on pastel paper, 25 x 52 inches (63.5 x 132.08 cm). Courtesy of the artist.

Rupinski creates a balance between broken-line touches of pastel and strong shapes. The linear nature of the trees and branches provides a grid through which atmospheric color glows.

Pastels

Pastels, sometimes called chalk pastels, are made by grinding dry pigments in water and then adding gum arabic as a binder. The wet paste is then formed into round or square sticks and allowed to dry. Shades and tints of pastel colors are made by adding white pigment to the paste. Pastel pencils consist of a pastel rod encased in a wooden sheath, much like charcoal, graphite, and Conté pencils.

Pastels are available in softer or harder densities depending on the amount of gum binder in the pigment. Different brands have different densities. Like the soft grades of charcoal and Conté, most pastels are easily blended. Pastels mix well with charcoal and soft Conté and can be sharpened in the same ways—by using a blade or sandpaper for sticks or an electric sharpener for pencils.

The choice to use pastel often comes from a desire to explore color drawing. The earliest pastel drawings, in sixteenth-century Italy and northern Europe, were usually charcoal or sanguine drawings enhanced by a few color touches in the light areas and highlights. Grays would sometimes be added in the transitions between light and dark, and browns were added to shadows. By the eighteenth century, especially in France, pastel had become a full-color medium. And by the end of the nineteenth century, pastel was, like watercolor, considered a serious art form.

Modern pastels provide a rich palette of colors and expressive properties. Pastel can be built up on the paper, color over color, and then drawn into repeatedly with a variety of strokes and marks. Colors can be mixed and blended on the paper to provide unique colors, shades, and tints. The drawbacks of pastel include exposure to toxic pigment dust, especially when using bright colors, and the vulnerability of the pastel surface to accidental smearing and damage. Artists who use pastel often wear gloves and a dust mask or they will place wet paper towels under the drawing to catch dust.

Pastel sticks, like charcoal and Conté sticks, can be used broadly to make wide marks, tones, and color passages. They can also be used on their edges or points for more precise marks, such as hatching or linear effects. Pastel pencils are ideal for line or hatching techniques as well as for definition in an otherwise broadly developed pastel surface.

Papers for pastel need to have enough tooth to hold the pastel particles. Pastel papers range from traditional laid and charcoal papers to paper coated with fine sand for greater textural possibilities. Fixatives are used to preserve the chalk surface and minimize smudging and smearing. Pastel drawings, like charcoal and Conté drawings, are best stored in a flat container between sheets of acid-free glassine or tissue.

Powdered Pigments

The same pigments used to make oil paints, watercolors, charcoals, pastels, Conté, and other mediums are available in powdered form in many art supply stores. Pure powdered pigments have a variety of uses. Some artists like to use them to make their own oil paints, watercolors, and pastels. This labor-intensive process can provide materials of the specific consistency desired by the artist, which commercial products may not provide.

Dry pigments can be used to tone and color drawing papers by spreading the powder over the paper and blending it into the paper's grain. The paper can then be drawn on with other dry mediums, such charcoal or pastel.

Some artists use dry pigments experimentally when exploring or extending the range of their drawing approaches. Others use dry pigments as a planned part of a drawing that requires soft effects as part of a layering process. The characteristics of dry pigments allow an artist to create mixed effects and a variety of layers by combining blended dry pigments and marks made by charcoal, Conté, pastel sticks, or wet mediums.

Drawbacks include exposure to airborne, potentially toxic color particles and the vulnerability of the pigments to accidental smearing. As with pastel, precautions should be taken to minimize exposure to dust particles. Drawings that include powdered pigments should be stored using the same precautions followed with chalk drawings: Place them in a flat container, interleaving sheets of acid-free glassine or tissue between them.

Colored Pencils

Colored pencils are essentially pigment mixed with wax and then formed into rods that are encased in wooden sleeves, just like graphite pencils. They also come in water-soluble forms in which the binder is gum arabic. Water-soluble colored pencils work well as an alternative to watercolor when a mix of line and wash is needed.

Although they can be erased and blended, colored pencils are less malleable than graphite pencils because of their wax or gum arabic content. Their hardness or softness is determined by the amount of binder in them. The wax or gum arabic binder minimizes toxicity by encapsulating the particles and binding them together. Though colored pencils are less toxic, there is still a danger from the particles on the hands. Always make sure to wash your hands after using most drawing materials.

Colored pencils can be sharpened in the same manner as other pencils, by using a blade or mechanical pencil sharpener. The wax in colored pencils may keep pastels, charcoals, or water-based mediums from adhering well

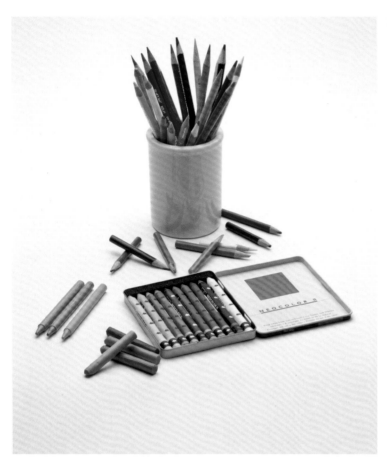

LEFT Photo credit: Peter Groesbeck.

RIGHT Samuel Thuman, *DDT*, 2013, colored pencil, marker, and graphite on illustration board, 13 x 18 inches (33.02 x 45.72 cm).

The colored pencil provides color and texturing in the upper portion of the drawing and in the center over the patterning of the woman's blouse. It also provides the pale blue background. The combination of materials creates interesting illusions of texture, expression, and pattern.

to colored pencil marks if they are too heavy or broad. Also, colored pencil marks are difficult to blend due to their wax or gum arabic content.

The most valuable property of colored pencils is their ability to produce fine lines in a variety of colors. As an alternative or addition to graphite pencil, colored pencils can produce fine, clear line-based drawings in full color. Broad color tones can be created through the use of hatching or by using the broad side of the pencil point roughed over the paper.

A variety of papers are suitable for colored pencils, from vellum and hot-pressed papers and illustration boards to mildly grainy sketch paper. Very rough charcoal and pastel papers may cause colored pencil marks to be unclear, though sometimes that is a desired aesthetic effect.

Colored pencil drawings do not usually require a fixative because they are less subject to smearing or smudging than chalk-based drawings. Still, flat storage and acid-free interleaving are recommended.

Samuel Thuman, *Still Life with Clay Head*, 2015, oil pastel on paper, 23 x 19 inches (58.42 x 48.26 cm). Courtesy of the artist.

Oil Pastels

While traditional chalk pastels are made of pigment with a light binder like gum arabic, oil pastels (also called wax oil crayons) are bound by an oil such as linseed oil, or wax, or both. Oil pastels have unique characteristics, which some artists describe as being similar both to wax crayons and to traditional chalk pastels. Depending on the brand, oil pastels may feel more waxy or more oily; they have varying degrees of maneuverability.

Most modern oil pastels are somewhat like children's crayons, although they are richer and stronger in color due to their higher pigment content. They are less fragile than chalk pastels but do not mix easily with chalk drawing mediums because of the resistant nature of their binders. They mix best with other wax-based mediums, such as colored pencils and grease pencils. They can be used to draw over dry watercolors but perform poorly on a wet surface. While fixatives are not required for oil pastel drawings, safe flat storage and acid-free interleaving are recommended.

Grease Pencils and Lithographic Crayons

Grease pencils, also known as china markers, use wax to bind their pigment. Commonly, the wax pigment rod is encased in a paper sheath that can be unraveled to expose more of the rod. Similar to colored pencils in composition, grease pencils' density is on the softer side but their color range is not as great as those of the colored pencils on today's market. Black, red, blue, green, and white are the most common colors.

Used primarily for practical purposes such as marking measurements on surfaces, mapping the parameters of shapes, and making written notations, grease pencils can also be used for fine-art drawing purposes. Because the pigment rod is large and hard to sharpen, grease pencils have a quality similar to children's crayons.

Lithographic crayons are similar to grease pencils. These are made from pigment bound with wax or another oil-based material. Lithographic crayons make rich dark lines and tones and are not water-soluble.

Children's Crayons

The term *crayon*, with Latin and French roots and in use since the seventeenth century, describes a great number of wax-based drawing sticks. The pigment is mixed with a wax binder and made into sticks, which are either left unwrapped or are wrapped in paper or wood. Although the name crayon is applied, most familiarly, to the waxy drawing sticks used by children, it is also used for professional artist materials such as Conté crayons.

Some adult artists do use children's crayons, however, liking their immediacy of color and line. Such crayons may not have the same chromatic intensity as professional mediums, but they mix well with all other wax-based mediums. Like oil pastels, they can be used to draw over dry watercolors. Storage of crayon drawings requires the same precautions as other drawings on paper.

Samuel Palmer, *Early Morning*,
1825, pen and dark brown ink with
brush mixed with gum on paper,
7²/₅ x 9¹⁷/₁₀₀ inches (18.8 x 23.3 cm).
Ashmolean Museum (Oxford). Photo
credit: Ashmolean Museum/The Art
Archive at Art Resource, NY.

His work reminiscent of that of the
British artist/poet William Blake
(1757–1827) and later, the American
Charles Burchfield (1893–1967),
Samuel Palmer (1805–1881) creates
a fanciful visionary world in his
drawings. Here, pen, ink, and wash
are used to illustrate a world that
could easily be inhabited by Hobbits.

Peter Groesbeck, *My Father Departed*,
2000–2013, India ink on paper,
10 x 10 inches (25.4 x 25.4cm).
Courtesy of the artist.

Abstract Expressionism and bad
dreams are paired in equal balance
in this wash drawing. Starting freely
on the paper with little preparation,
marks and washes are built up
quickly.

Fixatives

Fixatives protect and preserve the surfaces of pastel, charcoal, and other chalk-based drawings. They have a long history. Spritzing the surface of a drawing with milk or gum arabic, either by hand using a small stiff brush or by blowing droplets through a small tube, was common during the Renaissance. Other materials used to fix drawings included shellac and varnishes mixed with alcohol. These early fixatives provided stability in the short term but often encouraged the growth of mold, which eventually damaged the paper. Fixatives containing alcohol and lacquer and applied with an atomizer became common in the nineteenth century. These fixative sprays provided better permanency but could yellow the paper.

Modern fixatives come in workable (temporary) and permanent aerosol sprays. Most are made of non-yellowing acrylic materials that will not damage a drawing when used according to directions. Some artists prefer to not fix their drawings, while others like making their own fixatives and use atomizers or older fixing methods to apply them.

Fixatives of any type are potentially toxic and should be used only in spaces with very good ventilation, never indoors in an unventilated space. Ventilated spray rooms, portable ventilators, exhaust fans, or outdoor use are recommended for health and safety. Fixed drawings should be stored in the same way as other drawings, especially chalk-based works.

Inks

Inks have a long and romantic history. Early inks were made from such diverse materials as vegetable and berry juices, walnut juice, squid and cuttlefish ink, and ground charred bones or other carbon materials mixed with water. The water-based liquid vehicle for the colorant often included lacquers, alcohol, or other materials for stability. Some early inks were permanent, while others faded or changed colors with age.

Modern inks are grouped into two types: inks made from dry pigments dispersed in water and inks made from dyes. Both may have glues and lacquers added for quick drying and permanence, or they may simply be pigment mixed with water. Pigment-based inks tend to be more lightfast—meaning they do not fade readily—while dye-based inks may fade. For example, India ink, made from carbon dispersed in water, is very permanent because of the stability of the carbon pigment, while the dye pigments used in felt-tip marking pens are not lightfast. Ink manufacturers provide permanence ratings in their product information, and it is a good idea to consult them.

Elizabeth Gallagher, compositional studies for paintings, 2014, markers and pastel on paper, each 4 x 4 inches (10.16 x 10.16 cm). Courtesy of the artist.

The basic design is drawn in black marker. Color is added with markers and pastel.

Inks are generally transparent, but opaque and white inks are also available. Like writing inks, drawing inks come in a range of colors and can be used on surfaces of many kinds. Artists apply inks with pens, brushes, sponges, and a variety of other tools. Again, experimentation is key to understanding the creative properties of inks and the tools used to apply them.

Markers

Marking pens are useful as an alternative to traditional inks applied with pens and brushes. Markers are hollow tubes containing permanent (nonreversible, solvent-based) or nonpermanent (reversible) water-based ink with a fibrous, porous nib. Lightfastness is an issue, and product specifications should be checked carefully.

Markers come in a great variety of colors and sizes, with tips of various types. Fine-point markers simulate some of the qualities of traditional dip pens. The fibrous tips of so-called brush pens are longer and more flexible than those of other markers and simulate the marks made by a pointed brush. Markers are easily used in conjunction with other mediums such as watercolor and chalks for mixed-media effects.

Watercolor and Gouache

Watercolors of one form or another have been present in the history of drawing from its beginning. The earliest appear in Paleolithic art in caves and at gravesites. Water-based colors were commonly used by the Egyptians, Greeks, and Romans for drawings on documents, books, and frescoes. Beautiful watercolor designs illuminated medieval European manuscripts and early machine-printed picture books. Watercolor and gouache have been used historically to color illustrations first laid out in pencil or ink. Because of this, watercolor and gouache have often been included in the study, teaching, and practice of drawing by artists and designers. Since the nineteenth century, watercolor has been acknowledged as a major art form and is the preferred medium of many artists as a bridge between drawing and painting.

Watercolors are made by mixing dry pigments with water and gum arabic. Modern watercolors come in two forms: as dry cakes or as wet paste in tubes. Once they are dried on your palette, you can easily revive watercolors in either form by adding water.

Watercolors' permanency, durability, and lightfastness have improved considerably since the early nineteenth century, and modern watercolors have the same reliable qualities as oil paints and inks.

While traditional watercolor is generally transparent—in the sense that a color will show through another color laid on top of it—gouache is an opaque

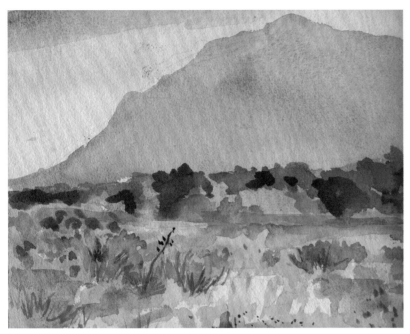

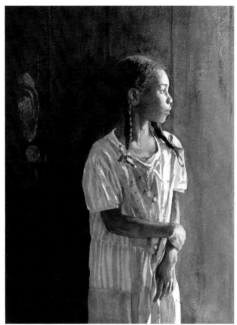

LEFT Al Gury, *New Mexico*, 1990, watercolor on paper, 11 x 14 inches (27.94 x 35.56 cm).

A light pencil drawing was used to lay out the composition. Color patches of thin watercolor were built up until darks and high-chroma colors achieved their full intensity.

RIGHT E. B. Lewis, *Waiting for Spring* (illustration for *Coming On Home Soon* [New York: G. P. Putnam's Sons, 2004]), 2004, watercolor on paper, 9¹⁄₂ x 11³⁄₄ inches (24.13 x 29.8 cm). Courtesy of the artist.

Lewis lays out the primary drawing in pencil and then adds washes of color, from lightest to darkest. This beautiful watercolor has a soft atmospheric quality created by keeping the edges from becoming too sharp and clear.

form of watercolor. To make gouache, chalk or clay is added to create greater density and opacity. Like traditional transparent watercolors, gouache comes dry in cakes or wet in tubes. Watercolor and gouache can be used together in the same artwork. Traditional watercolor makes extremely transparent washes, while washes of gouache range from slightly cloudy to very opaque.

Varieties of white opaque watercolor have been used for centuries, often in conjunction with ink drawings. When a master drawing is labeled as "pen and ink heightened with white," the word white refers to opaque white watercolor used for highlights in the drawing.

Watercolor or gouache washes are often used as a base for other chalk- or wax-based drawing mediums. Inks applied with brushes or pens are a traditional companion of watercolors. These mixed-media drawings have been a common aesthetic form since the late nineteenth century. Today, some artists mix watercolors with other mediums such as charcoal, pastel, and graphite pencil.

Storage and care of watercolor works are similar to that of other works on paper. Storing flat, layering with acid-free protective papers, and minimizing exposure to light aid in the longevity of drawings and other works on paper.

Tom LaPine, *Study in Harmony*, 2016, gouache on white paper, 12 x 7½ inches (30.48 x 19.05 cm). Courtesy of the artist.

LaPine first laid out his drawing with pencil and then built up large blocks of underlying tone with thinned, watery gouache. He finished the drawing with dense, flat strokes of gouache to create the effects of variety, movement, and color interaction.

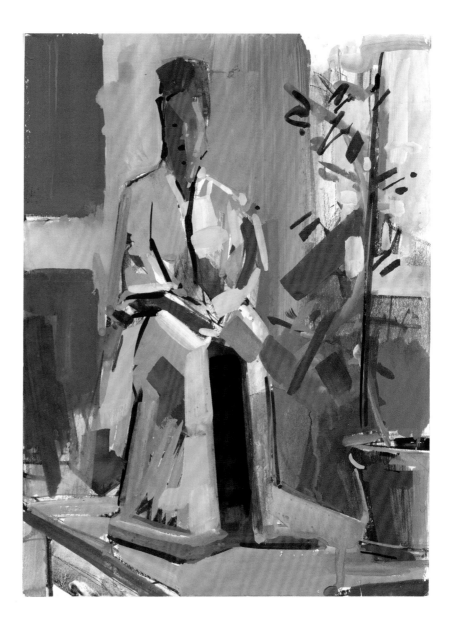

Acrylics

Developed in the early 1950s, the first true acrylic paints were an immediate success. Acrylic paints have the body and mixability of oil paints and are water-soluble and quick-drying like watercolors. Often used in mixed-media drawings or as a substitute for watercolor, acrylic is composed of pigment mixed with water and an acrylic polymer emulsion (polyvinyl acetate).

Acrylics are wet when squeezed from the tube but dry quickly to a non-reversible form. Acrylics can be applied with brushes just like watercolors and oil paints. Easily thinned with water or enhanced by a variety of acrylic

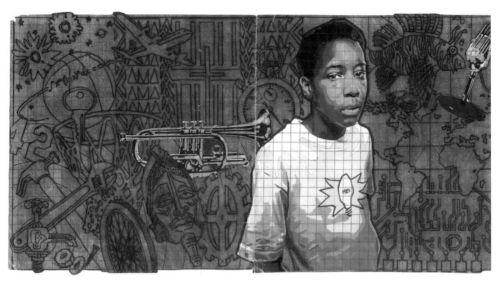

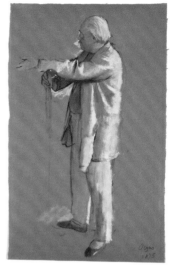

This layered drawing is a preparatory study for one of the many beautiful murals done by McShane for Philadelphia's Mural Arts Program. He made a pencil drawing, photocopied it, and then painted over it with acrylic paint. The image is gridded for transferal to a wall.

RIGHT Edgar Degas, oil sketch on brown wove paper, 1875, 18⁷⁄₈ x 11³⁄₄ inches (47.9 x 29.8 cm). Philadelphia Museum of Art (Philadelphia, PA). The Henry P. McIlhenny Collection in memory of Frances P. McIlhenny, 1986.

At first glance, Degas's oil drawings can be mistaken for pastel in their rich buttery surfaces and deft lines. Degas thought of drawing and painting as a single activity with similar aesthetic goals.

mediums, acrylics are often mixed with other drawing mediums, such as inks, watercolors, and chalks. Acrylics behave much like watercolor when diluted with water and can also be used like inks, applied with brushes or dip pens, especially bamboo pens.

Some artists complain that the quick-drying property of acrylics is a drawback, while others prize this quality. Most acrylics become darker as they dry. The addition of an acrylic medium to the paint will slow darkening, and keep the paint fresh and wet and looking more like oil paint. Most contemporary acrylics are lightfast, but it is advisable to exhibit and store acrylic drawings away from direct sunlight.

Oil Paint (on Paper)

Drawings done in oil on paper have been common since the sixteenth century. A technique favored by many nineteenth-century Impressionists and twentieth-century modern artists is called *peinture à l'éssence*. In this method, favored by Edgar Degas, the artist squeezes oil paint onto a blotter and drains out as much of the linseed oil as possible. The resulting thick paint is then thinned with turpentine and freely drawn with using a brush on heavily toned or white paper. Some of Degas's studies look like pastels but are actually done using the éssence method, which combines the richness of oil paint with the freedom of watercolor and pastel.

You can also draw with oil paint on paper without draining away the linseed oil. This can work well on heavy paper, but the linseed oil can bleed into and badly stain the paper, and the excess oil will cause the paper to yellow and become brittle.

Unknown Netherlandish artist, *The Death of the Virgin*, c. 1390, silverpoint on blue-green prepared paper, 11⁷/₁₆ x 15³/₄ inches (29.1 x 40 cm). National Gallery of Art (Washington, D.C.). Rosenwald Collection, 1950.20.2. Photo credit: Open Access NGA Images.

In this preparatory drawing for a larger painting in tempera on a wood panel, the image is carefully drawn in line with silverpoint. The paper of the sketchbook has been coated with a thin wash of colored chalk mixed with glue to provide a roughened surface that will allow the particles of the metal stylus to grip the paper better. Coating papers in this manner is a common practice in the use of metal point.

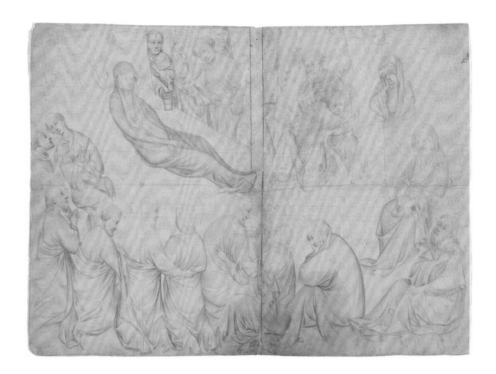

Metal Point

Thin rods of lead, silver, copper, and other soft metals have been used since antiquity for drawing and writing. In silverpoint, a thin rod of sterling silver wire or thin rod of metal is sheathed in a holder. Silverpoint makes a fine gray line, and different kinds of paper receive the silver in different ways: rougher paper grabs the silver easily, yielding a darker line, while smoother papers create a thinner, lighter line. Papers coated with washes of clay, watercolor, gouache, or gesso are commonly used for silverpoint and ensure a clean, strong line.

As silverpoint drawings age, the silver tarnishes, becoming a beautiful brown color. Fine silverpoint drawings, showing the silver's tarnish, were made by the Italian Renaissance master Leonardo da Vinci. Although silverpoint drawing remained popular for the remainder of the Renaissance and Baroque eras, its use declined with the invention of graphite pencils in the early 1500s. A revival of silverpoint occurred in the nineteenth century among artists such as the Pre-Raphaelites, and it remains in use today.

Sterling silver wires can be bought from jewelry supply businesses. The thin wire can easily be placed in a modern mechanical pencil. The medium is excellent for line and hatching where high detail and refinement are required.

Here are some examples of tools and the effects of scratchboard artwork.

Sgraffito and Scratchboard

Its name derived from the Italian word meaning "to scratch," sgraffito was very common during the Renaissance, and nineteenth-century illustrators often employed sgraffito to create simple, strong graphic images. In drawings on paper or wood, a first coat of paint or color, usually light in tone, is put down and allowed to dry. A second coat of another, darker color is applied, and lines are then scratched with a pointed metal tool through the top layer to reveal the lighter layer below. The result is an interesting, often beautiful layered effect.

Scratchboard was developed in the nineteenth century as an economical material for achieving effects like those of traditional sgraffito. Today's scratchboard is usually a heavy white paper coated with a layer of black gouache or a very thin black paper. A sharp, pointed metal tool is used to scratch lines through the black layer to create an image made of white lines. Scratchboard has some of the visual qualities of pen and ink and also those of woodcut and wood engraving. Scratchboard is used both in elementary school classrooms and by professional illustrators and artists.

Oil Sticks

Essentially oil paint in a stick form with a wax additive, oil sticks can be used for many forms of drawing. The added wax allows the paint to be spread or drawn on paper, canvas, or other surfaces. Oil-stick drawings can be manipulated with paint thinners to create washes and blurred lines. Oil sticks can be combined with other drawing mediums or with traditional painting processes to create interesting and diverse drawing effects. Like oil paints themselves, oil sticks can adversely affect paper.

Mixed Media

The term *mixed media* refers to any combination of two or more compatible drawing mediums, such as pencil and watercolor, watercolor and chalk, gouache and ink, or printmaking and watercolor. Often thought of as a modern art form, mixed-media drawings have actually been common since ancient times, though contemporary artists combine a much wider range of materials, such as charcoal and collage, acrylic and pastel, and so on.

Mixed-media drawings usually involve a layering process. For example, a pencil drawing might be overlaid with washes of watercolor and then with finishing touches of pastel. The main consideration is that the materials be compatible. Studying the history of mixed-media drawings can give you an idea of how to proceed, although many modern artists disregard the compatibility issue in favor of unique aesthetic effects.

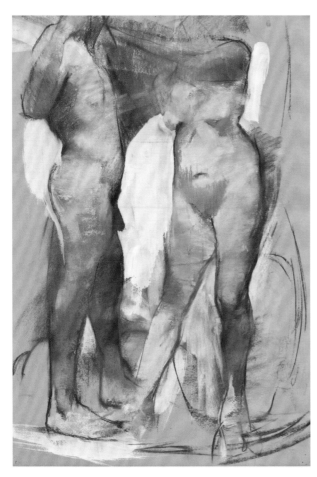

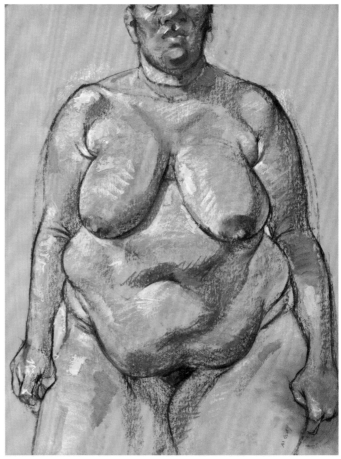

Martin Campos, *Nudes Dancing*, 1990s, pastel, charcoal, and gouache on wove toned paper, 24 x 18 inches (60.96 x 45.72 cm). Collection of the author.

This drawing was first laid out in charcoal on off-white paper. Washes of gouache color were then added. Campos finished the drawing with touches of pastel color. White gouache was used to clarify the contours and shapes of the figures.

Al Gury, *Nude*, 2012, charcoal, pastel, and oil paint on gessoed watercolor paper, 30 x 24 inches (76.2 x 60.96 cm).

A structural charcoal placement drawing defines the basic forms and contours of the model. Warm, bright pastel colors are used to heighten the light. Browns, greens, and purples deepen the shadows. Thick touches of oil paint added with a brush finish the highlights.

Edgar Degas, *The Star*, c. 1876–78, pastel over ink monotype on laid paper, 17³/₈ x 13¹/₂ inches (44.1 x 34.3 cm). Philadelphia Museum of Art (Philadelphia, PA). Bequest of Charlotte Dorrance Wright, 1978.

Drawing can even be combined with printmaking. Here, Degas has drawn with pastel on an ink monotype. A monotype is an image drawn directly on a plate of glass, metal, or plastic. The plate is run through a printing press and the resulting image is a one-of-a-kind print. A monoprint on glass is usually printed simply by the application of pressure on the paper by a roller or even a hand.

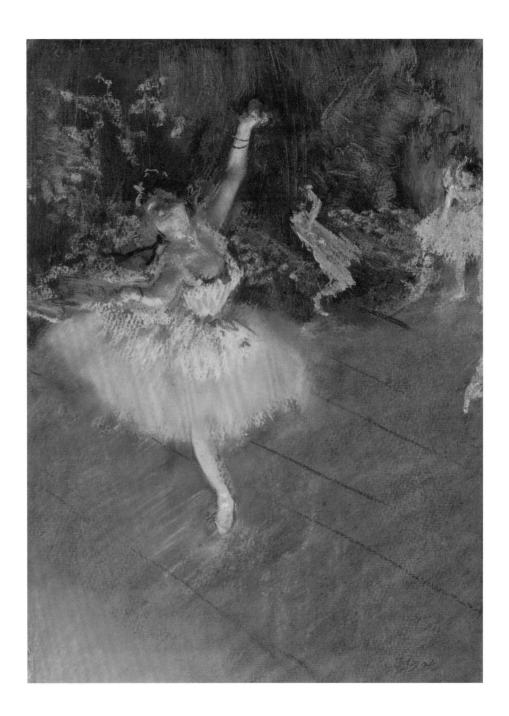

Digital Drawing

Some students eagerly explore digital drawing while others avoid it. Many artists debate the artistic legitimacy of digital drawing much as they do that of photography. Is it art or not? Is it just a tool or a legitimate form of fine art in its own right?

Regardless of the answer, it's inarguable that digital drawing is extremely useful. But there are some issues for both teachers and practitioners to consider: Is it necessary for a student to learn traditional hand-drawing skills if a computer can draw for them? Is skill in drawing by hand needed to make a really good digital drawing? An interesting test is to see whether a student can do the same drawing project with equal facility on a computer pad using a stylus as on a paper using a pencil. Obviously there are differences, but the underlying skills and sensitivities should be the same.

What students lack in hand skills may limit their computer drawing skills. The subtle effects that can be achieved with traditional drawing materials and techniques should make those who draw on computers more sensitive to the images they are making and more aware of the aesthetic and creative possibilities available to them. The goal for artists who are extremely proficient in digital drawing is to incorporate all their equally strong skills and aesthetic sensibilities in handwork into the computer art.

Artist, illustrator, and educator Mark Tocchet, whose work in both digital media and traditional materials is highly acclaimed, has this to say:

"For those of us who started out drawing in traditional media, the tablet and stylus (or more current tablet displays) offer exciting results but lack the same tactile experience that was for us a significant part of drawing. App creators have been aware of this for years. Although digital drawing programs can simulate the interaction of a mark-making tool with a variable surface grain (thereby creating much of a tool's visual character), the artist's experience creating the mark is quite sterile in comparison. Perhaps a younger generation of artists less accustomed to the tactile drawing experience won't see this as lacking in their digital drawing.

For me, one of the greatest assets of digital drawing is that the work is endlessly editable. An artist can go at the work fearlessly. Whatever looks right can be saved. Whatever bold or exploratory moves didn't work out can be eliminated without affecting whatever came before. Multiple versions can be kept for later review, use, or assimilation as the image develops."

TOOLS FOR DIGITAL DRAWING

- Mac (Apple) computer
- Wacom Intuos tablet
- Adobe Photoshop
- Adobe Illustrator
- SmithMicro Manga Studio
- CorelDRAW Graphics Suite
- Pixologic Zbrush

Mark Tocchet, *Apple Still Life Graphite Process*, 2008, Mac OS Corel Painter and Stylus on Wacom Tablet, each 10¼ x 7½ inches (26.04 x 19.05 cm).

Mark Tocchet, *Sunshine*, 2010, Mac OS, Corel Painter, Adobe Photoshop, and Stylus on Wacom Tablet, 7¼ x 4⁶⁹⁄₁₀₀ inches (18.42 x 11.91 cm).

DRAWING TOOLS

The drawing tools presented in this section are the most basic and common ones used by the great majority of artists, students, and art teachers. Not surprisingly, these tools have changed very little over the centuries and remain the most versatile, stable, and practical of drawing materials. Pens, brushes, erasers, and other materials provide the means to visualize both the first sketches for art images directly from mind to hand to paper. These essential materials also provide the means to take visual ideas through the development and exploratory phases to the final completion of an artwork in drawing material.

Pens

Practical tools for notation appeared very early in human history, and the history of pens mirrors the evolution of culture. Ancient pens ranged from sharpened sticks and bamboo branches to beautifully carved bird-feather quills. Traditional pens in use today can be made from wood, bamboo, quills, metal, and even glass. (Traditional Asian bamboo pens are especially popular.) Historical uses of pens included calligraphy, map-making, illustration, letter

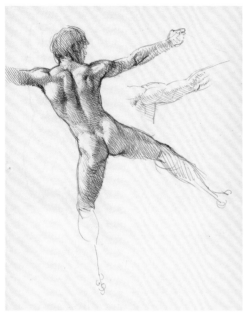

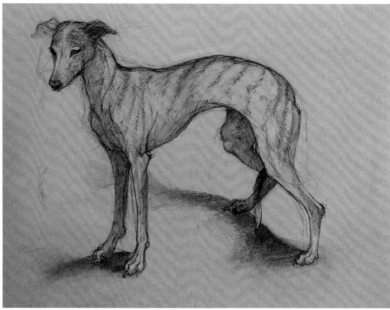

LEFT Arthur DeCosta, *Figure Study*, 1970s, ballpoint pen on paper, 11 x 8 inches (27.94 x 20.32 cm). School Collection, Pennsylvania Academy of the Fine Arts (Philadelphia, PA).

In this figure study done by the artist Arthur DeCosta, ballpoint pen is used as a concise tool in delineating the contours and shadow hatching of the figure. Ballpoint pen is one of the most straightforward and practical of pen tools.

RIGHT Patricia Traub, *Whippet*, 1990s, pencil, ballpoint pen, and white chalk on charcoal paper, 8 x 10 inches (20.32 x 25.4 cm). Courtesy of the artist.

The choice of ballpoint and pencil allows Traub to create the precise and delicate contours, as well as lines of movement and anatomy particular to a whippet.

OPPOSITE Photo credit: Peter Groesbeck.

writing, and fine-arts drawing. The sense of romance surrounding pens is as old as writing itself. Many people collect antique and modern pens, and artists often develop a fondness for certain pens.

Removable pen tips, or nibs, attached to wooden or metal holders, have been made of copper, bronze, steel, and even gold. These were dipped into small bottles of ink, and the liquid would be held in the concave back surface of the pen tip. The modern "dip" pen consists of a steel nib, which holds the ink, attached to a metal, plastic, or wooden holder.

Drawing pens can create lines of varying strengths and widths depending on the size of the point, its flexibility, and its ability to hold ink. Dip pens are kept clean by washing or flushing with water or solvents, depending on the type of ink used.

"Filler" pens draw ink from the ink bottle into a reservoir, alleviating the necessity of constantly dipping the pen into a bottle. The first reliable fountain pens appeared in the 1850s, though experiments with pens with ink reservoirs are documented from the tenth through the early nineteenth centuries.

Metal and fiber pen tips are easily damaged and should be stored in a container with the pen tips lying flat or standing upright. Fiber-tip pens, such as markers, are prone to drying out quickly and should be kept sealed when not in use.

Ballpoint pens, fine-point markers, fountain and cartridge pens, fiber-point pens, brush pens, and other types are excellent modern additions to the

LEFT Greg Biché, compositional study for a painting, 2013, ballpoint pen on white paper, 4 x 4 inches (10.6 x 10.6 cm). Courtesy of the artist.

In this quick and exciting design sketch, Biché uses ballpoint pen to capture the shapes and energy of the visual idea.

RIGHT Al Gury, notes for a landscape, 2010, ballpoint pen in sketchbook.

Ballpoint allows for a quick and energetic notation of the texture and movement of the trees.

artist's toolbox. All create unique effects, and inks can often be mixed with a variety of other mediums, especially watercolor and graphite.

Ballpoint pens are an extremely common and practical modern tool for drawing. Invented in the late nineteenth century, retractable ballpoint pens came into common use in the 1930s and 1940s. Designed as a writing tool, ballpoint pens are reliable, durable, and provide a variety of line qualities for sketching on a wide range of papers and surfaces. Many artists use ballpoint pens for sketching in sketchbooks.

Fine-point markers, usually containing permanent ink and available in a range of tip sizes, are excellent substitutes for traditional dip pens. Dip pens, however, allow greater variability in the width and organic quality of the line; although fine-point markers can be manipulated to a degree, they maintain a fairly constant line width.

Experimentation and practice will allow you to understand the aesthetic qualities and uses of each tool, enabling you to make informed tool choices and develop personal preferences.

Brushes

Like pens and papers, artist's brushes are surrounded by a sense of romance and beauty. Brushes have been a part of Western art history for thousands of years. Fine brushes have been found in Egyptian tombs, and the Romans employed a great variety of brushes for everything from fresco painting to encaustic paintings on wood panels. (Encaustic is heated wax mixed with dry pigments and applied with a brush or painting knife in the manner of an oil painting.) Medieval manuscript illumination depended on fine, delicate brushes and pens.

Claude Lorrain (née Gellée), *The Tiber from Monte Mario*, 1640–50, brush with brown ink on laid paper, 7¼ x 10½ inches (18.5 x 26.8 cm). British Museum (London). PD, Oo.7-212. Photo credit: © The Trustees of the British Museum/ Art Resource, NY.

A soft brush is used to create this superb example of atmospheric and aerial perspective. Lorrain works from lighter washes in the distance to rich darker ones in the foreground.

Highly skilled craftsmanship is needed to make fine brushes, but, for practical purposes, a good brush is one that's suited to what the artist wants to do. For this reason, brushes can be grouped into simple categories: soft brushes and bristle brushes.

Soft brushes made of sable, camel, badger, and other natural animal hairs are used for both broad and fluid strokes as well as fine detail work. Watercolor painters often prefer well-made soft fur brushes such as sables. Oil painters will often use soft brushes for surface detail and blending, while lower layers of paint might be applied with sturdier bristle brushes. Soft brushes are also often used to apply and blend dry pigments such as powdered graphite and charcoal to paper surfaces.

Soft fur brushes are, however, prone to wear and tear and do not survive extended rough use. For this reason, bristle brushes are a good choice for rough work. Bristle brushes are usually made from a stiffer animal hair such as hog or horse hair. Considered less desirable for watercolor because of their roughness of stroke, bristle brushes work well for heavier mediums such as oil paints, acrylic, and encaustic.

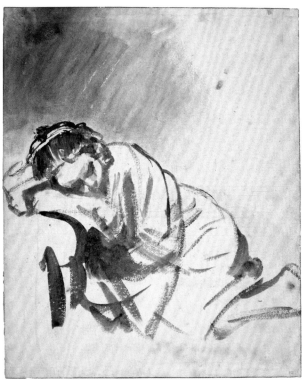

LEFT Arthur DeCosta, *Plant Study*, 1970s, pencil, sepia wash, and brush on paper, 11 x 8 inches (27.94 x 20.32 cm). School Collection, Pennsylvania Academy of the Fine Arts (Philadelphia, PA).

In this delicate and lovely drawing, DeCosta first laid out the image in detail with pencil. He used washes to describe basic tonalities and a pointed brush to refine the details.

RIGHT Rembrandt van Rijn, *Young Woman Sleeping*, c. 1654, brown ink and wash, some white gouache, $9^{17}/_{25}$ x $7^{99}/_{100}$ inches (24.6 x 20.3 cm). British Museum (London). PD 1895, 0915.1279. Photo credit: © The Trustees of the British Museum/Art Resource, NY.

In his brush drawings, Rembrandt uses a precise and energetic stroke that is reminiscent of Asian calligraphy combined with the quickness of the modern gesture drawing.

Contemporary brushes come in a variety of shapes and lengths: flat, round, and filbert (oval shaped); long, medium, and short. Brushes for calligraphy, illustration, ink, watercolor, oil painting, and other techniques are designed for those specific purposes.

Today, natural-fiber brushes are augmented by a wide variety of synthetic-fiber brushes and brushlike tools (brush pens, brush sponges). Synthetic brushes are designed to provide the same range of qualities as their natural cousins, though some artists complain that synthetic brushes don't have the same subtle and responsive qualities as natural-fiber brushes.

The care of brushes is an important matter. While a favorite old, worn-down brush can be an excellent tool, dry, stiff, or damaged brushes usually fail to give us the effects we want. Wet mediums like oil paints, acrylics, or shellac will ruin a brush if left to dry on it. Unlike watercolor or gouache, these materials cannot be reconstituted. To make brushes last, it is essential to wash them with soap and water and to re-form the point after doing so. Commercial brush cleaners, lubricants, and restorers are available, but simple care with soap and water is often best.

Brushes should be stored flat or with the tips upright. Never leave a brush tip down in a jar of water or solvent; this may irreversibly damage it.

Blending Stumps

Blending stumps (also referred to by their French names *estompes* or *tortillons*) are sticks made of soft paper rolled to a point. Stumps are used for blending in drawings made of charcoal, pastel, or Conté. A versatile tool, the blending stump can be used on its side to blend broad areas or on its point for finer modulations. The paper point of the stump, when dirtied with charcoal or graphite, also makes a kind of drawing tool itself. Paper blending sticks are cleaned by lightly sanding the surface with fine sandpaper.

Erasers

Erasers come in many forms and produce varying results depending on the eraser's composition and the drawing materials used. Pieces of cloth and soft fine leather such as chamois have been used as erasers since ancient times. Wads of soft white bread are known to have been used as simple erasers during the Renaissance. Modern erasers are generally made of rubber, vinyl, and other gum-based and rubberlike materials.

Kneaded erasers absorb charcoal, graphite, and pastel and leave no "crumbs" on the paper. They can be kneaded like putty when dirtied, making them clean for further use. It's important to note that erasers are used not only to remove or correct errors in drawings but also as drawing tools in themselves, and kneaded erasers are especially desirable for charcoal and chalk drawings where blotting, blending, and subtle modulations are desired.

Hard rubber erasers smear and absorb the drawing material and remove it in small crumbs. Rubber erasers are very good for erasing graphite lines, colored pencil lines, and harder drawing marks where more forceful erasing is needed. Crumbs left behind by rubber erasers must be brushed away. This brushing away may cause abrasion to the drawing, and so it should be done with caution. In addition, repeated erasing in an area with a rubber eraser may cause damage to the paper itself by wearing away paper fibers and even making a hole in the paper.

Erasers also come in materials such as vinyl and latex. While very effective and leaving less crumbs when used, these erasers can leave smear marks on the paper and have the same problems as rubber erasers.

Chamois cloth, a soft, slightly fuzzy natural or synthetic leather, is also commonly used as an eraser.

PAPER

For many artists, paper has an aura of romance and fascination. Paper as we know it was invented in China about two thousand years ago. Other paperlike materials, such as papyrus (made from reeds) and parchment (made from animal skin), can be traced back much earlier, to the ancient Egyptians. Arriving in Europe during the medieval era, papermaking was a laborious process. In the early fifteenth century, papermaking factories and more efficient production processes made paper more economical to produce and therefore more widely accessible. Its appearance coinciding with the invention of the printing press, commercially made paper rapidly replaced parchment and vellum and aided in the mass production and dissemination of printed books. Artists today use many types of paper materials, ranging from mass-produced paper to artisanal handmade papers.

The most common materials for making paper are cotton or linen fibers and wood pulp; the two major types of paper are laid paper and wove paper. To make laid paper, paper pulp mixed with water is allowed to settle on a wire screen or framed mold. The screens consist of a series of vertical wires, which can vary greatly in their width and spacing, held in place by a few evenly spaced horizontal wires. As the water drains away and the pulp is pressed by a weight, the texture of the wire is impressed into the paper pulp. Most drawing and book paper from the fifteenth to the early nineteenth century was made in this manner.

LEFT Unknown artist, *Portrait of a Boy*, 1940s, charcoal on white laid paper, 20 x 16 inches (50.8 x 40.64 cm). Collection of the author.

One of the beautiful attributes of using laid paper is the additional texture and sense of atmosphere it adds to a drawing. The less smooth texture of the paper fibers and the pattern of the wires remaining in the laid paper interact with drawing materials to create unique and varied effects. Here the overall richness and immediacy of the drawing is enhanced.

RIGHT Al Gury, *Figure Study*, 2010, pastel and charcoal on blue laid Strathmore charcoal paper, 24 x 18 inches (60.96 x 45.72 cm).

The color of the charcoal paper helps create a sense of depth in this drawing. The soft blue recedes behind the dark charcoal and warm color touches, which optically come forward.

OPPOSITE Photo credit: Peter Groesbeck.

The thickness of a laid paper depends on the amount of the paper pulp used, while the surface personality of the paper depends on the texture and spacing of the wires in the papermaking frame as well as the density of the pulp. Thicker, less homogenized pulp puts less weight on the wire frame and produces thicker, more rough-textured paper. More finely ground and mixed pulp places greater weight on the wire frame and produces finer, thinner paper. The many possible combinations of pulps and screens make for an enormous array of laid papers. Laid paper's characteristics have a direct effect on the character of the drawing made on it, and the variety of laid papers has always been a focus of exploration by artists in their drawings.

The texture of a laid paper and its watermark are clearly visible when the paper is held up to the light. Watermarks, which are maker labels impressed into the paper while wet, distinguish papers from one another.

Wove paper, invented in England in the late eighteenth century, is the most common type of paper today. In the process for making wove paper, paper pulp, often made from finely ground wood shavings, is soaked in water. The result is a wet paste of pulp, which is then spread on a woven wire screen whose mesh is much more even, close, and thin than that of the screens used for laid paper. When drained of its water, the paper is pressed

Like laid papers, woven papers
(with their variety of textures)
directly affect the look and
character of a drawing. In this
beautiful Modigliani drawing, the
fine lines delineating the clean
contours of the figure are possible
because of the smoother and closer
texture of the woven surface. The
continuous, even surface of this
piece of paper allows for unbroken
and finer lines.

to produce a fine, even surface. The texture of wove paper can be altered by rolling the paper through heated or cold presses. Hot-pressed papers are typically very smooth, while cold-pressed papers retain varying degrees of the texture of the paper fibers.

The choice regarding whether to use a hot- or cold-pressed paper depends on the quality of line and the aesthetic effects the artist wants. Hot-pressed papers, which are less absorbent and more resistant to the drawing tool, are generally better for fine line work and details. Cold-pressed papers, which are more absorbent, can be used for a greater variety of effects. For example, hot-pressed vellum is ideal for pencil or pen and ink, but takes watercolor or charcoal very poorly. Cold-pressed watercolor paper holds aqueous mediums and chalks well but may be too rough for pens or hard pencils.

Papers are also distinguished by the materials used to make them and by their qualities of longevity or archival permanence. Most papers are made from plant materials such as linen, cotton, and wood pulp. Permanence is relative to the amount of acid, or lignin, present in the paper pulp. Cellulose, the primary inert, acid-neutral material in paper, must be separated from lignin, which can cause acidic oxidation and the deterioration of paper. Acid-free papers, free of lignin and pH neutral, are usually labeled as such on the packaging or in the manufacturer's catalog.

Most cotton- or linen-based papers are relatively acid free and stable (unless attacked by mold or insects) because there is only a small amount of lignin in their fibers and the acidity is easily lowered in the fiber-washing process. During the first half of the nineteenth century, however, wood pulp became a major material for papermaking because it was more economical. Wood pulp–based wove paper was used for books, periodicals, and other printed materials. But wood pulp is high in lignin, and paper made from it quickly begins to yellow, darken, and deteriorate due to its high acid content. Such papers typically turn yellow within a year and often become brittle, deteriorating within a decade or two. It is important for artists to be aware of the permanence of the paper they are using. Within fifty years, drawings done on highly acidic papers like newsprint may be so unstable they cannot even be picked up without crumbling.

The cost of papers reflects the expense of the production process. Fine handmade, acid-free papers are usually the most expensive. Many fine papers are made by small, artist-run companies. Others are produced by large commercial paper manufacturers. But more expensive does not always mean better. Many artists find that their preferred papers are not the most expensive, and reasonably priced artist's papers are readily available today in laid, woven, and acid-free forms.

Types of Paper

Knowledge of and experimentation with a variety of papers is essential to finding your preferred materials. The range of papers available is enormous; those discussed here are the major types that you should be aware of.

Drawing papers come in four basic formats:

- Pads with sheets bound to a glued or wire spine
- Individual sheets
- Rolls
- Hard-bound sketchbooks

Basic drawing pads come in a range of standard sizes from 3 x 5 inches up to 18 x 24 inches, though larger pads up to 24 x 30 inches are also available. The size range of individual sheets is greater, going up to 30 x 40 inches. For larger pieces of paper, you'll have to purchase a roll; many kinds of paper—from craft paper to fine drawing, print, and watercolor papers—come in rolls. Your choice of a size of paper depends, of course, on your goal for the artwork.

Papers are also identified by weights. The weight is not that of an individual piece of paper, but rather the weight of a stack of 500 sheets of paper. The thickness of each sheet determines the weight. For example, 20-pound paper is the weight of 500 sheets of thin paper. Examples of this type of paper include printer paper, notebook paper, and so on.

By comparison then, 100-pound paper is the weight of 500 sheets of thicker paper. The thinner the paper, the lower the weight of a 500-sheet stack. The thicker the paper, the heavier the weight of a 500-sheet stack. Weights of paper are also affected by the dimensions of the sheet. For example, though smaller in dimension, a 5 x 7-inch sheet of very thick paper in a 500 sheet stack may weigh more than a 500 sheet stack of thin $8^{1}/_{2}$ x 11-inch paper.

Determining the right weight of paper for your drawing project is important, especially when you work with wet mediums. In those cases, thin paper will become rippled and curled by water, while heavier papers will remain flat.

Another element to consider in paper choice is acid content. This is usually noted by the designation pH (Power of Hydrogen). The higher the acid content, the higher the pH number. The lower the acid content, the lower the pH number. The higher the acid content, the more likely the paper is to yellow and even disintegrate. For example, newsprint, which is made from wood pulp, is highly acidic. Drawings done on newsprint may not

have a long lifespan. These drawings may yellow and even begin to crack apart within a few years. Acid free papers, such as those made from linen or cotton, may have an indefinite life span and never yellow or disintegrate. Many papers are a combination of acid-free fibers mixed with wood pulp fibers to cut costs but still create a paper that is reasonably durable. If the pH of the paper is not noted on the paper product, you can contact the manufacturer for that information.

SKETCH PAPERS AND NEWSPRINT

The term *sketch paper* refers to a range of papers, from newsprint to higher quality acid-free papers. These are typically sold in pad form and are very practical for classroom and studio work.

Newsprint is commonly used for charcoal sketching. Because of its low price, newsprint is often used for beginning drawing and preliminary sketches. Newsprint ranges from smooth to rough and is very good for charcoal, markers, pastel, and crayons. It is less appropriate for graphite pencils and fine-point pens because of its soft, woven, and absorbent texture. Do remember that newsprint has a high acid content and that drawings made on newsprint will deteriorate over time.

CHARCOAL AND PASTEL PAPERS

Papers for charcoal and pastel need to have enough texture to hold the grains of the drawing medium. Laid papers are commonly marketed for charcoal and pastel, but rough-textured woven papers can be excellent as well. Some pastel papers are coated with a fine layer of sand bound by glue to the paper. These provide a rich, toothy texture for the pastel to cling to. Commercial charcoal and pastel papers come in a wide variety of colors and textures, and handmade papers are also popular for these mediums.

COLORED CRAFT PAPERS

A wide variety of colored papers in diverse textures, sizes, and hues are available. These include craft papers, printer papers, construction papers, and decorative papers. Generally used for craft and design projects, they are relatively inexpensive.

PREPARED PAPERS

Prepared papers have an added surface or coating made of clay, color wash, glue, sizing, or textured materials like sand. For example, silverpoint is often done on clay-coated paper or paper with a gouache or gesso wash to provide a better grip for the silver grains.

Like papers, sketchbooks come in many sizes and qualities. The small pocket sketchbook is the artist's companion.

OPPOSITE David Wilson, *Studio*, 2011, pencil on paper, 16 x 20 inches (40.64 x 50.8 cm). Courtesy of the artist.

Wilson shows his working environment via this finely delineated line drawing.

Before the nineteenth century, when a great variety of colored papers began to be manufactured, it was very common for artists to create their own colored or toned papers by laying down a wash of watercolor, gouache, or something else over the pale paper surface. In this manner they created the exact tone and color they wanted. Many artists still do this today.

COMMERCIAL PAPERS

Commercial papers made for office or industrial use are often used for drawing.

Printer paper, letter paper, ledger paper, tracing paper, and so on can all provide excellent and inexpensive surfaces for drawing. But, if you use a commercial paper, do pay attention to its acid content and permanence.

PAPERS MADE FROM RICE AND OTHER FIBERS

A great variety of papers made of things other than linen or cotton fibers or wood pulp are available in art supply stores. Rice paper, used for calligraphy and watercolor, is not made from rice at all. It derives from the fibers of the rice paper plant, a small tree. Rice papers come in various densities and textures and can include ornamental elements such as colored fibers, threads, or even leaves. Mulberry tree bark is also commonly used to make paper. Typically rough in texture, it has a variety of uses in drawing and craft. Papers made from papyrus, flower petals, and plant bark are also available.

SYNTHETIC AND ALTERNATIVE SURFACES

Many contemporary artists experiment with alternative drawing surfaces. Plastic sheeting, Mylar, Yupo paper, Plexiglas, glass, metal, ceramic, and fabric all offer possibilities as drawing surfaces. One of the most common drawing surfaces in contemporary art is Mylar, which provides a paperlike surface but adds translucency to a drawing. Mylar is made from polyethelene. Yupo paper is another a popular surface for drawers and watercolorists. It is made from polypropylene.

Sketchbooks

Sketchbooks used to be beautifully hand-bound, with covers of leather or heavy paper. Some contemporary sketchbooks are likewise handsomely hardbound, while others are softcover books bound with glue. Sketchbook papers may be laid or woven, hot or cold pressed, and varied in pH designations. Some have colored papers. Watercolor-paper sketchbooks are excellent for small-scale watercolor sketching.

THE DRAWING STUDIO—
FURNITURE AND EQUIPMENT

Drawing can be done anywhere, anytime, with the simplest of means. Casual sketching does not require any particular furniture or equipment, but when setting up a studio, you've got to give such matters careful thought. The studio environment you create and the drawing equipment you choose can significantly affect the quality of your art. If your drawing board is warped, uneven, or too small for the paper, the drawing may be damaged. Your choice whether to draw standing at an easel or sitting at a tilted drafting table may affect your physical connection to the drawing process.

Drawing Boards

Boards should be smooth so as not to affect the texture of the drawing. Lumps of dried paint and gouges on the board will show up in the drawing and hurt the process and the final result. The board should also be the appropriate size for the paper.

Boards made of wood, Masonite, and fiberboard are common. Drawing boards with attached clips can be useful, but the clip may limit the drawing surface of the board. Tape, pushpins, and removable clips are good alternatives (see below). For very large drawings, you may need a lighter, more easily portable board; foam core is ideal for very large paper sizes. Drawing boards should be stored flat to prevent warping.

Clips, Tape, and Pins

Basic clips sold in all art stores are essential; spring clamps and bulldog clips are the two most common. Any adhesive tape—masking tape, plastic tape, even duct tape—can be used to secure a drawing to a surface, but to prevent damage to the paper you may want to choose an artist's tape that will not stain, tear, or leave residue on the paper. Lightly adhesive, artist's tape grips the paper but does not damage it when pulled away. Pushpins or thumbtacks are also commonly used to attach paper to drawing boards or other surfaces. Pins should be used with caution, however, as the holes they poke in the drawing might adversely affect its aesthetic.

Cutting Tools and Rulers

Utility knives, scissors, and other cutting tools are useful for sizing and trimming paper. Make sure your cutting tools are sharp; otherwise, you risk damaging the paper. The cutting surface is also important: paper can be damaged if cut on a dirty or uneven surface. Also, you may want a tool to guide the blade and protect you when cutting. Rulers with a raised fence, available in most art supplies stores, prevent you from being cut if the blade slips. As an alternative, paper can be torn along the edge of a ruler, producing an attractive deckled, or roughened, edge. Caution must be taken, however, to keep the tear even and continuous.

Easels, Tables, Stools, and Horses

Easels are essential to many forms of art-making, and a solid, stable easel is an important part of the drawing studio. Different kinds of easels, from tabletop easels to large mechanical studio easels, provide opportunities for a variety of working methods and processes. Many artists prefer to draw standing or sitting at an upright easel rather than at a table or bench.

LEFT Here you see a variety of viewfinders, measuring devices, and plumbs.

RIGHT A homemade viewfinder in use.

A drawing table—also called a drafting table—should likewise be stable and solid, and you should be able to easily adjust it to the desired angle: flat for watercolor and at a comfortable angle for dry mediums.

Instead of an easel or table, you may prefer to work sitting in a chair with drawing board propped up on a stool in front of you, which gives you a basic tilted drawing surface. Or, alternatively, you might want to sit on what's called a horse—a specially designed bench with a seat and a high extension at one end for propping up the drawing board.

Plumbs, Viewfinders, Grids, and Calipers

Carpenter's plumb bobs have long been a feature of artists' studios. Used to determine alignment and balance in a drawing, they can easily be made with a weight (such as a metal bolt) attached to a string.

Viewfinders are very useful for determining the parameters of a composition. When you're drawing from a still life or a life model, you may find a viewfinder to be especially helpful in designing the composition. You can make your own viewfinder simply by cutting a rectangle in the center of a piece of paper or cardboard, but adjustable plastic viewfinders are sold at art supply stores.

For centuries, artists have used grids to help them lay out the forms of the objects they are drawing. Grids help both in determining an object's proportions and its position within the composition. A simple grid can be made from a piece of wire screen bought at a home supply store.

Calipers, commonly used by architects and engineers, are also used by artists as measuring tools. Especially useful when drawing from observation, the calipers allow you to easily compare the relative sizes of objects.

Lighting

Good, clear light, whether from windows or light fixtures, is essential in any studio environment. Fluorescent light provides a broad, cool, even light in the room, while incandescent lights give a warm light with directional focus. Flood bulbs provide a broad warm light, while spot bulbs give a focused light. Daylight-corrected bulbs and fixtures of many kinds are available but may be more expensive. Clip-on fixtures as well as light stands for spots and floods are common in studios. Your main concern is to have enough light to see well. Natural daylight, both for illuminating a studio and to provide clear vision for materials use, seeing color, and so on, has been considered the best form of light. Light coming from a northerly direction through windows or a skylight is the most even and consistent light. Though its temperature changes slightly from season to season, it is very consistent and evenly cool and clean in color. Light through windows and skylights from any other direction, while often beautiful, varies greatly in temperature and intensity. Choosing the right lighting for a workspace is both practical and personal.

STORAGE, PRESENTATION, AND CONSERVATION OF DRAWINGS

Drawings can be affected adversely by light, moisture, fungus, insects, and other factors, and the care and storage of drawings is one of the most important aspects of working with drawing mediums. The longevity of drawings depends on the choice of materials and on planning for their care and preservation.

Storage

Works on paper should be kept away from direct light. Direct sunlight is the most damaging, because sunlight's ultraviolet (UV) rays can damage paper and fade drawing mediums. Ambient light from windows may do less damage, but drawings should be kept as far away from windows as possible.

Drawings that are not being displayed should be placed in a storage container that keeps them flat, clean, and stable. Flat files, Solander boxes, and acid-free paper storage boxes are all good choices. Ideally, the drawings should be separated by smooth interleaving sheets, which will protect them from abrasion and from rubbing together. Glassine is a translucent, extremely smooth acid-free paper typically used for interleaving. It is essential that drawings be kept in acid-free conditions, whether through acid-free interleaving or acid-free boxes or file systems. Paper, leather, or plastic portfolios are good alternatives for drawing storage. Again, the interior of the portfolio should be acid free to protect the drawings.

Matting and Framing

Matting and framing present a drawing for viewing while also protecting it. When matting, use acid-free mat board, sometimes called museum board, as well as acid-free backing and mounting tapes. The mat should be thick enough to provide a space between the drawing and the glass of a frame or other matted drawings lying on top of it in storage. Excellent archival matting systems are available from companies that specialize in archival storage and matting systems for drawings, photographs, and other works on paper.

Drawings usually need to be framed under glass to protect them from abrasion and the harmful effects of dust, smoke, and other contaminants in the air. Ordinary picture glass is commonly used, but specialized glass that minimizes UV damage and glare is readily available.

Conservation

As for painting, sculpture, prints, and other artworks, conservation of drawings is an important concern. Most large museums have laboratories for the conservation of works on paper. The profession of the paper conservator, like that of a painting or sculpture conservator, requires expertise both in the art-making process and in the chemistry of art materials. But conservation begins with the artist: your own knowledge of drawing materials and their properties can help ensure your drawings' long-term survival. And proper storage practices can, to a degree, protect and lengthen the life of even those done with flawed materials.

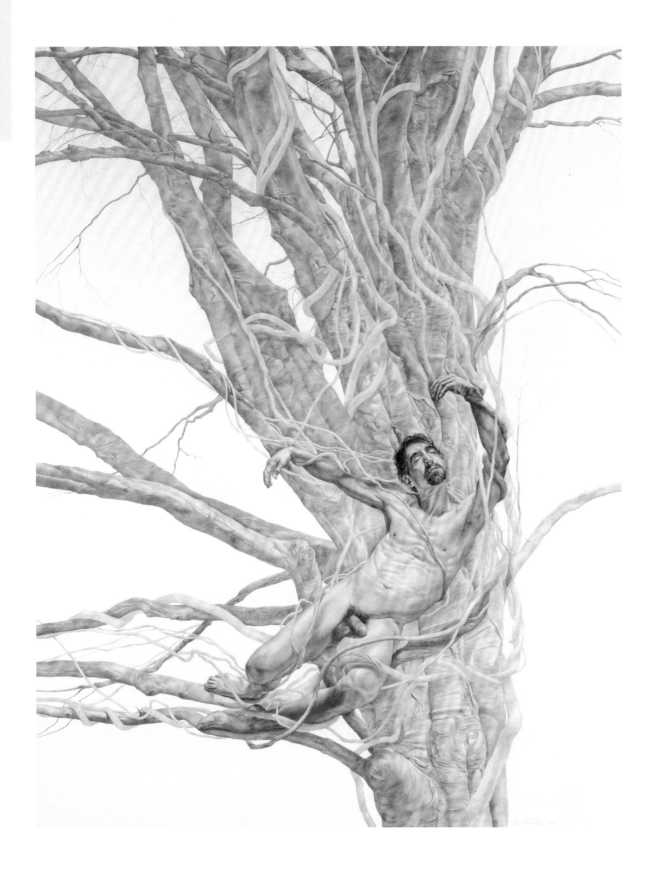

ESSENTIAL DRAWING SKILLS

Drawing is both a craft and a form of expression. The two go hand in hand. Skill without beauty and feeling can be admirable but empty. Expression without a formal language in which to organize and present the artist's ideas and feelings can be shallow and unclear.

In an artist's training, should one come before the other? Not necessarily, but at some point you must explore the elements of skill-based training. This chapter describes the formal, skill-based processes of drawing, sequentially presenting the foundational elements of line, shape, form, light and shade, depth, and composition. Practical tips on how to hold drawing tools, measure, and blend are also discussed.

But before addressing specific foundational elements, a word about the famous phrase *learning to see*. Art teachers often talk about learning to see. What does this mean? Seeing means understanding what you are looking at. Seeing means clarifying the formal and informal artistic elements of the subject. Seeing means organizing the experience of the seen subject and filtering that experience through the principles, materials, and processes of drawing to create a strong artwork. It is not magic or even intuition. Learning to see and understand what you are looking at means learning how to organize and translate that experience into shapes, lines, proportions, depth, and other properties through the use of specific tools and materials.

HOLDING DRAWING TOOLS

The way you hold a pencil or piece of charcoal makes all the difference in the type, character, and quality of the lines, tones, and other marks you make. Gripping a pencil, pen, or stick of chalk close to the point—the way you do when writing—produces short, dark, choppy lines. But gripping the drawing tool too tightly causes what some people describe, negatively, as a heavy hand. Holding the tool farther up its body lengthens the mark and allows it to be more curved, and holding it at arm's length from the paper allows for broad, sweeping marks.

When working with chalk or charcoal, holding it flat against the paper between thumb and forefinger and gliding it smoothly along the paper's surface produces a graceful, gliding stroke that is easy to curve or keep straight. Never be afraid to break a piece of chalk or charcoal to get the size that suits your hand and creates the kind of mark you desire.

You should practice holding drawing tools at different lengths and in different positions and applying different amounts of pressure. Take careful note of the kind of mark each technique makes until you can comfortably and consistently create the mark you desire. Never be afraid to experiment. To break through your fear, practice making marks that are both delicate and aggressive.

Gripping a pencil tightly near its point, as you do when writing by hand, produces a short, stiff, dark mark.

Holding the pencil farther down the shaft allows for a longer and lighter stroke.

This change of hand position allows the pencil strokes to come from the whole arm, producing far more graceful and fluid strokes.

This variation on the grip shown in the previous image allows for more variety and movement in the pencil marks.

Holding a charcoal stick like a writing implement creates the same short, heavy, dark marks as it does with a pencil.

Holding the charcoal stick farther back allows for a longer and lighter stroke.

This position allows for the lightest touch of all, but you may not have as much control as you do when using the other hand positions.

Here, broad strokes are achieved by holding the drawing tool on its side flatly against the paper. This works well for charcoal, pastel, and graphite sticks. Also, this image shows the application of a ground, or imprimatura, used when you create a drawing by erasing or wiping out marks.

MEASURING

Careful measuring enables you to compare the size relationships of objects in space and to create an accurate, proportional composition. The simplest form of measuring is to compare the size of one object to another.

Basic Measuring

To measure, extend your arm to its full length and "lock" it in place; keeping your arm locked minimizes inaccuracies. If possible, close one eye so that the visual image appears flat and the relationships between objects become more easily measurable. Using a tool (a pencil, paintbrush, ruler, calipers, or even your fingers) to measure against, place the top of the tool at the top of the object to be measured. Place your thumb at the bottom of the object. This gives you its height, which can then be compared to the height of other objects. By turning the tool sideways, you can compare widths or even diagonal dimensions.

The alignment of objects within the compositional frame can also be gauged by using a measuring tool as simple as a pencil, assessing how high or low the objects are in relationship to one another. Hold the measuring tool horizontally along the bottom of one object and gauge how much higher or lower the other objects are in relation to it. The nearer the object is to you, the lower the bottom of the object will be in the compositional frame. The farther away the object is, the higher it will be in the frame. Besides checking top and bottom alignments, you can also check the alignments of the objects' sides or the relative positions of ellipses and angles within the compositional frame.

Choices concerning measuring have a direct relationship to the aesthetic the artist chooses for a given work. For more expressive images, you may want to use this simple measuring technique in a loose way, but for a very detailed, perspective-oriented work you will want to be very precise. In works that employ distortion or exaggeration, accurate measuring is secondary to the feeling of the relationships in the composition.

Some artists prefer to measure everything in detail first and then to sketch everything in. Others first sketch freely, measuring later to correct relative sizes, proportions, and relationships. There is no right or wrong as long as the image turns out the way you want it to.

Measuring should be done with the arm held straight out and locked to avoid movement and error.

This position is useful for measuring smaller intervals but requires a steady hand to avoid errors.

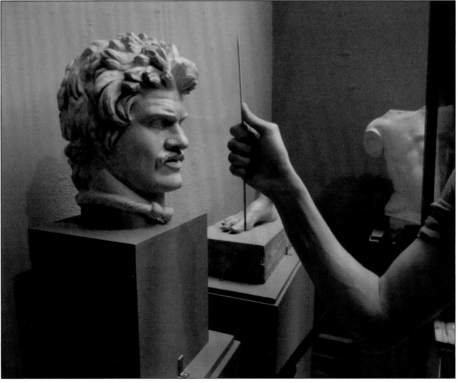

Accurate measuring has allowed the artist to sketch these objects in the right sizes, proportions, and relationships to one another. The objects can be made larger or smaller on the page, of course; what's important is that their proportions and relationships be accurate.

Gridding and Transferring Drawings

Gridding is a time-honored practice for measuring while drawing as well as for transferring drawings onto canvases, walls, or other surfaces. Gridding helps the artist visually align measurements, foreshortening, and angles using the grid's geometric framework, which is composed of evenly spaced horizontal and vertical lines that divide the visual field into a series of regular squares.

Some artists like to use a grid to plan the whole image. Others simply use it to check their drawing and identify and correct errors. A simple grid can be made by cutting a square hole out of a piece of cardboard and then taping several strings horizontally and vertically across this viewfinder's window. You should use the same number of horizontal and vertical strings and make sure they're evenly spaced. The more strings used, the smaller the grid squares and the more precise the grid. A grid can also be easily made from the wide-gauge screen wire sold at building supply stores.

After developing a preparatory drawing for a painting, an artist may want to transfer the drawing directly to the canvas. For an exact one-to-one transfer, the dimensions of the canvas must be exactly the same as the drawing's. But it's also possible to use a gridding system to enlarge the drawn image when transferring it: Draw a grid over the drawing and then another of the same proportions onto the larger surface. Each square of the smaller grid will contain lines that can be drawn in the corresponding squares of the larger grid.

Here a grid is being used to help plan and measure the relationships between objects in a still life.

The image as seen through the grid must be transferred to the page in the same set of relationships.

A grid identical to the one used to view the still life is drawn on the paper. The shapes and relationships of the objects are drawn exactly as seen through the gridding tool.

There are alternate ways of transferring drawings. You can, for example, create a preparatory drawing the exact size of the final surface, then cover the reverse side of the drawing with soft vine charcoal or chalk. Place the drawing carefully on the canvas or other surface, and, using a drawing tool such as a pencil or even the pointed end of a paintbrush, trace over the contours of the drawing with enough pressure that the chalk lines are transferred.

Or you can prick the contour lines of the drawing with a pin or a roulette with metal teeth designed for this purpose. Again, the drawing must be the same size as the surface to which it is being transferred. Place the drawing on that surface and dust the holes in the drawing with charcoal dust using a soft cloth, powder puff, or a gauze bag filled with the dust. When you lift the drawing up, a dotted line following the contours of the original drawing will have been transferred. Then just connect the dots.

Finally, a drawing can be traced and then transferred to another surface. Place a piece of tracing paper over the drawing and draw over its outlines as seen through the tracing paper. (A soft graphite pencil is good for this purpose.) When the tracing is finished, turn it over and coat the back of the traced image with a heavy coat of graphite, using the side of a pencil lead or a soft graphite stick. Replace the tracing paper right-side up on the surface you wish to transfer the image to and redraw the image on the tracing paper with a pencil, exerting enough pressure that the graphite on the opposite side of the tracing paper presses onto the new surface.

Sight-Sizing

Sight-sizing is a traditional method of drawing an object at the size it is in the artist's sight on a scale of one to one. For an accurate sight-sized measurement, the artist must position the drawing surface relative to the object in such a way that the placement and drawing of the object on the page reflect the actual size of the object in the artist's sight. Horizontal and vertical measurements must be accurately transferred. After initially positioning the object, the artist adds other details, successfully aligning each. The closer the artist is to the object, the bigger the drawing of the object will appear on the page. If the object is close, the drawing will closely reflect its actual size. The farther away the artist is, the smaller the image will be on the page.

Choose sight-sizing if you want to create precise measurements. The method works well in a setting where you are working alone with the subject and can get as close as you want. Difficulties arise when you cannot get close enough, as in a crowded class.

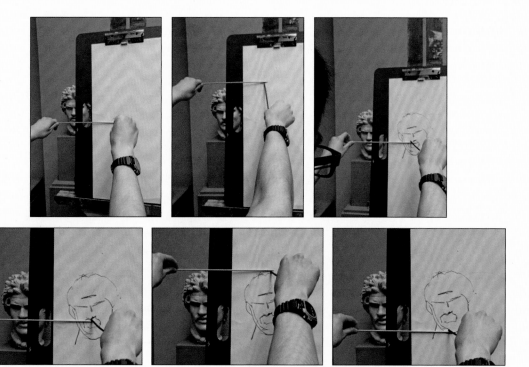

In sight-sizing, positions and measures are translated from the object to the paper in a one-to-one relationship. The size of the drawing on the page depends on how close the person drawing is to the subject.

BLENDING AND ERASING

Blending can be a help or a hindrance. Beginners often over-blend out of a desire to be careful and exact. But too much blending can make the drawing flat, uninteresting, and bland. By the same token, too little blending may result in harshness or a lack of subtlety.

Blending can create subtle modulations in tone, consistency of that tone, as well as texture and transitions between areas of a drawing. It can also create a sense of atmosphere, or sfumato, by softening the edges and contours of forms. Choosing whether and how to blend depends on the aesthetic goals of the drawing. Some careful, refined drawings may require blending as part of the drawing process. For example, the eighteenth-century French painter Pierre-Paul Prud'hon (1758–1823) developed a drawing by first laying down the contours of a figure and then roughing-in loose hatching strokes to create light and shade. This was followed by blending the rough hatches to create even light and shadow masses. After correcting and erasing, he finished the drawing with fine directional hatching to complete the texture, form, and light and shade of the figure. Blending was a crucial part of his layering process.

Blending can also be used as a tool for correcting or modulating marks or areas of a drawing before going on to develop it further. Whatever the reason for blending, it must be considered carefully and used wisely.

Erasing, like blending, is an important tool when used wisely but a liability if not. Some teachers of foundational drawing prohibit both blending and erasing, forcing students to rely on their direct drawing skills. Too many beginning students want to erase every perceived error as they go, but this can inhibit them from seeing the whole picture and can also impede their confidence. Erasing an error is important when the artist understands that a correction or adjustment is needed, but it should not be an emotional reaction to perceived imperfections.

METHODS OF DRAWING

The three most foundational, and most common, forms of drawing are direct (additive), subtractive, and mixed methods. They are basically ways of organizing, developing, and finishing a drawing. These three methods cover a great variety of styles and permutations.

Pierre-Paul Prud'hon, *Standing Male Nude*, c. 1810–20, black and white chalk, stumped, on blue paper, 22 x 15 inches (55.9 x 38.1 cm). Metropolitan Museum of Art (New York, NY). Bequest of Walter C. Baker, 1971 (1972.118.226a). Photo credit: © The Metropolitan Museum of Art; image source: Art resource, NY.

Prud'hon began his drawings with a contour-line description of the figure, then described light and shade masses with rough, loose hatching marks of charcoal and white chalk. He then blended and modulated these masses and built a top layer of fine, thin directional hatch lines, which add refinement. The rough first layer of hatches can often be seen in parts of his unfinished drawings.

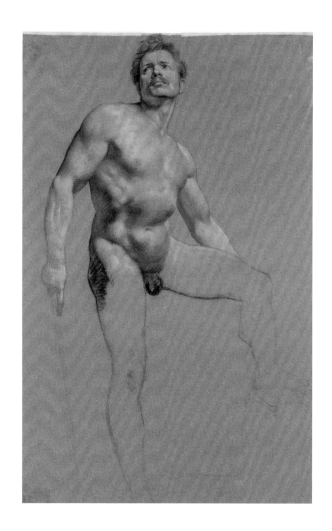

Direct (Additive) Methods

Direct drawing processes are probably the oldest and most common forms of drawing. In direct (additive) methods, drawings are constructed by placing marks, lines, and tones directly on the drawing surface and then gradually adding to them. This drawing process can produce something as simple as a quick pencil sketch or as complex as a finely rendered and shaded composition. Often associated with line drawing, direct methods can also include the addition of shading, washes, and blending. For example, the process may begin with a light pencil layout of a form to describe the basic parameters of the object or image. The next step is to refine the structure of the image. Erasing to make corrections can be done at this phase. Finally, details, contours, and shading are added to create a finished drawing.

The following series of drawings of a pear demonstrate elements of line, tone, planes, and so on. As the oldest, most direct and practical form

Flat outline.

Classic organic line.

Classic broken line.

Light and shade mapped out.

Shading lightly sketched in and blended to make a soft effect.

Hatching lines added to strengthen the shadow and interior contours.

Darker tones added to create a stronger chiaroscuro effect. The charcoal is applied using the stick's side to emphasize planes.

Background tonalities are added to emphasize dark and light. Adding a dark background on the left strengthens the light; leaving a lighter background on the right emphasizes the shadow.

Light and shade created by atmospheric tones using no lines at all. The grain of the paper adds to the effect.

of visualization in drawing, these examples lay out the basic processes and concepts to be understood and used, by the beginner as well as by the accomplished practitioner. The first group addresses line and line quality.

The next sequence of drawings—of a pear and a portrait—address erasing, or subtractive, approaches. An imprimatura, a light layer of charcoal that creates a tonal middle ground for erasing light, has been added. The drawing is then manipulated by both the subtraction and addition of line and tone.

The pear is blocked out to emphasize plane changes. Plane changes occur wherever a curve truly changes direction.

A layer of vine charcoal—an imprimatura—has been first added to the paper, followed by the layout of the pear. This is in preparation for using a wipe-out, or erasing method, for developing light and shade.

The shadow mass is roughed in.

Edges are softened by blending and light planes are lightly erased.

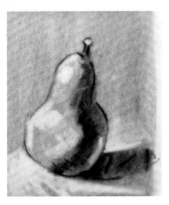

The sketch is finished by adjusting the clarity or softness of edges and adding highlights and reflected lights by further erasing.

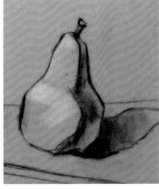

Here, gray charcoal paper is used rather than a charcoal ground or imprimatura. Light has begun to be added with white chalk used on its side to emphasize planes.

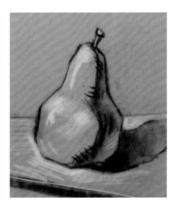

The sketch on toned paper is completed by adjusting line quality, tonalities, accents, highlights, and reflected lights.

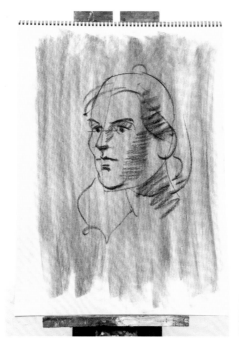

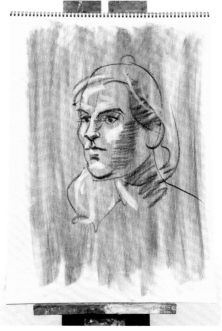

A portrait has been sketched out over a layer of charcoal in preparation for using the wipe-out method.

The portrait can then be developed in the same manner as the pear drawing on the opposite page.

Subtractive Methods

Subtractive methods, sometimes referred to as layered methods, are characterized by alternately removing and adding elements. The most common form of this process is called the wipe-out method.

The wipe-out method is a way of creating form quickly through the use of light and shade. The process begins by placing a layer of graphite, charcoal, chalk, or pastel over the entire drawing surface. This is often blended into the paper to create an even middle value and an illusion of atmosphere on the paper. The image can then be sketched in to show the basic shape and structure of the subject. Using a kneaded eraser, you can then lightly erase the light areas as they appear on the subject, resulting in an immediate illusion of light, shade, and form. Further erasing can create highlights. Additions of darker touches will enhance the details and shadows. The finished drawing will have a strong sense of light, shade, atmosphere, and form. Variations of this form can include direct drawing on top of the erased areas to add line effects. Alternately, you could complete the drawing by erasing gradations of tone, thus creating an atmospheric drawing devoid of lines.

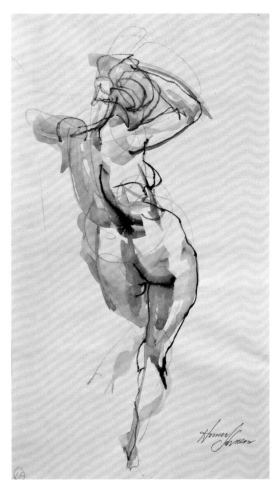

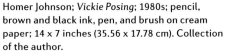

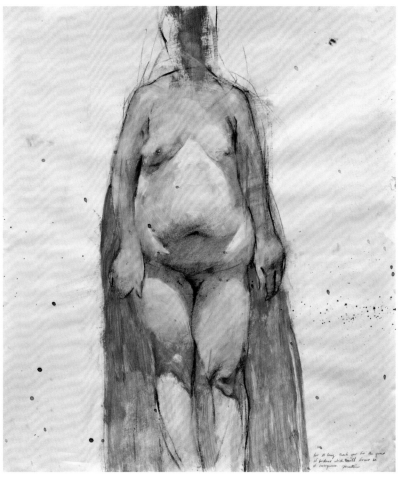

Homer Johnson; *Vickie Posing*; 1980s; pencil, brown and black ink, pen, and brush on cream paper; 14 x 7 inches (35.56 x 17.78 cm). Collection of the author.

A swift, continuous, and curvilinear movement of a pencil captures the basic gesture of the figure. Ink washes in black and brown describe the big areas of shading on the figure. Johnson finished the drawing with a line made with a sharpened bamboo pen dipped in black ink.

Martin Campos; *Nude Figure*; 2000; pencil, charcoal, brush, white gouache, and watercolor wash on white paper; 22 x 18 inches (55.88 x 45.72 cm). Collection of the author.

This drawing is lightly laid out with pencil and charcoal. Large gouache washes describe the shadow masses. Campos finishes the drawing with line accents made with a pointed brush dipped in black ink.

Jerome Witkin, *The Beauty Contest (Noose/Tag on Neck)*, 1996, charcoal on paper, 23¼ x 18½ inches (59.02 x 46.99 cm). Courtesy of Jack Rutberg Fine Arts (Los Angeles, CA).

This preparatory sketch for a finished painting shows a mysterious interior. A great variety of marks describe the general shapes and the composition. Some blending provides richer tonality in this essentially closed form drawing.

Flat outline, classic line, and broken line are the three major types of line.

Mixed Methods

Many artists build their drawings by using a variety of materials and additive, subtractive, and layering processes—a technique known as *mixed methods* or, sometimes, *mixed media*. (For more on mixed media, see page 63). For example, an artist might begin with a direct pencil sketch, followed by a layer of graphite powder, partial erasure of the graphite, and then the addition of ink wash and lines. The possible combinations are endless, but the basic idea is to combine and layer materials to create a unique and visually interesting aesthetic statement. Twentieth-century artists experimented extensively with mixed methods and mixed media, producing works on paper that included mixtures of wet and dry mediums as well as collage. At their best, such works are extremely interesting and expressive. The downside is that the layering process and the materials used might not be stable or permanent. Depending on the artist's goals, these considerations may or may not be important.

TYPES OF LINE

Drawing with line and line-like marks is probably the most ancient, immediate, and economical of all drawing forms. There are three basic forms of line: flat outline, often referred to as contour line; classic line, which shows great variety in the ebb and flow, density, and clarity of the mark; and broken line, which is created by disconnected marks that appear continuous from a distance.

Flat Outline

Flat outline, also referred to as contour line, is the oldest, simplest, most graphic form of line drawing. From Paleolithic cave drawings to children's drawings, comics, and maps, simple outline easily and directly communicates a concept, idea, or image. Flat can be angular, curvilinear, short or long, expressive or controlled, but the common denominator is its bent-wire-like consistency and its tendency to enwrap the whole circumference of an image with an unbroken, even outline.

Because of its practicality, flat outline shows up constantly in many fine art forms, commercial arts, and technical and scientific illustration. Flat outline can also be mixed with other forms of line, as well as with shading, color, and other mediums. Although it describes shapes well, however, flat outline does not easily communicate the volume or three-dimensionality of objects. That said, flat lines can also be used in the interior of the overall shape to describe details and variations in the subject.

Many modern artists adopted flat line or flat contour drawing to create two-dimensional, shape-oriented abstract images. The French painter Henri Matisse was a master of contour, or flat line, drawing.

Blind contour drawing is an exercise that many are familiar with from beginning drawing classes. Art teachers often ask students to draw an object or setup, such as a still life, using one continuous line and without ever looking at the page. The exercise is meant to enhance hand-eye coordination. The resulting drawing has the characteristics of a flat contour line drawing but—especially when done by a beginner—may not look very much like the object drawn!

KKI2

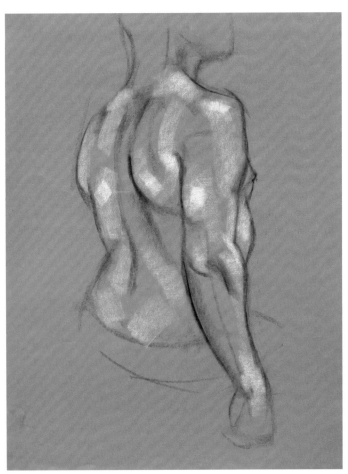

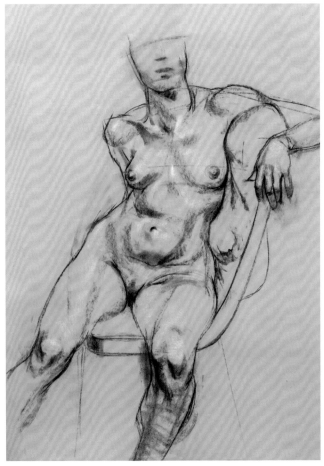

Al Gury, *Figure Study*, 2000, white pastel and charcoal on brown laid charcoal paper, 24 x 18 inches (60.96 x 45.72 cm).

In *Figure Study*, I used a broader and softer interpretation of line quality than in *Nude Study* to the right. The line has almost no clear edges. I also utilized the strong texture of the laid paper for variety. I "brushed on" the white highlights using the side of the white chalk.

Al Gury, *Nude Study*, 2012, charcoal and white pastel on laid cream charcoal paper, 30 x 24 inches (76.2 x 60.96 cm).

In *Nude Study*, I described the form of the figure with an organic, changing line, which varies from sharp to soft. Even though I added tones and white chalk to suggest shadows and lights in the figure's form, it is the organic line quality that really creates and finishes it.

Cross-contour drawings use flat lines to create a topographical description of a form. Lines undulate over and across the form as well as around it to show the form's high, intermediate, and low points, describing the object's volume in a diagrammatic way. Cross-contour line drawings are used for teaching abstract concepts of volume and have a scientific application in the making of topographical maps.

Classic Line

Classic line is organic, not static and flat. It creates a sense of depth and three-dimensionality by varying the thickness, clarity, and darkness of the line as it follows the contours and shapes of the subject. Elegant, clean, and pure, classic line is associated with the aesthetics of classicism.

Classic line causes forms to appear to swell forward or to recede, following the basic optical model that sharper, darker, clearer comes forward; softer, grayer, fuzzier recedes. As a general principle, as a form swells and moves forward or outward, the line becomes thicker and darker. As a form diminishes or recedes, the line lightens and softens. This is especially useful in drawing organic forms like the human body, but it also works extremely well in line drawings of a still life, landscape, or other subject.

Developed by the ancient Greeks and brought to a high degree of sophistication by Renaissance artists, classic line, in a variety of forms, can quickly bring a sense of volume to any object. Classic line does not depend on light or shade for its solidity (see the section on open and closed form, page 118), though various techniques for introducing light and shade are often used in classic line drawings.

Approaches to classic line vary according to the aesthetics of the artist. Jean-Auguste-Dominique Ingres relied heavily on continuous organic line alone to create form in his drawings, even though light and shade effects are also present. Other artists, like Peter Paul Rubens, have integrated classic line with atmosphere and tonality to achieve a mixed, balanced effect.

Subtle line touches in the interior of the object can add detail and complete the form. For example, rich classic line can describe the contours of the torso of a life model, while more subtle, light, or discontinuous line touches can describe the torso's interior anatomy.

Broken Line

Broken line is the most variable of the line types. Unlike classic line, it is not continuous and shows a great range of variation. Broken line can also exhibit the greatest amount of individual personality. Energetic and creative, it is associated with more expressive and tonal forms of drawing. For example,

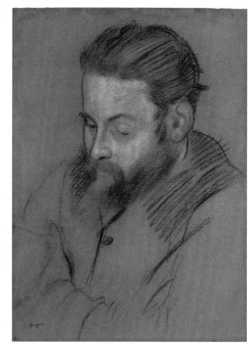

the eighteenth-century French painter Antoine Watteau (1684–1721) used lines that could be described as "sketchy." When viewed up close, you can see their stop-and-start quality, applied according to the texture of the subject. However when viewed from a distance, Watteau's lines appear even. The twentieth-century Expressionist painter Willem de Kooning (1904–1997) used broken, variable lines in an aggressive way to create drawings that have both flat and spatial elements.

Various strengths of broken line can be used in the interior of the form to describe its complexity, as well as around the subject to create a sense of energy and atmosphere.

HATCHING AND OTHER DESCRIPTIVE MARKS

To describe form, depth, texture, and other visual elements in easily readable ways, artists have invented a great variety of marks. Along with the different types of line discussed prior and open- and closed-form drawing (see page 118), the visual language of marks can be very broad. There are some basic ones, however, that are foundational, practical, and perennial in drawing. These include hatching, scumbling, graining, and stippling.

Hatching

Hatching, sometimes called cross-hatching, is a technique of describing volume by building up small lines over each other to describe form, contour, and light and shade. Hatching techniques are common in figure and portrait drawing, still life, and landscape drawing, where descriptions of form are required. The use of hatching can be observed in drawings and paintings from as early as the ancient Greco-Roman era, and examples of classic hatching are seen in fifteenth- and sixteenth-century Italian Renaissance masters like Raphael (1483–1520) and Michelangelo Buonarroti (1474–1564).

Classic hatching techniques are economical, never random, and usually very controlled and consistent. The term cross-hatching has led to some misunderstanding of the process. Usually, hatching does not resemble random tic-tac-toe or X marks. Hatching that is confused or random or that makes the subject look hairy damages the sense of form that is hatching's purpose. On the other hand, the tic-tac-toe or X kinds of hatching marks can be very useful for filling in large flat areas of tone.

In the most basic, classical type of hatching, there is typically a long hatch, which describes the direction of the light and the shadow mass, followed by specific contour hatches, which describe the turning of smaller, more specific forms in both the light and shadow masses and which mark transitions and direction changes between forms. These smaller contour hatches are the source of the name cross-hatching because they do, in fact, cross the contours and other hatch lines.

The line weight of hatching marks varies, following the rule sharper, darker, clearer comes forward; softer, grayer, less clear recedes. Nearer forms will have stronger and darker hatch marks, while diminishing or receding forms will have lighter hatching lines.

Renaissance and Baroque masters developed their own interpretations and touches in hatching, and there are a number of hatching variations. Still, at no time does hatching become random, messy, or superficial unless the artist is choosing to do so to serve a personal aesthetic or create a specific expressive effect. Good examples of hatching for study range from those used by sixteenth-century Italians such as Annibale Carracci (1560–1609) to the hatching employed by nineteenth- and twentieth-century masters such as John Singer Sargent (1856–1925) and Paul Cadmus (1904–1999). As hatching forms evolved, inventiveness and aesthetic necessity created unique practices: Sargent gave a looser, more expressive feeling to his hatching; Cadmus brought clarity and finesse to the ancient craft of classic-style hatching.

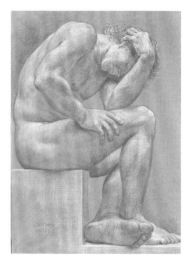

Paul Cadmus, *Male Nude (#179)*, 1983, crayon and olive green acrylic on gray paper, sheet: 24⅝ x 17⅝ inches (62.6 x 44.9 cm). Smithsonian American Art Museum (Washington, D.C.). Gift of the Sara Roby Foundation, 1986.6.12. Photo credit: Smithsonian Art Museum/Art Resource, NY; © VAGA.

Cadmus almost sculpts his figures with energetic, concise hatch lines following the surface directions of the form.

OPPOSITE Pierre-Paul Prud'hon, *Bust of Female Figure*, c. 1814, chalk on blue wove paper, sheet 11 x 8⅝ inches (27.9 x 21.9 cm). Philadelphia Museum of Art (Philadelphia, PA). The Henry P. McIlhenny Collection in memory of Frances P. McIlhenny, 1986.

Prud'hon builds his figures by starting with a rough outline in black chalk. He next lays in the light and shade masses and forms with equally rough hatch lines. He then blends the whole piece. To finish, he refines the surface with delicate, clean hatch lines to model the final form and create subtlety of tonality and modulation.

Scumbling

Often used for dry-brush effects in oil painting, scumbling has a similar use and appearance in drawing. Although scumbling is similar to graining (see below), it is rougher and does not necessarily require a sharpened drawing tool. A rough dragging of the drawing tool, such as a charcoal stick, over the drawing surface can create quick and broad atmospheric effects and create a layer for other touches and modulations. Scumbling is especially useful in more expressive drawings.

Graining

Graining is the process of building tone slowly, delicately, and evenly with a sharpened drawing tool over the grain of the paper. The grain, or weave, of the paper is crucial to this approach, as is the sensitivity of the hand and tool to the surface of the paper. Graining was a popular shading approach in nineteenth-century academic drawing. In academic life drawing, graining was used both to create shadow masses and variations in anatomy in the figure and to develop a sense of tone and depth around the figure.

Graining is often combined with both classic hatching and broken line to create beautiful and rich atmospheric effects. It can be a good choice when making a drawing that requires subtlety and delicacy in its tones and overall development.

Stippling

The term stippling refers to a buildup of small dots to create varieties of tone and densities of form. Stippling creates a strongly open-form effect, though from a distance a stippled image can seem very solid. Often associated with the Pointillist approach of French painters like Georges Seurat, it is also favored by some illustrators because stippled effects reproduce so well.

SHAPE

All visible things have shape, whether they are solid forms like a pear or amorphous atmospheric structures like a cloud. Shape describes structure and is characteristic of both two- and three-dimensional forms: a flat snowflake has a shape and so does a volumetric crystal.

Shape can be thought of in two ways. The first is the simple geometry of any object (for example, circle, oval, square, rectangle, triangle). Most objects can be simplified to one of these shapes. For example, a flower can be simplified to a round or oval shape that gives basic character to the

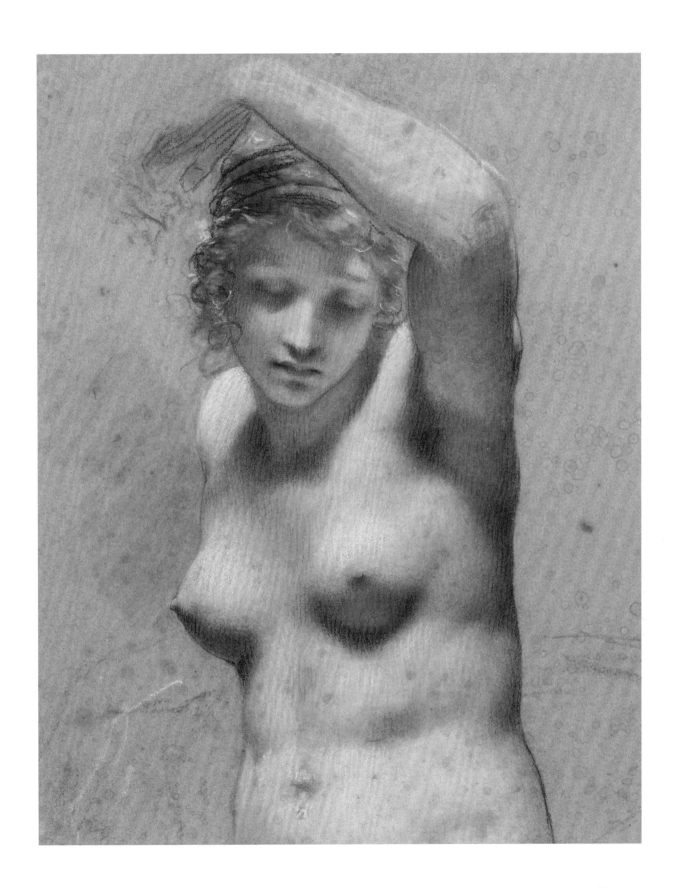

LEFT Simple descriptions of the shape of an object organize the experience of its form and mass. Most solid objects can be defined by a simple shape to start the drawing process.

RIGHT In this sketch, the positive elements are the objects and table. The negative spaces are the background and opening of the handle.

blossom regardless of the details of its petals. The basic shape gives the object cohesiveness and organization, and creating basic shape descriptions is often the first stage in laying out a drawing.

The second way of thinking about shape is to attend to the more complex, complete shape or contour of a specific object. The shape of a specific flower includes all the ins and outs of its details—a complete silhouette. When drawing, this more complicated shape can be added to or built on top of the basic geometric layout. The layers of shape provide a map for the addition of details, the further development of form, and the creation of aesthetic effects. Using both aspects of shape creates a drawing that is solid geometrically and confident in its details.

Paying attention to shapes is critically important when designing a composition. The shapes' relationships to one another within the rectangular field of the composition create balance, movement, and different types of visual statements. To go back to that flower shape: In a still life, it might be connected to the shape of a vase, a table shape, the shape of a window behind the table, and the shapes of architectural elements in the room. All these shapes together provide the composition's layout.

Shapes are essential to composition whether the image is realistic or abstract. In a painting by the Italian master Titian (c. 1488–1576), shapes are an important underlying part of the composition, setting the arrangement of figures, trees, and other objects within the picture's rectangle. In the mature work of the twentieth-century Dutch painter Piet Mondrian (1872–1944), shapes and colors are the dominant compositional elements.

LEFT Al Gury, *Compositional sketch of shapes*, 2001, pen and brown watercolor wash on watercolor paper, 8 x 5 inches (20.32 x 12.7 cm).

In this compositional sketch, I defined the essential shapes of the characters in clear and simple terms. No details were added to confuse the strength of the shapes.

RIGHT Al Gury, *Storyteller*, 2001, sepia wash and pen on watercolor paper, 11 x 9 inches (27.94 x 22.86 cm).

In this finished drawing, the shapes of the figures have remained an integral part of the composition.

Positive and Negative Space

Positive space generally refers to the solid objects or shapes in a composition, while negative space commonly denotes the areas around or between the objects. Positive and negative spaces in a drawing can be flat or suggest spatial depth. For example, in a drawing of a vase on a table, the shapes of the vase and the table will constitute the positive space; the background around the vase and table will be the negative space. By this definition, all the solid objects in a composition can be thought of as the positive space and all the non-solid shapes around and between the objects are the negative space. In a landscape drawing, for example, the positive space would be the land and trees while the negative space would be the sky and air around and between them.

In an abstract drawing in which depth is not a factor, the positive space is defined by the active, dominant shapes while the negative space is marked out by the passive, nondominant shapes. In some cases, they might have equal intensity. Balance between positive and negative space is crucial to the success of a composition and the aesthetic statement of an artwork. In works by the twentieth-century American abstract artist Robert Motherwell (1915–1991), positive and negative spaces have equal strength.

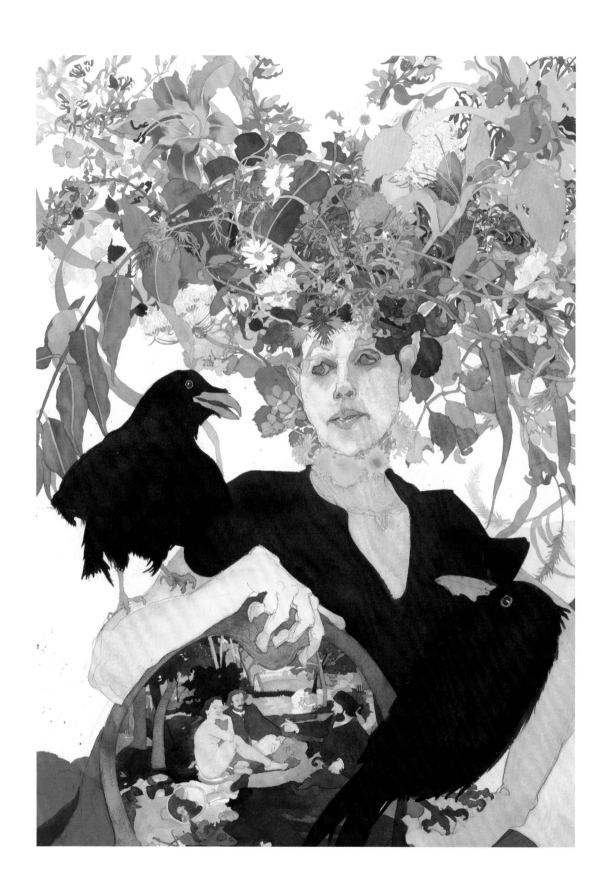

This "log cabin" quilt provides a perfect example of tessellations, or repeated patterns.

OPPOSITE Joan Becker, *Le Dejeuner sur L'Herbe*, 2013, watercolor on paper, 40 x 30 inches (101.6 x 76.2 cm). Courtesy of the artist and Gross McLeaf Gallery (Philadelphia, PA).

Becker focuses on the flat shapes, as well as the positive and negative qualities of all the elements: plants, the woman, the bird, the Manet image, and so on. Illusions of depth are secondary or nonexistent. This allows her to create a strong sense of graphic design within the rectangle.

The interplay between positive and negative space is fairly clear when the scene or composition is simple. The more complex the composition or scene, the more difficult it becomes to identify positive versus negative spaces.

Patterns and Tessellations

Pattern refers to repeated shapes within a composition. The shapes can be interlocking or separate, but pattern depends on repetition. Patterns can be evenly repeated, as in a plaid fabric, or they can be organic and variable, as in a leopard's spots. The main point is that they create a visual connectivity and balance among themselves and the composition as a whole.

Patterns are especially important in the works of modern artists like Georges Braque and Henri Matisse. For many modern artists, the use of patterns in the artwork of ancient and non-European cultures was a great stimulus and source of invention and creativity.

Tessellations are repeated, interlocking groups or blocks of patterns. The patterns of checkerboards and other game boards are tessellated, and fabric designs, such as quilt patterns, often depend on repeated blocks of shapes. Tessellations and patterns are useful in teaching the concepts of positive and negative space and balance in a composition—a topic furthered explored in the section on composition (page 128).

DEPTH AND PERSPECTIVE

Two types of perspective are most common in drawing: geometric perspective and aerial perspective (also called atmospheric perspective). Both utilize the concepts of foreground (nearest the viewer), middle ground (midway between the viewer and the farthest distance), and far ground (farthest from the viewer and the foreground). Both attempt to believably simulate how the human eye and mind perceive depth.

Geometric Perspective

Geometric perspective—also called linear perspective or mathematical perspective—uses horizon lines and vanishing points to construct a rational, architectural illusion of depth. Ancient Greek architects used geometric perspective and other optical tricks to create visual balance and harmony in their temples. Renaissance artists were fascinated by the geometric perspective they saw in ancient Greek and Roman buildings and artworks and developed systems of geometric perspective used to this day.

A fine example of Renaissance geometric perspective is seen in the Italian painter Pietro Perugino's (c. 1446/52–1523) Sistine Chapel fresco

David Wiesner, illustration for *Tuesday* (New York: Clarion Books, 1991), 1991, watercolor on Arches 140 lb. cold-pressed watercolor paper, 11 x 22 inches (27.95 x 55.88 cm). Courtesy of the artist.

Classic aerial perspective is used in this beautiful illustration. The larger, clearer forms appear to come forward while the smaller, less clear ones diminish. In addition, the positions of the frogs follow diminishing geometric lines.

Christ Giving the Keys to Saint Peter. In this famous picture, the figures, buildings, and illusion of depth are organized around geometric recessions of one- and two-point perspective. The twentieth-century Dutch artist M. C. Escher (1898–1972) is a good example of a modern artist who used linear or geometric perspective. Escher's complex illusions result partly from tricks he played with perspective.

Aerial Perspective

Aerial or atmospheric perspective creates illusions of depth through size relationships, distances, edge differences, light and shade, color, and other elements. The illusion of atmospheric perspective can be created through the manipulation of many combinations of tones, textures, lines, and so on, but the common denominator is that the foreground of a space and its objects are sharper, clearer, larger, or darker relative to the recessive areas, which are softer, less clear, smaller, and less dark.

During the Renaissance, this form of perspective was often used in conjunction with geometric perspective. For example, in Perugino's painting *Christ Giving the Keys to Saint Peter*, mentioned previously, atmospheric illusions of depth are added to the geometric perspective. The foreground figures are larger, clearer, and have more tonal contrast as compared to the distance, which is softer, smaller in scale, and less defined than the foreground. The nineteenth-century French Romantic painter Jean-Baptiste-Camille Corot (1796–1875) used atmospheric perspective extensively, creating illusions of soft, hazy atmospheric depth through

Thomas Eakins; perspective drawing for *The Pair-Oared Shell*; 1872; graphite, ink, and watercolor on paper; 31¹³⁄₁₆ x 47⁹⁄₁₆ inches (80.8 x 120.8 cm). Philadelphia Museum of Art (Philadelphia, PA). Purchased with the Thomas Skelton Fund, 1944.

This Eakins drawing is a classic example of one-point geometric perspective. Eakins worked out the spatial positions of his subjects in obsessive detail. His high school training in mechanical drawing remained a useful tool throughout his entire career.

Vincent van Gogh; *Haystacks*; 1888; reed pen, quill, and ink over graphite on wove paper; 9½ x 12½ inches (21.1 x 31.8 cm). Philadelphia Museum of Art (Philadelphia, PA). The Samuel S. White 3rd and Vera White Collection, 1962.

In this sketch, Van Gogh creates an even field of interpretive textural marks over the picture plane of the rectangle, then establishes the foreground with darker lines and dots.

Larger, sharper, darker, clearer comes forward, while grayer, less clear, and smaller recedes in this classic diagram of aerial perspective.

relationships among colors, tones, and textures. The depth is "felt" through these relationships rather than "reasoned" through geometric perspective. Aerial perspective was also a preferred technique of many Romantic artists, such as Eugène Delacroix, and of French Impressionists and Postimpressionists who followed, including artists such as Pierre-Auguste Renoir and Vincent van Gogh.

Foreshortening

Foreshortening conveys perceptual perspective by modulating forms so that they appear to be moving forward or receding backward in space. In drawing, foreshortening is often used to describe the projections of forms such as the limbs of a life model and to show the overlapping of organic forms. Some general rules apply in foreshortening:

- Forward-moving forms appear larger than receding forms.
- Forward-moving forms are sharper and clearer in definition relative to receding forms, which are less clearly defined.
- Overlaps of forms are defined by their contours.
- Measurements of forms shorten radically in foreshortening.

For successful foreshortening, you must carefully measure the height and width of the forms as they appear from your point of view. You must clearly identify the angles of recession, assess the overlapping contours of all parts of the forms, and adjust the clarity, sharpness, and contrast of forward-moving forms relative to receding forms.

There are two basic types of foreshortening: normative and extreme. Normative foreshortening occurs as contours overlap, especially in organic forms. A drawing of a life model, for example, might show the contours of one muscle in an arm hanging in a relaxed manner at the model's side. The way in which one muscle crosses over another on a diagonal is the normal overlapping of forms in the body. This is the most common or "normal" form of foreshortening. Normative foreshortening can be used in drawing many organic and inorganic forms such as plants, animals, and still-life objects. Line quality and weight are important in these visual descriptions.

Extreme foreshortening occurs when a form or group of forms—for example, a model's arm—is extended toward the viewer. The forward-moving form obscures the receding forms. The foremost form, perhaps the hand, will seem much larger than the rest of the arm. By combining measurement with heightened line, tone, and edge clarity, the artist can make the hand seem to zoom forward as the rest of the arm recedes or disappears behind it.

Many people who are just beginning to draw are dismayed by foreshortening. Learning the rules and carefully planning the relationships can make this form of perspective not only an accurate tool but also a welcome choice in a composition.

Diane Edison, Nude *Self Portrait*, 1995, pastel on black paper, 44½ x 30 inches (112.40 x 76.2 cm). Courtesy of the Pennsylvania Academy of the Fine Arts (Philadelphia, PA). Art by Women Collection, gift of Linda Lee Alter. Acc. No: 2011.1.57.

Edison uses normative foreshortening in most areas of this powerful drawing, while moving toward more extreme foreshortening seen in the overlaps of the head position and features. This image is a fine example of pastel and contemporary self-portraiture.

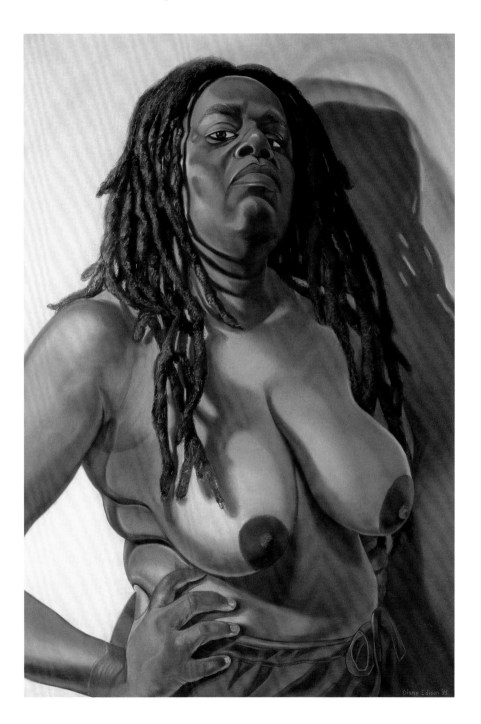

CLOSED VERSUS OPEN FORM

Drawings can be characterized as either closed form or open form. Closed form is created by contour or classic line alone and does not depend on other elements such as shading. If a closed-form drawing does have shading, the shading could be removed and the drawing would retain its basic form via the line. Closed-form drawing is integral to many schools of aesthetics and to methods from classicism to simple diagrammatic illustration. Good examples of closed form are provided by the works of the German Renaissance artists Albrecht Dürer (1471–1528) and Hans Holbein the Younger (1497–1543). Even though both beautifully elaborated their drawings with shading and interior detail, the key element in both artists' work is the enwrapping, organic, classic line of the contours.

Closed-form drawing includes flat-outline drawing. Henri Matisse utilized enwrapping flat outlines in his drawings to describe shapes and patterns. The much-loved drawings of the American artist and writer known as Dr. Seuss (Theodore Seuss Geisel, 1904–1991) also utilize flat line to strength the description of his characters.

Open-form drawings, by contrast, exhibit a combination of light and shade, broken-line suggestions, and variation in line weight. Open-form drawings can range from being almost closed in appearance, like those of Rembrandt, to an extreme in which there are no lines of any kind, as

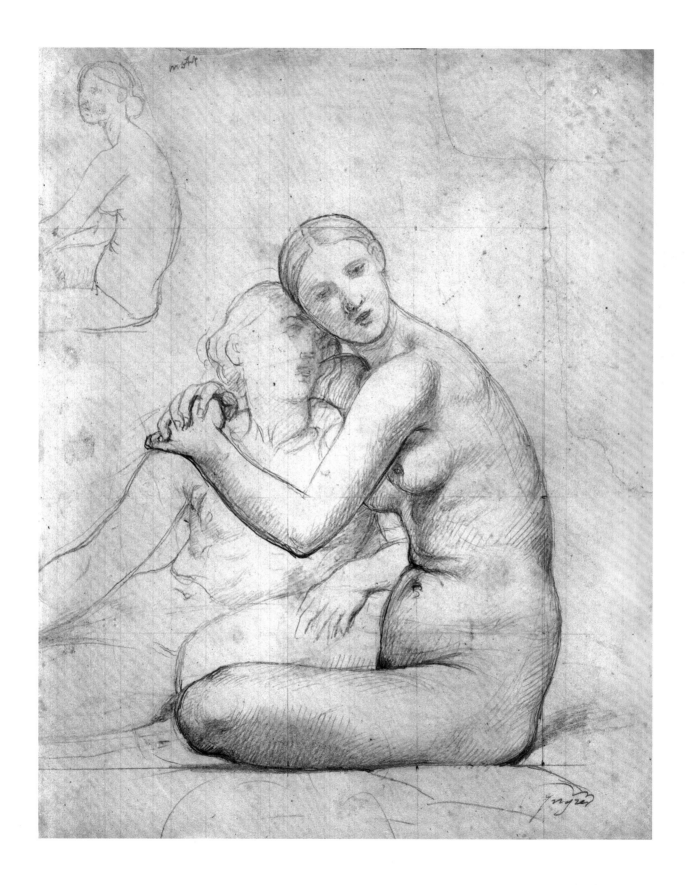

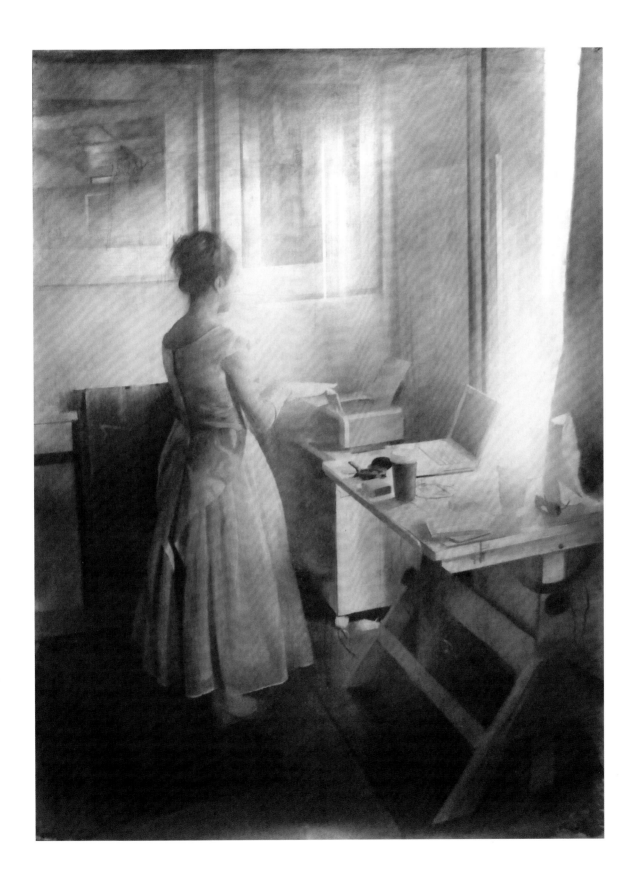

in Seurat's Pointillist works. Although Rembrandt's drawings incorporate
powerful line elements, those are complemented by a wide variety of tonal
effects and other suggestions of atmosphere and depth, making his drawings
especially rich and emotionally evocative. Seurat, in many of his drawings,
dispenses with line marks altogether, simply dragging his charcoal over
the texture of the paper to create tone and atmosphere. The drawings of
Rembrandt and Seurat would begin to lose their coherence if the tone and
atmosphere were deleted.

Not all drawings are clearly either open or closed form. Some artists
skillfully combine both approaches in a balanced, harmonious way.
A drawing can depend equally on line, shading, and other marks. The
balance would suffer if any of the elements were deleted.

PLANES

Planes are used in drawing three-dimensional forms to emphasize the sculptural solidity of objects. You can create a plane wherever a curved line or surface changes direction and end it where it changes direction again. Even a circle or a three-dimensional ball can be planed. This faceting is especially important in figure drawing, where turning the soft contours of a body into a set of planes gives the form a sense of solidity. Michelangelo often emphasized and enhanced the planes of his figures to add strength and energy to their forms.

A good exercise is to take a drawing of a human figure and plane out its forms as an analytical diagram. Planes can be intermixed with curving contours to create an overall sense of fluidity and variety.

TONALITY, LIGHT, AND SHADE

Since the Classical Greek period, Western artists have used tonality, light, and shade to reveal form and depth in objects. Artists also use these elements to create mood and a sense of drama or emotion in artworks. In a refined, line-oriented drawing, small amounts of shading can enhance the form created by the changes in line quality. In a more dramatic work—one created with a broken line or intended to have a strong sense of atmosphere and depth—light and shade become the primary elements in the design and

Julia Hall, *Study of light and atmosphere*, pencil on paper, 2014, 7 x 5 inches (17.78 x 12.7 cm). Courtesy of the artist.

This sketchbook image combines broad hatching, erasing and blending, and line to create an atmospheric effect of light and shade. The simplicity of the shapes and lack of detail add to the open-form quality of the drawing, and to a dominant sense of atmosphere, or sfumato. Hall uses a minimal line to enhance shape delineation.

A typical grayscale. Having an image of the grayscale in your mind when drawing can make it easier to gauge values.

execution of a drawing. Open-form, or atmospheric, drawings depend on light and shade for their existence. Meanwhile, you can create closed-form, line-oriented drawings with minimal amounts of light and shade.

Chiaroscuro

Chiaroscuro is an Italian Renaissance term referring to a strong and dramatic sense of light and shade. The term can be used to describe light and shade contrasts in any drawing, in open or closed forms, as well as in artworks in which a strong contrast between light and dark is an important part of the narrative of the image. Primarily though, the term chiaroscuro is used in the context of drawings in which there is a strong and dramatic use of light and shade.

Sfumato

Another Italian Renaissance term, *sfumato* refers to a visual sense of a hazy or smoky atmosphere. A sfumato effect is achieved with edges that seem to dissolve into the surrounding atmosphere. Leonardo da Vinci famously used sfumato effects in his drawing and painting.

Value or Tone

The term *value* refers to an area's lightness or darkness and is synonymous with tone or tonality. A simple value or tone scale shows gradations from absolute white to absolute black with a number of steps, or middle tones, in between. This is also sometimes referred to as a grayscale. Grayscale charts usually show ten steps, or gradations of value, in which light values are numbered from 1 to 4 (where 4 marks a transition to midtones), midtones from 4 to 7 (where 7 marks a transition to dark values), and dark values from 7 to 10. A grayscale chart can help artists identify values in what they observe and match them to their drawings.

Light and Shade

Light and shade in nature, and thus in a drawing, can be clear or unclear, specific or generalized. When there is a specific light source, such as a lamp or light from a window, we say that there is directional light present in the scene. In an environment where there is only generalized ambient light,

Study of a Male Nude exhibits a broad range of tonalities and use of the full grayscale. The darker tones (7–9), which are more defined and are aggressively described and have clearer edges, within the figure's shadows cause his forms to swell forward optically. Lighter midtones (4–7), which in this drawing are softer with less clearly defined edges, create optical recessions. Highlights (1–2) and dark accents (8–10) complete the sense of form.

such as on an overcast day outdoors or from overhead fluorescent light in a room, we can say that there is no specific light direction. The light can also be mixed, with a variety of light sources or directional light in the midst of a lot of ambient light.

Analyzing the light on or around a subject is crucial to describing the volume of the object in a drawing. For example, a vase on the sill of a small window will exhibit a strong sense of light and shade, especially if the only light in the scene is coming from the window. If there are other lights on in the room, the light and shade on the vase will be affected, reducing the effect of the backlighting. If the vase is placed on a table in a room lit by overhead fluorescent lights, the ambient light that fills the room will destroy any sense of strong directional light and shade on the vase.

We thus have three lighting setups: The first creates form by strong opposition of light and shade. The second creates form with a mixture of light, middle, and dark values. The third description of form depends on line quality, rather than light. Lighting must be set up thoughtfully to achieve the desired effect in a drawing. A good exercise is to set up three types of lighting situations and do drawings of each.

Light mass refers to all the light areas in the object, including subtle variations within the light mass. *Shadow mass* is all the shadow on the object, including variations in the shadow mass and reflected lights. The concept of light mass/shadow mass assumes that there is a distinguishable light direction on the subject that creates clear distinctions between light and shade on the object. If the subject were surrounded by light, there would be no clear light or shadow masses.

Transition refers to the area where the light meets the shade. Depending on the intensity of the light source, transitions can be more or less dramatic. The passage where the light transitions into the shadow is usually the darkest passage because it receives the least reflected light and is farthest away from both the direct light and the reflected lights.

Reflected lights are of two general types. In the first, ambient light in the atmospheric space around the object filters into the shadow to slightly illuminate what might otherwise be an absolutely black shadow. The more ambient light in the room, the greater the amount of reflected light. Also, the shinier or more reflective the surface of the object being drawn, the sharper the reflected lights will be. For example, a vase made of shiny glass or metal may have sharp reflected lights. A vase made of a dull or rough material may have only faint reflected lights.

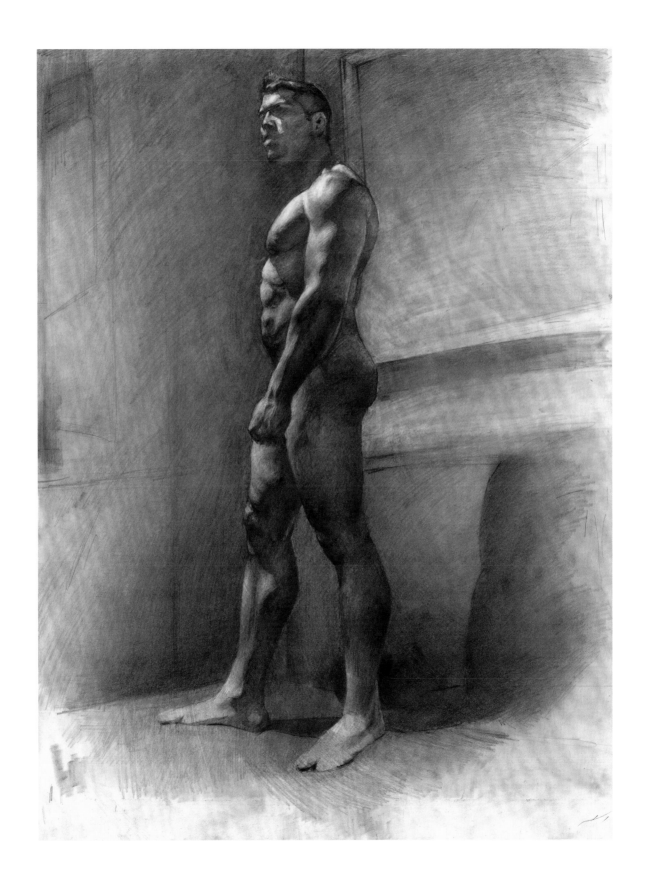

Jensen's drawing exhibits a variety of marks, lines, and tones. This drawing depends on both line and tonal effects and mixes closed and open forms.

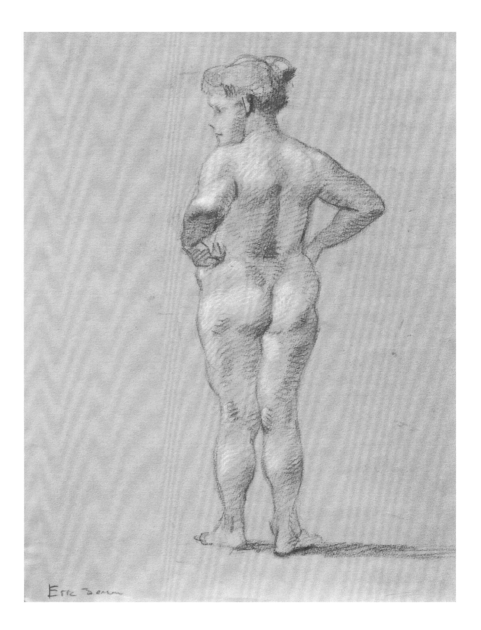

In the second type of reflected light, light from the light source or from the ambient light reflects off an object onto others nearby. Light bouncing onto an object from another object enters the shadow to make a rather clear line of illumination. A classic example happens when you place a white vase near a dark vase. Light bounces from the white vase into the dark shadow of the dark vase. Sharp, pale reflected lights result. Also, the color of one object may bounce into the shadow of another. In drawings of the nude human figure, a common effect is reflected light from a torso bouncing into the shadow of an arm. The result is both a glow of light and a glow of color.

Although subtle reflected lights are common in shadow masses, they should not be overemphasized. Overdoing them may result in the weakening of the overall light and dark masses of an object or a scene. Beginners often overdo reflected lights in their effort to carefully render what they see, but it is important to remember that the whole ensemble matters more than the details.

Like drawing techniques in general, methods of describing light and shade can be described as additive, subtractive, or mixed. In additive approaches, descriptions of light and shade are constructed through a buildup of lines or tones added to the shapes, usually on pale or white paper. The light paper provides the basis for the light mass, while the dark tones are added and built. Overworking shadows makes them flat and black, so to give a sense of luminosity, especially in the darks, the light paper should slightly show through all the tones.

Additive approaches can also be used on middle-toned papers, which establish the middle tone while dark and light are added to create a complete sense of tonality and form. The middle-toned paper can be completely covered by the drawing medium, such as Conté or charcoal, or the paper itself can provide a sense of unity in the darks. Light can be created by adding light or white chalks or pastels. In either case, it remains important to utilize the grain and luminosity of the paper to keep the darks and lights from going flat and dull.

Subtractive approaches include the wipe-out method discussed earlier (see page 99). Wipe-out methods rely on a ground of charcoal, graphite, or other chalks rubbed onto the surface of pale or white paper. The areas of the light mass and related tone variations are then erased from the ground to create an illusion of masses of light and dark. Further erasing can create modulations and reflected lights. The ground is usually a middle tone or darker. The lighter the ground, the more the darks may have to be modulated. The darker the ground, the less modulation may be needed in the dark mass.

In both additive and subtractive methods, lines or other marks may be added for clarity, definition, and expression. Wipe-out drawings can also be done on middle-tone and colored papers with the addition of light touches in the light mass.

In mixed effects, a variety of marks can be used to build a drawing in which value is a factor. The German artist Käthe Kollwitz used a mixed effect of lines, erasures, white chalks added for highlights, and so on to build up a rich effect of light and shadow on both pale and toned papers.

Roger Peterson; *Adventures*; 1998; pen, graphite, and ink wash on paper; 12 x 5 inches (30.48 x 12.7 cm). Collection of the author.

Peterson created the great variety of textures in this drawing by changing the direction and shape of the lines used to describe each object.

TEXTURE

To create texture in a drawing, you must observe the differences in the surfaces of the object you are drawing and then decide what kinds of drawing tools to use and what kinds of marks to make to simulate those textures. For example, a sharpened graphite pencil, as opposed to a sharpened charcoal pencil, might provide just the right size of mark, or vice versa.

The relationships of textures to one another must be carefully assessed and planned. Lack of textural variety can create a bland evenness or flatness in a drawing.

Too often, beginners tend to make all the surfaces in a drawing look the same. Over-blending is a common problem, as is doing the drawing in detailed pieces without evaluating the overall composition and its textural relationships.

COMPOSITION AND THE COMPOSITIONAL FRAME

Composition refers to the arrangement of visual elements into a pictorial structure. This structure is most often enclosed within compositional margins such as the edges of the paper, or a crop line around the margins of the composition. This enclosure focuses both the artist's and the viewer's eye on the important elements of the artwork. This margin simply represents the outside parameters of the image. Just like composition in other creative disciplines such as music and literature, composition in visual art gives organization to the work and directs the audience to the experiences the artist wants them to have.

Composition may consist of nothing more than positioning a sketch on the page or it may involve a complex arrangement of many elements in an image. A composition can be rationally planned or explored in a subjective manner. In any case, it requires thought and planning to be successful. Compositional difficulties arise when the sense of organization is awkward, incomplete, or unbalanced.

Jerome Witkin; *What Remains of the Death of Children*; c. 2011, graphite; Conté crayon, Prismacolor crayon, and collage on paper; 46³/₈ x 34³/₄ inches (117.80 x 88.26 cm). Courtesy of Jack Rutberg Fine Arts (Los Angeles, CA).

Witkin creates a stage set of emotional and visual experiences in this composition. The elements relate to one another from side to side, and the composition possesses a sense of wholeness while providing interesting stops and side tours for the eye.

A viewfinder (see page 83) can be extremely useful when planning a composition. The hole in the viewfinder, which can be a rectangle, square, circle, or other shape, encloses the composition, allowing you to orchestrate the elements of the image you want to create in a focused manner. Preparatory thumbnail sketches made with the use of a viewfinder will help you visualize the composition possibilities.

Thumbnail Sketches and Storyboards

When planning a composition, it may be advisable to do some preparatory sketches. The thumbnail, or compositional sketch, allows the artist to quickly work out the basic formal and informal elements of the drawing on a small scale. Trying out a variety of arrangements in the rectangle of the compositional frame gives you a good idea of what the finished drawing will look like.

One of the pleasures of looking at artists' sketchbooks is seeing their ideas change and evolve through many small compositional sketches. One thumbnailing strategy is just to sketch the elements of the image freely and then to draw a rectangle around a portion of the sketch to establish the compositional frame. Another is to first draw a number of rectangles and then to sketch the elements of the composition within these frames.

Storyboards are another form of compositional planning, one used frequently by painters, illustrators, animators, and makers of live-action films and videos. A storyboard consists of a series of compositional frames laid out sequentially. Each important scene or image in the story is drawn, in sequence, in the rectangles. Storyboards are usually sketchy, intending only to show the main elements of a shot or scene. The whole narrative can then be edited and adjusted for content, flow, and unity.

Dummy books are also sketched out sequentially. A dummy book is a series of sketches of the pages of a visually-driven book. Children's book illustrators routinely create dummy books to present to publishers. These, along with samples of finished illustrations, present the whole character and content of the book for consideration by the publisher.

Sophie Courtland, sketchbook page for a composition, 2014, pencil on white paper, 7 x 5 inches (17.78 x 12.7 cm). Courtesy of the artist.

In this sketchbook drawing, Courtland has worked out the elements of a complex narrative scene within the compositional shape and margin. Loose crop lines mark the margins of the composition. Notes on the page suggest artists Courtland was thinking about as influences for creating the image.

Robert Byrd, sketch and page layout for *Smiling Lady* (illustration for Byrd's *Leonardo: Beautiful Dreamer* [New York: Dutton Children's Books, 2003]), 2003, HB and 2B pencil on tracing paper, 8 x 18 inches (20.32 x 45.72 cm). Courtesy of the artist.

In this preparatory compositional sketch, Byrd has worked out all elements, not only in the primary image, but also in the page layout. The large illustration has a compositional design that balances and repeats the arrangement of text and secondary images on this two-page book spread.

Zane L'Erario, storyboards for film stills, 2012, pencil and black marker on white paper, 11½ x 8 inches (29.21 x 20.32 cm). Courtesy of the director and Front House Pictures.

Compositional decisions are extremely important to the creation of scene shots in a film. Here, the director has made compositional storyboard decisions about each frame using scale, positive and negative shapes, and the compositional margin.

Page Position

Consideration of the position of the image on the page is the simplest form of compositional planning. First, think about the desired size of the drawing. Mark the parameters of the figure or object with a few simple points on the page. Then build the drawing within these parameters. Consideration of effective page position, especially for single objects like a life figure or a lone still-life object, will develop your instinct for composition and design.

Visual Point of View

The artist's point of view in relation to the objects being drawn is likewise an important consideration. For example, if the viewer is standing slightly above a still life, the objects on the tabletop will seem to recede away from one another. The objects that are closer to the viewer will be placed lower on the page relative to objects that are farther away, and vice versa.

The arrangement of the objects' bases describes where they are spatially in the composition. One error beginners often make is to align all the bases of the objects too closely along the same base line. This can be corrected through measuring with a drawing tool, such as a pencil, to gauge the alignment of the bases and correct their positions, moving them up or down on the page.

In this view from slightly above, the artist can utilize traditional Renaissance perspective and optical rules easily.

This view from above flattens the scene and emphasizes shapes rather than forms.

Picture Plane

The picture plane is the flat, "up-front" surface of the picture within the compositional frame. Sometimes the term denotes the theoretical flat surface of an image, but it can also mean the flat material (paper or canvas, for example) on which the picture is created. Both flat and spatial pictures have a picture plane. When discussing nonrepresentational drawings and paintings, or flat abstract images, the picture plane refers to the overall surface and the elements composing the image. Everything is up front—visually and physically—on the surface of the paper. In spatial, perspective-oriented images, such as landscapes, depth beyond the picture plane is revealed via receding perspective lines or relationships of sizes and tones (aerial perspective). The picture plane is figuratively a window through which the image is seen. It is not uncommon for students analyzing a depth-oriented image to reduce it to a flat-picture-plane drawing of the shapes that make up the composition. Abstract or other flat images preserve the picture plane, while three-dimensional images break through it. Picture plane has been a common part of the discussions surrounding flat, modernist painting in the twentieth century. The picture plane was a less important topic of a discussion in earlier eras, when images were considered to be windows revealing spatial depth and forms.

For example, in a Rembrandt painting, we seem to be looking at the image through a transparent window. The flat picture plane is "dissolved" by the illusion of depth and perspective in the painting. In an artwork lacking in spatial depth, such as an abstract work by the Dutch painter Mondrian, the painted surface of the canvas and the content of the painting are one and the same. The flatness of the picture plane is reaffirmed by the abstract elements' lack of depth.

Compositional Organization

A number of reliable compositional formats have been in use for thousands of years. The ancient Egyptians favored rectilinear formats. The ancient Greeks took their compositional cues from the classical concepts of balance, order, harmony, and restraint. Seventeenth-century Dutch and Flemish painters favored curvilinear arrangements that emphasized energy and strength. Being aware of the basic types provides a good platform from which to explore compositional arrangements. Development of a personal sense of composition comes from both knowledge and experimentation.

Common Compositional Problems

The most common compositional difficulties are these:

- An image or idea drawn without consideration of the compositional frame or its position on the page, thus creating a sense that the image is "floating" randomly on the page. This can greatly weaken an image.

- Confusion regarding the relation between the subject matter and the shape and proportions of the compositional frame, creating lack of clarity as to which shapes or forms are more important and which are less so.

- The size or scale of the elements (that is, of forms and shapes) within the compositional frame, and whether the elements are running off or extending outside of the compositional frame or staying within it. If the extension of forms or shapes outside the compositional frame is accidental and not intended, this must be considered a compositional error and a redesign is recommended.

- Lopsided, unstable images placed too far to one side of the composition, thus creating a sense of visual imbalance in the composition. In this error, balancing elements are not present and must be created. Asymmetry is a choice of balances. Lopsided imbalanced images are considered to be in error.

- Too much empty space around the primary subject, creating a lack of focus, thus diminishing the importance of the subject. The more space around an object the less important it is. For example, an image of a room that focuses the compositional frame closely around a table and chair creates a sense of the table and chair being the subject.

The more space added around the table and chair, the more the room itself becomes the subject. Additional balance and compositional choices must be considered for the good of the whole image.

- Lack of clarity in the composition regarding what the subject or focus of the image is through lack of considered focus of the elements of size, shape relationships, lines of movement, light, shade, and so on. This approach can create a scattered, unbalanced, and confusing composition.

- Lines of movement that direct the viewer's eye out of the composition and weaken the focus of the primary theme, thus drawing the viewer away from the subject. This can weaken the strength and importance of the subject, especially in a narrative image.

- Too much light tone or color at the periphery of a composition, directing the viewer's eye out of the composition and weakening the focus of the image.

- Inconsistent use of marks, line weight, tonality, and textures that confuses spatial relationships, perspective, focus, and object solidity in a composition.

Solving these problems requires planning and consideration of the compositional frame, the subject, the arrangement and sizes of the shapes, movements within the composition, perspective and depth, and the kinds of marks and drawing techniques to be used. Taking the time to inventory the essential elements to be used in a drawing is extremely important, and doing thumbnail sketches of various compositional alternatives can help you avoid most of these difficulties.

This image presents an even balance between the two figures. In many ways, they are mirror images of each other.

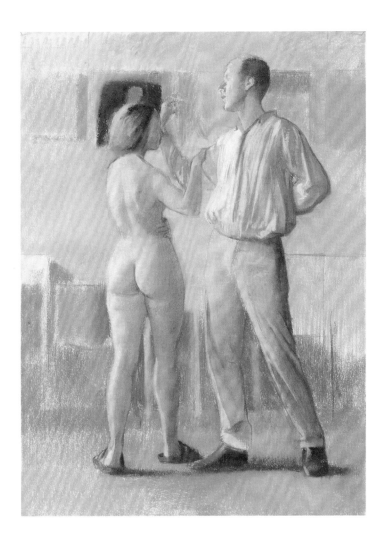

Symmetrical Compositions

Most compositions utilize symmetry, asymmetry, or a combination of the two for their basic organization. Let's look at symmetry first.

In a symmetrical composition, the primary object is placed in the center of the rectangle or compositional frame. Its details and contours may not necessarily be even, but its position and focus are central. Other objects may accompany the central object, but their positions must be more or less evenly balanced on either side of the central object.

Symmetrical compositions convey a sense of stability, focus, and order. For example, in Raphael's painting *Alba Madonna*, the Madonna and Child occupy the central position in the composition, although there are a variety of shapes and movements within the composition. To create even more stability, the objects are grouped in a pyramidal shape, the most stable of

all shapes. Symmetrical compositions also featured in the works of modern Italian painter Giorgio Morandi (1890–1964). In his still-life paintings, the sizes and shapes of the objects vary, but they are always grouped together in the center, providing a central visual focus. The environment around them, though it varies somewhat, is also evenly balanced relative to the objects.

When symmetry is taken to the extreme—with both sides of a composition mirroring each other, it is called mathematical symmetry. An architectural example of mathematical symmetry is the façade of the ancient Greek temple the Parthenon. If the Parthenon's façade were divided evenly by a central vertical line, each side would perfectly mirror the other.

Symmetrical compositions can be elegant, stable, and peaceful, but there is the danger that they can seem static and dull unless enriched by the other formal and informal drawing elements. To enliven the symmetrical image, you may add other elements to the image such as color choices, textures, line tone variety, and so on.

Asymmetrical Compositions

Asymmetrical compositions are arranged within the compositional frame as a series of balances that offset one another, usually with a major form or shape to one side of the arrangement and a variety of small forms or shapes, in a variety of sizes, balancing it. Multiple balances, or offsets, can occur in an asymmetrical image, but the whole conveys a sense of balance and integration.

For example, in the Degas painting *Women Ironing*, the figures of the women, mainly in the upper left portion of the image, are balanced by the large diagonal shape of the ironing board. The equivalent visual weight of each of these elements creates a sense of balance in the whole painting. Weight is a term describing the visual importance of a shape or form in a composition. A large shape or form may have the greatest visual weight, balanced by shapes or forms of lighter visual weights. If the visual weight is out of balance, the whole arrangement may be visually awkward.

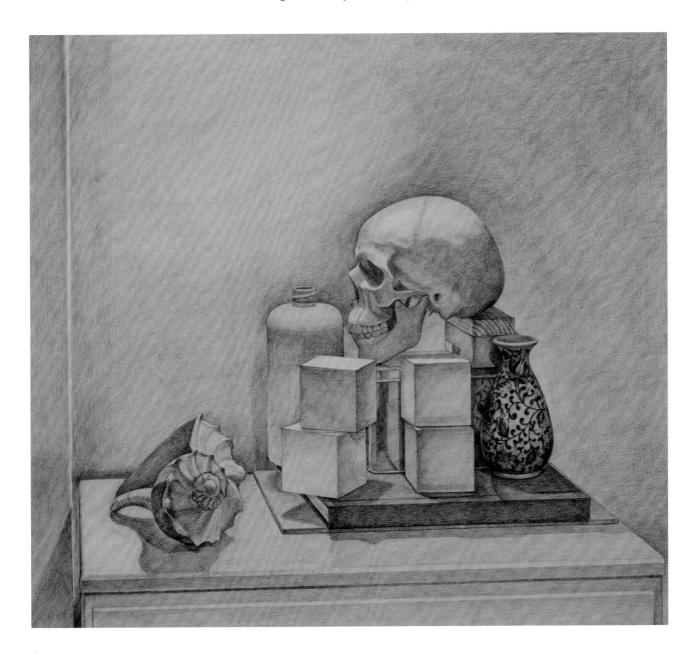

CLOCKWISE Asymmetrical, symmetrical, diagonal, and pyramidal compositions.

Other Compositional Arrangements

Besides those just described, a number of other common compositional formats have recurred historically. These have entered the language of compositional choice by virtue of their reliability and their ability to express the aesthetics of the periods when they appeared and the artists who devised them. For example, the pyramid-in-a-circle composition of Raphael's *Alba Madonna* reflected the goals and aesthetics of the early Renaissance: balance and stability. The curvilinear or "figure eight" format, often used by Rubens, creates movement in a composition but also reflects the energy of the Baroque era in Europe.

The following compositional types can incorporate both symmetry and asymmetry, and the different formats can be used individually or mixed together. The choice of which to use, alone or in combination, should be based on what you want to convey to the viewer. In the end, your own aesthetic sense is needed to create good compositions regardless of compositional devices.

PYRAMIDAL

Pyramidal compositions are characterized by large stable forms weighted at the bottom, typically appearing as triangles. A good example is Raphael's *Alba Madonna.*

Pyramidal compositions are the most stable and quiet of all, as opposed to curvilinear compositions, which are highly active.

CURVILINEAR

Curvilinear compositions are based on movement, lines flowing in S-curves or figure eights, creating a sense of fluid energy and grace. A good example is the *Deposition* by the Italian Mannerist painter Pontormo (1494–1557).

Curvilinear compositions provide a sense of fluid and graceful movement throughout the image.

DIAGONAL

Characterized by strong diagonal movements across the rectangle, diagonal compositions evoke feelings of anxiety and drama. A good example is Rubens's *Prometheus Bound.*

The diagonal composition on the left creates a sense of vertigo and movement.

HORIZONTAL

Characterized by horizontal movement across the picture plane, horizontal composition is employed in many landscapes. Good examples are those by the seventeenth-century Dutch landscape painter Philip de Koninck (1619–1688).

Horizontal lines create a visual sense of restfulness and expansiveness.

VERTICAL

Dominated by strong upward movement, vertical compositions feature in works such as the American painter Georgia O'Keeffe's *Radiator Building, Night, New York*.

Vertical lines of movement create a visual sense of height and narrowness.

ANGULAR

Characterized by interlocking angular lines of movement, angular compositions can have a stable, gridlike structure or can create a sense of nervous movement, as in *Nude Descending a Staircase* by the French-American artist Marcel Duchamp (1887–1968).

The use of diagonals and angles creates an interwoven design of strong balance within the compositional frame and on the picture plane.

CIRCULAR

Circular compositions are dominated by circular shapes, sometimes repeated. The French artist Robert Delaunay (1885–1941) used repeated circles to develop his energetic, colorist compositions.

Circular compositions create a visual sense of lightness and of slow, repeated movements.

CUBIC

Cubic compositions depend on organized, interlocking rectilinear geometry and shapes. A good example is the Dutch artist Piet Mondrian's painting *Broadway Boogie Woogie*.

Cubic compositions create a visual sense of locked and unwavering stability on the picture plane.

OVERALL

Characterized by an even distribution of all elements or marks, "overall" compositions can seem random or chaotic at first glance. Overall compositions can be figurative or abstract. The work of the American Abstract Expressionist painter Jackson Pollock (1912–1956) displays a broad overall distribution of marks or paint spatters without a particular focus within the compositional frame. (See the illustration on page 142.)

Although composed of individual movements and shapes, this type of composition must be taken in as a whole.

Brian Chippendale, page from the graphic novel *Puke Force* (Montreal: Drawn and Quarterly, 2016), 2014, pen and marker on white paper, 16 x 20 inches (40.64 x 50.8 cm). Courtesy of the artist.

With a style reminiscent of the "overall" compositions of the painter Jackson Pollack, Chippendale creates a busy and complex cinematic effect in *Puke Force*. A sense of anxiety results by no one image or area having visual precedence within the compositional frame. The viewer's eye is pulled back and forth, up and down, and across the arrangement.

When Is a Drawing Finished?

Knowing when a drawing is finished depends on the goals of the drawing, which you should decide on before beginning the work. Getting clear on your goals takes time and lots of practice, of course, but, basically, a drawing is finished when all the relationships within it have been harmoniously visualized. Make sure, for example, that the classic line quality throughout the drawing has been adjusted to produce a believable spatial effect and that the tonalities create a strong sense of form and depth. Finishing means gauging these and other elements relative to one another.

In an overworked drawing the line quality, shading, details, and so on seem out of balance within the whole. The drawing feels fractured. Beginners often give equal emphasis to all parts of a drawing, thus flattening and weakening it. It is essential to critique all the relationships and aesthetic effects in a drawing before deciding whether it is finished or needs adjustments and corrections. Never assume a drawing is really finished without this thorough critique.

Marina Fridman, *Untitled*, 2014,
charcoal and pastel on paper,
18 x 24 inches (45.72 x 60.96 cm).
Courtesy of the artist.

In terms of composition and value,
the window in the right center
focuses and organizes all the other
pictorial elements. Using a full value
scale range in an extremely open-
form approach, Fridman directs the
viewer slowly and quietly through this
highly balanced tonal composition.
The appearing/disappearing figure
of a woman adds mystery and is a
beautiful use of tonality.

Tonal Compositions

In tonal compositions, the viewer's eye is directed and focused by strong
tonal masses of light and shade. Typically, there is a major focus where the
eye enters the picture, often via a mass of light or a light shape. For example,
in Rembrandt's drawings and etchings, the viewer's eye first enters the
composition where light focuses on a major figure or group. From there,
the eye is led through the composition to secondary and tertiary masses
of light and to middle and dark tones. The whole is bound together and
balanced in the compositional frame by the dark areas of the composition.

TOP The basic design of the Golden Section: the long side of the rectangle is 1.618 times the length of the vertical side on the far left. The image includes a golden spiral.

BOTTOM LEFT The layout for the Golden Section.

BOTTOM RIGHT This golden rectangle shows the increments of the golden section and of pi.

The Golden Section

The Golden Section is a system of geometric measurement used to create pleasing and harmonious proportions in compositions. Descending from ancient Greek mathematical explorations of nature, the Golden Section has been used to create balanced designs in buildings, paintings, sculptures, and on book pages since it first captured the imagination of early Renaissance artists and designers. Also referred to as the Golden Ratio, Golden Proportion, Golden Mean, and the Divine Proportion, the Golden Section was thought by both ancient and Renaissance thinkers to contain divinely mandated proportions found throughout nature. The Golden section has been found to exist naturally in the proportions of some organic structures such as shells, plants, and even in human anatomy. Artists have also imposed the Golden Mean on their works, believing it will make the design of a piece more pleasing. Whether or not this is true, the Golden Mean is also simply another tool that you can use in the composition of drawings.

Simply place a rectangle, the longer side of which is 1.618 times the shorter side, over the piece in question. The diagrams above illustrate the basics of the visual design of the Golden Section.

The pot has an even and minimal amount of space around it, making it the focus or subject of the image.

Cropping the side of the pot creates a sense of visual flatness and strong asymmetry.

If the image of the pot fills the compositional frame, touching its sides, and even running out of the frame, the image will become a flat shape within the frame rather than a dimensional form. Depth is replaced by flatness and even a sense of abstraction.

The large amount of space around the pot creates a composition in which the space is as important as the object.

Cropping

Cropping determines the relation of the objects in a composition to the compositional frame. Cropping is common in two-dimensional artworks, and, in a general sense, all compositions are cropped. In a typical portrait, for example, the background and much of the sitter's body are cropped out to frame the sitter's face.

The key to successful cropping is to make sure it serves the artist's aesthetic and pictorial goals. There are a few important points to consider:

- If cropping will cut out part of an object, removing it from the pictorial frame, will this hurt or help the image?
- Will cropping through a major form or detail of an object make it appear truncated or cutoff?
- If an object's outer edge touches the compositional frame, creating flatness and lack of depth, is this desirable? It may be in an abstract work, but it could be very awkward in figurative work meant to look three-dimensional.
- When drawing a human figure, never crop through a major landmark such as a joint, which will make the limb seem cutoff or truncated. If you crop just above or below the joint, however, the viewer will sense that the limb continues beyond the frame of the image. Typically, figures are cropped in the following ways: to show the head and neck, the head and shoulders, or the torso to the waist and then to a full figure length.

Drawing from Photographs

If used properly, photographs can be excellent drawing aids, providing exact visual information and helping you plan a composition. But artists drawing from photographs must grapple with a number of potential problems.

A photograph is monocular—the camera produces an image seen with only one "eye," so to speak. That means that, however detailed its imagery, a photo conveys a sense of flatness. It cannot provide the perceptual sense of depth that binocular vision can. Not only do photographs not usually document the subtle recessions of space, edges, and atmosphere that we see in nature, but they capture only a moment of light. When you walk into a dark room from bright outdoor light, the room will seem almost black. Then, as light slowly filters into your eye, you see more luminosity, even in a dark room. But a camera, capturing just one brief moment of exposure, cannot usually reveal that luminosity. For this reason, many photographs show shadows as black and burned-out and light areas as whited-out and flat.

If you draw only what the photograph presents, you may be copying the very elements that will make your drawing seem flat—that, in effect, will make it look like a photograph. So taking time to become aware of what photographs can and cannot do is essential when using them as a references. To the information provided by the photograph, you need to add the effects and experiences you've learned from observational drawing, using all you know about creating depth, form, texture, light and shade, and so on.

Artists like Ingres, Eakins, Degas, and many others have used photographs as references. The key to their drawings' success is that they interpreted the photographic information through the lens of their experience of drawing from observation. You should do the same. For example, when drawing a figure from a photograph, you'll need to modify its contours and planes with additional line quality and variety. Otherwise, the figure's contours may appear flat and continuous, like a cutout. And because subtle anatomical modulations in the figure may not be clear in a photograph, you'll need to interpret the photograph using your knowledge of anatomy. Textural differences that might appear bland in a photo also need to be interpreted and enhanced.

Some recommendations when working from photographs:

If possible, photograph the subject with a variety of exposures to provide maximum light and shade information. Photoshop may be of great help in adjusting the reference photographs.

Evaluate the range of enhancements that must be added, such as line variations, textural diversity, and spatial descriptions.

Do thumbnail sketches before starting the finished drawing to get through all the difficulties of working from your reference photographs.

This photograph of a still life is a good starting point for a drawing. However, notice how the camera lens has created a subtle arc from side to side that distorts the actual alignment of the perspective and angles of the table and objects. The artist will have to visually organize the whole ensemble of the still life by adding and adjusting perspective, tonality, edge differences, atmospheric effects, and so on to produce a believable drawing.

ESSENTIAL AESTHETICS IN DRAWING

The term *aesthetics* has been used to refer to the study of beauty, perceptions of beauty, the study of perception, styles in art, underlying principles in art, and so on. In the modern world, though, *aesthetics* mostly refers to the study and discussion of the many elements of style and the underlying principles of art movements.

Arthur DeCosta found his aesthetic
compass in the works of the
sixteenth-century Italian masters
Titian and Paolo Veronese as well as
eighteenth-century British painters
such as Henry Raeburn and Thomas
Gainsborough. The results, seen in
this lyrical drawing, truly represent
DeCosta's aesthetic heart.

For example, abstraction possesses certain visual characteristics, such as the simplification of shapes in nature, and this quality can be thought of as one of the identifying aesthetic principles of abstraction. Further, a discussion of abstraction's aesthetics might include considerations of the various stylistic and procedural elements of abstraction. Discussions of hard versus soft edge, of geometric versus organic abstraction, and of the ways these effects are accomplished all help constitute aesthetics of abstraction. Rather than focusing on ideals of beauty, aesthetics now covers the body of visual characteristics, physical processes, and critical ideas that identify a particular artistic style or approach to art-making.

Aesthetic definitions and interpretations have long been at the core of artistic development in the West. The philosophical ideals of the Greek Classical period (fifth and fourth centuries BC)—balance, order, and harmony—wielded great influence over Western culture for centuries. Images of ideal beauty, as embodied, for example, in statues of the goddess Aphrodite, are common even today, especially in the advertising of beauty products. Classical Greek temples have perennially influenced architectural forms in Europe and America; their visual qualities of solidity, symmetry, and balance served as emblems of culture in the Renaissance and in the early American republic.

Very different from the Classical ideal is the aesthetic of Expressionism, which encourages the expression of personal feelings and ideas through materials and imagery. A dominant form of art-making in America and Europe from the 1920s on, Expressionism evolved in the 1950s into the Abstract Expressionist movement, which combined energetic expression with the abstraction of shapes from nature. In the modern world, where many aesthetic forms and styles exist side by side, this kind of synthesis is common—as are debates, sometimes ferocious, over the nature and merit of artistic styles.

Several major aesthetic/stylistic traditions are perennial guideposts for the art of drawing, forming the foundation for what we do today. Classicism, Realism, Abstraction, and Expressionism all provide guidance regarding formal and informal elements such as line, shape, form, content, symbol, narration, mood, and even political and social points of view. These four foundational forms—classicism, realism, abstractionism, and expressionism—are inclusive of many stylistic variations and personal and technical approaches but can be seen as important organizing trends and points of departure for artistic exploration. The four aesthetics interweave and inform one another regardless of the final look or style of a work:

Martha Mayer Erlebacher, *Torso X*, 1990, pencil on charcoal paper, 15½ x 20¾ inches (39.37 x 50.70 cm). Courtesy of the artist.

Balance, order, refinement, and harmony are hallmarks of Erlebacher's work.

There are expressive qualities in Roman fresco painting, abstract qualities in realistic drawings, classical elements in surrealistic drawings, realistic elements in Fauve drawings, and so forth.

Drawing materials and techniques allow artists to visualize their aesthetic approaches. For example, a sanguine pencil can be used to define the fine, fluid line quality of a classically drawn nude. Large lumps of charcoal may capture just the right feeling in an Abstract Expressionist drawing. Each aesthetic approach has its list of most commonly used materials, and it's important when studying drawings in books or museum exhibitions to take note of which materials were used to create the work's look and feel. Gaining a basic sense of these core aesthetic traditions and their associated mediums will help you make better choices when developing your practice of drawing.

Bruce Samuelson, *Untitled*, 2009, pastel and charcoal on ragboard, 22 x 21 inches (55.88 x 53.34 cm). Private collection.

As a contemporary painter who integrates modernism and tradition, Samuelson has chosen the Classical Greek statue the *Nike of Samothrace* as the subject of this mixed media drawing. The graceful S-curved movements and balances seen in the original sculpture are reinterpreted through the lens of abstracted and restructured shapes.

CLASSICISM

Classicism is characterized by visual balance, harmony, and grace. In classicism, nature is perfected, not copied. Classical art does not reflect the world of nature as it is but depicts it as it could be. For example, Classical Greek statues portray bodies that are ideal, and these perfected bodies reflect a perfect intellect and soul. Periodically reemerging, the Greek classical ideals have influenced Roman art, medieval icon painting, Renaissance art, nineteenth-century French academic art, and the art of other periods. Governments, revolutions, and individual artists have officially canonized the classical ideals as the hallmarks of their missions and goals, and Greek classicism remains a well from which contemporary artists draw inspiration and identity. Not only do classically oriented artists incorporate the elements of balance, grace, and harmony into their work but they may also choose subjects that ultimately derive from Classical Greek imagery.

Njideka Akunyili, *Sean*, 2005,
charcoal on white paper,
30 x 24 inches (76.2 x 60.96 cm).
Courtesy of the artist

Here is a moment in time lovingly
described through the observed
details of a body, the movement of
fabric, and the relationship of the
model to the unique space he is in.
Rhythmic movements of the body
are balanced in the composition by
the geometry of the architecture.

REALISM

Today, the term *realism* is a catchall for forms of art that look "real" or seem to
have been done from observation. Realism covers a wide variety of aesthetic
choices, ranging from very carefully rendered, closed-form images to loosely
described, atmospheric, open-form ones. The term *representational* is more or
less interchangeable with *realist*, and it, too, covers a huge diversity of styles
and aesthetics.

Linda Gist, *Cleome*, 2000s, watercolor on paper, 26 x 21 inches (66.04 x 53.34 cm). Courtesy of the artist.

Gist's lovely botanical drawing exhibits a realism that is almost—but not quite—photographic.

OPPOSITE Eleanor Arnett, *Abstraction—Gloucester*, 1960s, pastel on charcoal paper, 11 x 14 inches (27.94 x 35.56 cm). Collection of the author.

Arnett, who was a student of the German abstract painter Hans Hofman (1880–1966), took nature as a point of departure in exploring its underlying abstract shapes and forms. Here, she creates strong geometry and rich color while preserving the character of rocky outcrops in the Gloucester, Massachusetts, harbor.

Originally, realism was associated with work of the French painter Gustave Courbet, whose philosophy was that the artist's own experience should be the basis for art. Courbet explored contemporary political and social themes in his work during a time when the French art world was dominated by classicism and Romanticism. For Courbet, drawing and painting from observation were imperative, as was the direct and honest use of paint and other materials in art-making. Realist artists took nature as they found it rather than improving or perfecting it, and Courbet's subjects came from the world around him: friends, workers, and so on.

Photography was another powerful influence in the development of realism. Controversy over its appropriate use by artists began almost as soon as photography was invented in the 1820s by Nicéphore Niépce (1765–1833), and the debate about drawing and painting from photographs continues today.

A realist artist is one who has found a place and a language in the broad gamut of representational aesthetics. The key factor is that the artist is using representational imagery—a portrait, a figure, a landscape—as the artwork's primary organizing subject. An attitude of being true to nature is common in realist art, even though the individual artist may bring many personal elements to the artwork. Realist work today is often influenced, sometimes subtly, by elements derived from classicism, Expressionism, modernism, and, of course, photography, which led to the development of the hyperrealistic artistic style known as photo-realism.

ABSTRACTION

The term *abstraction* is also very general, involving the identification and simplification of essential underlying formal visual elements in nature, a scene, an object, or a visual idea. These elements can include shapes, lines of movement, patterns, colors, textures, and forms, among others. Abstraction is often associated with modernism, a movement in Western art that in the late nineteenth and early twentieth centuries turned away from classical academic and realist art. The idea of abstraction as an aesthetic movement, however, overlooks the fact that all art may incorporate formal, underlying abstract design or compositional elements. Abstract drawing in the modernist sense depends on a flat picture plane and the simplification of shapes, forms, and colors; the whole visual idea is embodied in these flat, often patterned elements. But realistic or representational drawings also depend on underlying

abstract concepts for structure, strength, and organization. Classical Greek sculptures, for example, have a very strong sense of abstract geometry in their forms. The difference is that, in representational art, the abstract elements are part of a larger set of visual ideas, such as the specific details of an object or scene and the depth and reality of the subject.

As an aesthetic form, abstraction can vary greatly. Some abstract works have no recognizable images; others simplify from nature. Because abstract artists identify what is essential in an image or visual idea, there is great room in abstraction for interpretation, invention, and recombination of many objective and expressive elements.

de Kooning

Willem de Kooning, *Seated Woman*, 1943, graphite on wove paper, 13¼ x 10¼ inches (33.7 x 26 cm). Philadelphia Museum of Art (Philadelphia, PA). Bequest of Elizabeth M. Petrie, 2003. Photo credit: © The Willem de Kooning Foundation/Artists Rights Society (ARS), New York.

De Kooning's portrait is representational insofar as it contains recognizable imagery, but it is also abstract in its simplification of observed forms.

Jan Baltzell, *#8-D1*, 2008, charcoal and pastel on blue paper, 32 x 40 inches (81.28 x 101.6 cm). Courtesy of the artist.

Baltzell abstracts, or simplifies, lines, marks, colors, and textures from nature. Her response to these abstracted elements is presented through a quick, nervously energetic and emotionally vigorous style. The combination integrates abstraction and expressionism.

RIGHT Charles E. Burchfield, *Orion in December*, 1959, watercolor and pencil on paper, 39⅞ x 32⅞ inches (101.2 x 83.4 cm). Smithsonian American Art Museum (Washington, D.C.). Photo credit: Smithsonian Art Museum/Art Resource, NY.

Works by American watercolorist Charles Burchfield, though based on nature, powerfully express a vision that is highly personal.

OPPOSITE Bruce Samuelson; *Torso*; 1990s; graphite, charcoal, and wash on white paper; 18 x 16 inches (45.72 x 40.64 cm). Collection of the author.

The emotional charge of this drawing makes it expressionistic, while the figure clearly incorporates classical elements.

EXPRESSIONISM

Expressionist art describes personal, individual, intuitive feelings. Some say Expressionism grew out the work of nineteenth-century Romantics such as Eugène Delacroix and was filtered through the physicality and semi-abstraction of the group of French painters called the Fauves in the first decade of the twentieth century. There are many forms and permutations of Expressionist art. It can be semi-realistic, like that of the German Expressionists who emerged between the end of World War I and the 1930s. The German/Danish painter Emil Nolde (1867–1956) used harsh, emotional descriptions to create powerful portraits. Surrealists like the German painter Max Ernst (1891–1976) incorporated strongly expressionistic elements into their work. But Expressionism can also be completely abstract, as in the work of the Abstract Expressionists of the 1950s and 1960s, including the American painter Jackson Pollock. Pollock was expressionistic in his choice of technique and materials (dripped and spattered paint) and in his energy.

Theoretically, Expressionism could incorporate elements of all the major aesthetics described prior. The common denominator is that there is a strong presence of physical or emotional expression in the work. Typically, Expressionist artists begin with the feelings they wish to express and then choose the right mediums and aesthetic forms for their work.

ESSENTIAL DRAWING DEMONSTRATIONS

The following demonstrations are considered essential to both foundational training in drawing and portfolio-making. All of the essential concepts, methods, materials, aesthetics, and history described in earlier sections of *Foundations of Drawing* bear fruit in this chapter.

John Lee, *Still Life Drawing*, 2012,
graphite on paper, 18 x 24 inches
(45.92 x 60.96 cm). Courtesy of
the artist.

Lee captures the overall relationships
and atmosphere in this quickly done
graphite drawing.

For example, perspective and measuring, foreshortening, size
relationships, point of view, line and tone, and so on, are all used in every
demonstration and must be understood and employed to complete drawings
of the subjects in this chapter. In a sense, "Essential Demonstrations" pulls
together all the elements of *Foundations of Drawing*. The strategies used in
learning to effectively draw the subjects in this section provide ways of thinking
and organizing any topic or subject. For example, learning to organize the
structures of a still life is very similar to the organizing processes of designing
a building. Understanding and organizing the complex and beautifully subtle
elements of a figure drawing or portrait is similar to the thought process of
designing a digital drawing. The elements, practices, and processes presented
here hone and develop the visual/mental processes used in a great variety
of artistic and practical pursuits.

RIGHT Nicholas Zimbro, *Still Life*, 2005, charcoal and graphite on paper, 4 x 2 feet (121.92 x 60.96 cm). Courtesy of the artist.

All relationships, sizes, shapes, and angles and perspective in this drawing were carefully detailed in a graphite underdrawing. Value and atmospheric effects are added and developed from near to far.

PAGE 160 Arthur DeCosta, *Figure studies*, c. 1970s, pen and black ink on cream paper, 8 x 6 inches (20.32 x 15.24 cm). Courtesy of the School Collection, Pennsylvania Academy of the Fine Arts (Philadelphia, PA).

DeCosta's vibrant sketches of the figures on this sketchbook page are a result of his repeated practice to master the anatomy and movement of the human body from memory, knowledge, and imagination.

DRAWING STILL LIFES

Still life is at the core of most drawing curricula. From still-life drawing we learn the basics of shape, form, measurement, perspective, line quality, and other drawing elements and we begin to experiment with drawing tools and materials. The lessons learned in still-life drawing inform all the other drawing genres.

Paolo Uccello,
Chalice, Perspective Drawing,
circa 1460, pen and ink on paper,
3^{27}/$_{50}$ x 9^{16}/$_{25}$ inches (9 x 24.5 cm).
Gabinetto dei Disegni e delle Stampe,
Uffizi Gallery (Florence). Photo
credit: Scala/Art Resource, NY.

Like many early Renaissance
artists, Paolo Uccello explored his
fascination with the underlying
structures and geometry of volumes
and spaces. In this elegant drawing,
he analyzes the direction changes
of curves in perspective and breaks
them down into planes or facets,
creating a stronger sense of
sculptural form in the object.

While still life was historically considered to be a less exalted subject than the figure, it was and remains where most students begin to learn to draw in a formal way. The first steps in a practical foundational drawing curriculum involve sketching the simple shapes of humble objects like tin cans and pieces of fruit. From these basic beginnings, students of drawing can be gradually introduced to more complex drawing problems, materials, and aesthetics.

A History of Still-Life Drawing

Pictures of objects and plants are among the most ancient in art. Depictions of flowers, fruit, ritual and everyday objects, weapons, and so on adorned ancient Cretan and Egyptian frescoes as well as the walls of Roman villas. The ancient Greeks and Romans loved to include small still lifes in their mosaics. Usually decorative, these still lifes ranged from the very detailed and realistic to the suggestive and expressive. Some of the most beautiful are in the frescoes found in the buried Roman cities of Pompeii and Herculaneum. They depict baskets of fruit, flowers, and other details of domestic life.

Still life had a strong presence in medieval European art. Depictions of liturgical objects, flowers symbolizing moral virtues and vices, and the object symbols, or "attributes," of saints were common. For example, a white lily was a symbol of purity, a red rose was a symbol of faith, and so on. Images of keys, vases of flowers, reliquaries, swords, fruit, and other objects composed a symbolic visual language that told Bible stories and stories of the lives of the saints. Some of the most beautiful medieval still lifes are seen in the decorative borders and the details of elaborate capital letters in illuminated manuscripts.

Artists of the Renaissance inherited these still-life traditions, but they also transformed still lifes into analyses of three-dimensional form. For example, the artist Paolo Uccello (1397–1475) created a drawing of an elegant chalice that ranks as one of the most magnificent perspective drawings of the age. Continuing the long tradition of imbuing still-life objects with symbolic content, Renaissance- and Baroque-era artists developed the genre of still life to a high degree. For these artists, still life was a thing of beauty in itself, but was also a vehicle for studying perspective, geometric structures, and even symbolism.

Flemish and Dutch artists of the seventeenth century excelled at still-life painting and drawing. Dutch homes prominently displayed elaborate still lifes of food and flowers—symbols of prosperity. Watercolors and

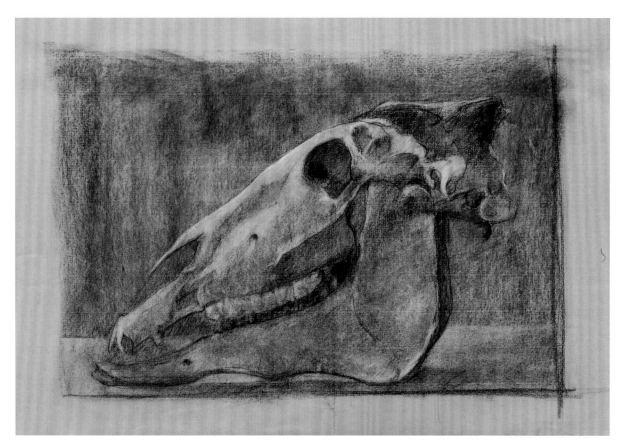

Anonymous, *Horse Skull* (student drawing), 2012, charcoal on gray laid charcoal paper, 18 x 24 inches (45.72 x 60.96 cm). School Collection, Pennsylvania Academy of the Fine Arts (Philadelphia, PA).

OPPOSITE Piet Mondrian, *Chrysanthemum*, 1908–09, charcoal on paper, 10 x 11¼ inches (25.4 x 28.7 cm). Solomon R. Guggenheim Museum (New York, NY).

Mondrian became known in art history after World War I as an abstract painter, the master of flat rectangles and squares in red, yellow, blue, black, and white. Part of his evolution prior to that was his love of drawing individual flower blossoms in pencil or watercolor.

hand-colored book illustrations depicting varieties of tulips and other garden flowers became popular collector's items. But alongside this tradition of extravagantly displaying wealth arose the genre called the *vanitas*. The Belgian-born painter Pieter Claesz (1597–1660) presented the underlying grimness of life and the inevitability of death in his many vanitas paintings, which showed magnificent bouquets of flowers being nibbled away by caterpillars or depicted human skulls carefully placed within the composition. The message was that nature and death triumph over extravagance and vanity.

The eighteenth-century painter of still lifes and interiors Jean-Baptiste-Siméon Chardin (1699–1779) made the intimate domestic still life popular. His work is unencumbered by the moralizing of the vanitas painters. Reminiscent of the work of Johannes Vermeer, Chardin's depictions of humble items like a loaf of bread and a pitcher of milk laid the groundwork for the everyday still lifes of the French Impressionists. Impressionist painters such as Édouard Manet (1832–1883) looked to these lovely, simple, familiar images for inspiration.

The modern era continued the love affair with still life, though often as a point of departure for studies in form, color, and pattern. The French painters Paul Cézanne (1839–1906) and Henri Matisse and the American Arthur Beecher Carles (1882–1952) used still life for their signature aesthetic explorations. In the hands of these artists, still-life compositions lent themselves to explorations of the formal elements of art, shape, color, geometry, line, expression, and abstraction. Today, still life remains a popular genre for artists of all kinds.

Georges Braque, *Still Life,* 1912,
charcoal, crayon, cut prepared
paper, and traces of graphite on
laid paper mounted on cardboard,
sheet (sight): 24½ x 18¼ inches
(62.2 x 46.4 cm) Philadelphia
Museum of Art (Philadelphia, PA).
The Louise and Walter Arensberg
Collection, 1950. Photo credit:
© Artists Rights Society (ARS),
New York/ADAGP, Paris.

Braque, like Picasso and others of
the Cubist movement, explored the
underlying purity of flat shapes and
patterns. The shapes in this lyrical
still-life drawing all exist right on
the picture plane.

Joan Becker, *Pencil Sharpener*, 2009,
gouache and charcoal on watercolor paper,
29 x 41½ inches (73.6 x 105.4 cm). Permission
of the artist and Gross McCleaf Gallery
(Philadelphia, PA).

Becker combines a love of still-life with a
deep interest in the flat patterns and the
shapes of objects.

Demonstration: Drawing a Still Life

Drawing a still life requires planning, development, and finishing. It's best to start with a group of simple objects or forms. Choosing objects that are too complex or that have too many textures and details can be frustrating for a beginner.

You must consider your goals for the drawing: Are you doing it for practice in understanding the structure of simple objects or for the purpose of visualizing a complex composition? Point of view, page position, size, materials, and so on should all be considered, but lighting is an especially important factor. If the drawing is more about closed-form line, ambient light or the flat light of fluorescent overhead lighting is acceptable. If your goals include emphasizing light and shade, however, you should establish a directional light source; you might set up a spotlight or use the directional light from a window. And finally, as with any drawing, you must decide on the drawing medium and the type of paper you wish to use.

After setting up the still life and lighting it appropriately, make thumbnail sketches, using a viewfinder if you wish, to become familiar with the subject and to help plan the composition. Then lay out the basic lines of the major shapes and angles. Adjust them through sighting and measuring until you've achieved a correct overall feel within the rectangle of the page.

At this point the whole map of the still life should be visualized, including the light and shadow masses, if they are to be an important part of the drawing. Check and correct everything to make sure the proportions, measures, page position, point of view, and lighting direction are correct.

More specific structures such as individual planes and the shapes of details can now be described. Remember, though, that your drawing is still very much in the layout phase and that your lines should still be lightly drawn and focused on structure.

Now the drawing can be finished to achieve the desired visual effect. Enhance the line quality, tonal relationships, spatial relationships, and depth and clarity. For a classic line drawing, adjust the line edges relative to one another following the visual rule sharper, darker, clearer comes forward and softer, grayer, less clear recedes. For a tonal drawing, adjust all the values, cast shadows, and reflected lights to produce an overall sense of light and depth in the drawing. Finishing brings together all the desired effects in a harmonious whole based on your aesthetic choices.

Before beginning to draw, choose a point of view. Here, the point of view is from slightly above the grouping.

Also, plan the amount of space around and between the objects.

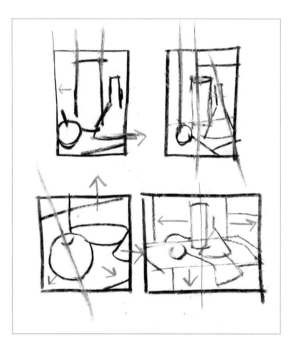

Making thumbnail sketches of different compositional choices can help you determine your drawing's layout.

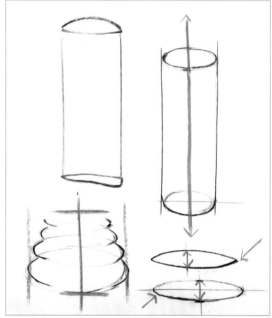

It can be very difficult to reproduce the symmetry of vases, cylinders, and other objects and to correctly draw and balance ellipses. You can map out the smooth curve of an ellipse by assessing how deep the curve is and marking its lowest point. Next, mark other points along the curve on either side of the first mark. Then, literally, connect the dots. Use a plumb line to check the balance and symmetry of objects and use a measuring tool to check their lengths and widths. Use points or dots to indicate the correct angles, parallels, symmetries, measurements, ellipses, and the correct placement of objects. A viewfinder aids in the positioning of the objects inside the compositional frame and in determining the amount of space around them.

Still-Life Drawing, Step by Step

1 | When beginning still-life drawing, it's better to choose a simple arrangement of simple objects.

2 | A viewfinder can help you determine the compositional frame.

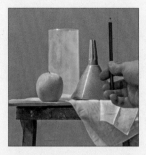

3 | Carefully measure the objects and their relative positions.

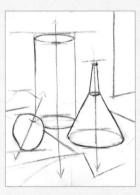

4 | Start the drawing by marking points for the placement of shapes.

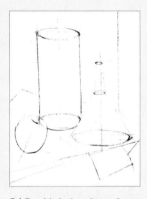

5 | Establish the objects' measurements and relationships on the page.

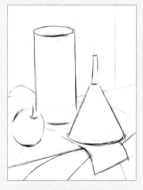

6 | Lay out the drawing and correct it using a light, loose broken line.

7 | Next, modulate the line quality.

8 | Map out the shadow masses.

9 | Then add and modulate the shading. Finally, add and correct the details and add the last line modulations.

Giovanni Galliari, *Egyptian Stage Design*, c. 1800, pen and brown ink with brown wash over graphite on laid paper, mount: 9¾ x 13¾ inches (24.7 x 35 cm), image: 7¾ x 9⅜ inches (19.7 x 23.8 cm). National Gallery of Art (Washington, D.C.). Joseph F. McCrindle Collection, 2009.70.124. Photo credit: Open Access, NGA Images.

Galliari uses aerial perspective to describe this fictional stage set. Tonality and scale create a sense of mass to the antique structures as well as a sense of visual recession in space. It was very common for artists of the eighteenth and nineteenth centuries to keep travel sketchbooks of antiquities for later use in studio-created artwork.

DRAWING INTERIORS AND ARCHITECTURE

Drawing interiors and architectural structures is excellent for foundational drawing study, practice, and portfolios. The lessons you'll learn while drawing interiors and architectural spaces will equip you with skills in measuring visual relationships, organizing illusions of both linear and aerial perspective, and designing compositions. The ability to draw interiors and architecture will also provide the artist with effective solutions for creating environments for figural or still life compositions in which the space the objects and forms occupy is important. Architectural and interior drawing skills address both open-form and closed-form drawing strategies and aesthetics by providing the artist with options and room for artistic and personal growth and choice. Finally, architectural and interior drawing has a number of practical applications in art and design professions such as architecture, interior design, and public space planning.

A History of Interior and Architectural Drawing

The tradition of drawing and painting interiors and architectural structures goes back to the ancient Greeks. Greek mosaics contained lovely trompe l'oeil ("fool the eye") architectural elements. The walls of Roman villas were decorated with both architecturally correct and fantasy interiors, buildings, and painted landscapes. Tromp l'oeil architectural details and interiors were especially popular—and beautifully done. Paintings excavated at Pompeii and Herculaneum give us insight into Roman painting and drawing methods.

From the fifteenth through the eighteenth centuries in Europe, interior and architectural drawing became highly developed. Italian Renaissance masters such as Leon Battista Alberti (1404–1472) and Filippo Brunelleschi (1377–1446) reinvigorated the study of architecture and brought it to new heights. The work of the ancient Roman author Vitruvius (c. 80–15 BC) and his thoughts on architecture inspired both men. Alberti is credited with a new understanding of the classical orders of architecture and the proportions required for a classical building. His work *De Pictura* is a treatise on the nature of Renaissance painting, perspective, composition, and color. Brunelleschi is credited with the development of the system of linear perspective that we use today. Drawing was the chief method for exploring perspective, whether for architectural plans, small paintings, or large frescos.

Using both linear and aerial perspective, the Dutch and Flemish painters of the seventeenth century brought the painting and drawing of the intimate household interior to a high art. The Dutch painters Johannes Vermeer (1632–1675) and Pieter de Hooch (c. 1629–1684) produced some of the finest examples. Both masters combined accuracy in architectural lines, measurements, and perspective with a rich sense of light and shade, illusions of atmosphere, color, and detail.

In the nineteenth century, the great academies of art maintained and taught the traditions of drawing and painting classical Greco-Roman architecture and interiors. An interest in Middle Eastern and Asian interiors complemented these classical subjects, and making sketchbook watercolor renderings of buildings and interiors became a favorite exercise of European artists traveling in Asia and the Middle East.

Informal interior scenes were among the most important subjects of the French Impressionists. Gustave Caillebotte (1848–1894) brought an almost photographic quality to his paintings of interiors; his painting *The Floor Scrapers* (1875) brings together the exact architectural perspective of a room with a poetic fall of light on the reflective floor. Interiors continued to be an important subject for the Postimpressionists and early modern artists.

François-Marius Granet, *A Cloister*, c. 1800, brown wash over graphite on wove paper, sheet: 5⅛ x 4³⁄₁₆ inches (13 x 10.7 cm). National Gallery of Art (Washington D.C.). Joseph F. McCrindle Collection, 2009.70.130. Photo credit: Open Access, NGA Images.

A masterful presentation of a complex architectural structure in aerial and one-point perspective, as well as fine use of brush and brown wash.

In his painting *Bedroom in Arles*, Vincent van Gogh (1853–1890) combines imagination, expression, and believability into a harmonious whole.

Artists such as Edgar Degas and the Danish painter Vilhelm Hammershøi (1864–1916) created believable and accurate descriptions of interiors as settings for intimate dramas, while the French painter Pierre Bonnard (1867–1947) focused on the feelings and moods of his interiors. The American Abstract Expressionist painter Richard Diebenkorn (1922–1993) created a series of monumental paintings and related drawings, prints, and other works called the Ocean Park series. These abstract and semi-abstract works recall the architectural forms of the small California town where Diebenkorn lived and worked for a short period of time. The Ocean Park series combines a geometric architectural formalism with expression of the location's light and color.

Rackstraw Downes, *Queensborough Bridge with Roosevelt Island Tramway*, 2007, pencil on paper, 26 x 26⅞ inches (66.04 x 68.26 cm). Courtesy of Betty Cunningham Gallery (New York, NY).

Downes captures the almost surreal complexity of the urban environment.

In recent decades, contemporary American artists such as Rackstraw Downes, Gillian Pederson-Kragg, John Moore, and Michael Grimaldi have carried on the great tradition of architectural and interior drawing and painting. Industrial parks, train yards, abandoned buildings, and cramped modern office spaces have joined ancient Roman ruins and seventeenth-century Dutch interiors as suitable subjects.

John Moore, *Tree and Ventilators*, 2009, charcoal on paper, 30¼ x 22½ inches (76.83 x 57.15 cm). Courtesy of Locks Gallery (Philadelphia, PA). Photo credit: Will Brown.

The buildings and industrial structures of the background are seen as a dreamlike image through the menacing intense darks of the tree. Aerial perspective and tonality are the organizing visual factors.

Reza Ghanad, *Dystopian Society/Graphic Novel*, 2014, watercolor, pen and brush over a graphite layout, 15 x 8 inches (38.1 x 20.32 cm). Courtesy of the artist.

Ghanad presents a complex futuristic world of architectural geometry in this beautiful drawing done in traditional pen and wash.

Compositional choices for interior drawings are similar to those for still lifes and other subjects: symmetry, asymmetry, and other possibilities.

Demonstration: Drawing an Interior

Begin drawing interiors by picking a simple subject such as a room in your home or another familiar space. A viewfinder is a good tool for helping you see possible compositional frames and align verticals and horizontals. The viewfinder will familiarize you with the lay of the land, so to speak, and increase your comfort level with the process.

Do loose thumbnail sketches of the subject using a variety of compositional choices. Graphite pencil is excellent for thumbnail sketches and can also be used for a larger finished drawing. Charcoal is not as good for small sketches but creates a powerful effect when used for a large tonal interior drawing.

An important decision is whether your drawing will be primarily a closed-form line drawing, an open-form tonal drawing, or a drawing with mixed effects. To be believable, closed-form line drawings require an accurate assessment of the scene's linear perspective. A broken-line drawing will give you a little more latitude in expression but will still require a close analysis of the linear perspective. Open-form tonal drawings allow for the most freedom of interpretation.

When you've chosen a view, lay out the major elements of the space with a few lines. The line weight of the marks, regardless of the medium, should be light to allow for adjustments and easy erasing.

You can now establish an anchor line, or baseline, which will be your main reference for measuring and centering. This should be a dominant line in the composition—the edge of a major wall, the angle of the floor, or the side of a window. (Alternatively, you can draw a simple grid over the picture plane's rectangle to use as a guide for measuring.)

To ensure the correctness of the drawing's basic underlying structure, measure the lengths, angles, and relationships of all the other architectural elements in relation to the baseline. Lay them out lightly with your drawing tool, working within the rectangle. You may discover at this point that the drawing has not been laid out properly—that nothing fits properly and that some elements even run outside the rectangle. If any elements or lines are incorrect, erase and move them to the correct positions or relationships. Making corrections is a lesson in itself.

Once the basic guidelines and measurements of the large architectural elements have been established, add smaller elements, shapes, and perspective lines. These might include angles of door frames, floorboards, window frames, and any furniture shapes. At this stage, you should carefully check the whole layout for accuracy and revise it if necessary.

Once the layout and all the relationships are correct, you can finish the drawing with varied line quality, tonal modulations, and any important details and textures. Finishing the drawing also involves making aesthetic choices: for example, you might dissolve the line layout with the addition of strong light and shade or finish the drawing as a closed-form line rendering. When finishing, remember the simple visual rule, sharper, darker, clearer comes forward; softer, grayer, less clear recedes.

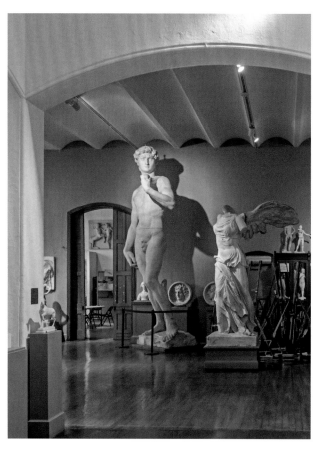

The drawing process begins with the selection of an appropriate space for the exercise. This example is based on a photograph of a section of the Cast Hall at the Pennsylvania Academy of the Fine Arts.

Al Gury, *Thumbnail sketches for a drawing of the cast hall*, 2016, black Micron pen on white paper, 7 x 6 inches (17.78 x 15.25 cm).

Preliminary thumbnail sketches will familiarize the artist with the space and its proportions.

Interior Drawing, Step by Step

1 | Begin the layout by placing basic measurement points and lines within the rectangle. A correct layout is critical to the success of the drawing. Central vertical and horizontal lines provide anchoring points for the whole rectangle.

2 | Now add the basic structural shapes and perspective lines, positioning them by measuring and sighting the angles of lines and edges.

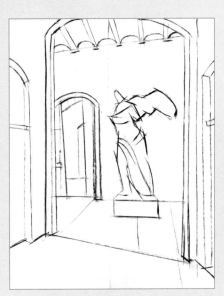

3 | The layout is now ready for the additions of tonalities, line modulation, aerial perspective, and details.

DRAWING PORTRAITS

Portraits and self-portraits provide another opportunity to investigate all the elements described previously: proportion, tonality, balance, shape, line. Portraits and self-portraits show the artist's attention to and analysis of structure and visual organization.

The real adventure in portrait and self-portrait drawing comes in learning how to get a likeness, express personality and feeling, and create characterizations that can tell a human story. Self-portraits in particular are a wonderful way to explore both the analytical and emotional aspects of the face. Self-portraits document the moods and daily reality of the artist as well as their evolution over time.

Formal and Informal Portraits—A History

Portraits are some of the most important documents of human life and history. In Western culture, two basic types of portraiture have developed: formal and informal. Portraiture from Greece's Classical period (fifth and fourth centuries bc) and from Rome's Republican era (509–27 BC) exemplify these two basic variants. The first—formal and based on Greek classicism—is intellectual and elevated, embodying ideals of beauty and perfection. The second—more personal, factual, and naturalistic—presents very particular likenesses and the personalities of the people depicted.

Formal portraits present people at their best. While such portraits may capture a fairly close likeness, the image is improved and dignified. Besides the classical portraits of the Greco-Roman era, examples of formal portraits in Western history include the elegantly elongated depictions of Byzantine emperors and saints, the refined likenesses of the leaders of Renaissance and Baroque society, and the rich and powerful of the nineteenth century. Formal portraits tell us very little about the inner life of the people depicted but a lot about their class, position in society, and so on. The artists who create them often "edit" the person's actual appearance so that he or she fits the expectations of fashion and convention—removing a mole, adding more hair, improving a complexion, or enlarging or trimming a bust are all common practices.

Formal portraits serve as documents for nations as well as families. For example, portraits of George Washington tell us about the strength and leadership abilities of America's first president but very little about his inner life or even what he really truly looked like.

Formal portraiture is alive and well today. The halls of hospitals, schools, and corporations are lined with formal portraits of founders and board members. Families commission formal portraits of living and deceased relatives in oil, watercolor, pastel, and charcoal. Formal portraits of children are very common. Society portrait painters are almost as acclaimed today as they were in the nineteenth century.

By the fifteenth century, in Italy, Holland, and France, artists' studios commonly produced formal portrait drawings and studies. A careful drawing of the portrait's subject was the first step; the drawing would then be used for developing the portrait in oils either by transferring the drawing to a panel or canvas or using it as a guide. Drawings done by Peter Paul Rubens were often handed over to his workshop assistants, who completed the portrait. By the eighteenth century, formal portrait drawings in pastel had become

fashionable. The French artist Maurice Quentin de la Tour (1704–1788) was one of thousands of artists working in the area of pastel portraiture.

In continental Europe and the United States in the nineteenth century, formal portraits and the drawings and preparatory studies they were based on were being bought by connoisseurs and collected by museums. (Today, most major museums hold collections of portrait drawings, which can be studied online or in person in drawing archives.)

Informal portraits present their subjects as they really seem to be. The pose is often relaxed and seemingly "unposed." Republican-era Roman portraits, usually done for funerary or family memorial purposes, tell us what the subjects really looked like and often a fair amount about their personalities. Romans of the Republican era respected this form of honesty. Some interesting examples of informal portraiture come from medieval Europe, including likenesses of builders and masons interwoven in decorative carvings on the façades of cathedrals. And naturalistic self-portraits of artists sometimes appear at the sides of otherwise formal Renaissance paintings. For instance, in *Adoration of the Magi*, by the Italian painter Sandro Botticelli (c. 1445–1510), the artist looks out critically at us from the painting's right-hand margin.

The seventeenth-century Dutch master Rembrandt did formal portraits of wealthy citizens but also more personal and informal portraits that appeal to modern eyes. Rembrandt's late self-portraits and many of his small portraits of Christ are marvels of the depiction of the human soul and the reality of the human individual.

Still, informal portraits were fairly rare before the nineteenth century, when they became a favorite subject of the French Impressionists and other artists. American Thomas Eakins, the painter of many great portraits, was criticized for the naturalism of his portrait subjects—they were too real and informal for Victorian taste. Mary Cassatt, the American painter who became an important associate of the French Impressionists, did many touching and personal portraits in pastel, oil, and printmaking mediums of her family and friends. Édouard Manet's great painting *Le Dejeuner sur L'Herbe* depicts a casual group of people—clothed men and nude women lounging in a park—whose faces are very specific and individual. In part because the people were all recognizable individuals in Paris, the painting caused a great scandal.

Informal, naturalistic portraiture has remained important. Good examples of informal portraits can be found in the work of the twentieth-century British painters Lucian Freud (1922–2011) and Euan Uglow (1932–2000), and Gwen John (1876–1939).

Scott Noel, *Portrait of Vivien*, 2008, pastel on paper,
44 x 30 inches (111.76 x 76.2 cm). Courtesy of the artist.

Noel explores both the casual nature of friends and models
in the studio as well as the formal aspects of shape and
composition through his pastel drawings.

Milton Avery, *Untitled (Seated Woman)*, 1930s, graphite on
off-white paper, 11⅛ x 8½ inches (27.9 x 21.6 cm). Philadelphia
Museum of Art (Philadelphia, PA). Gift of Harvey S. Shipley Miller in
memory of Mrs. H. Gates Lloyd, 1986. Photo credit: © Milton Avery
Trust/Artist Rights Society (ARS), New York.

Completely subjective response to the sitter characterizes this
Avery drawing. The correctness of size relationships and anatomy
are subordinated to a quick description of lines of movement and
poetic feeling.

LEFT Daniel Miller, *Ernst Barlach*, 2012, India ink on wood applied with sable brush), 20 x 11¼ inches (50.8 x 28.57 cm). Courtesy of the artist.

An extremely responsive and subjective use of pen and ink line and wash captures a heavy, slightly decayed and downtrodden feeling and character.

RIGHT Steven Assael, *Venus with Leopard Corset*, 2002, graphite on paper, 17½ x 11⅜ inches (44.45 x 27.94 cm). Courtesy of Forum Gallery (New York, NY).

Assael combines a precise, incisive and analytical use of fine line and carefully graded tonality to create this powerful, iconlike image.

Drawing Portraits from Photographs

For reasons of convenience and necessity, you may sometimes have to do a portrait from a photograph or several photo references. The important thing to remember is that a photograph presents a monocular view of the sitter and may not clearly show edges, spatial differences, and details, which you will have to add based on your experience drawing from life. Other elements, such as planes, tonal variations, and textures, may not be clear from the photograph, so your experience and knowledge of drawing processes and even of anatomy are truly important. Copying a photograph literally produces a portrait that looks like a photograph.

Nevertheless, successful portraits can be done wholly or in part from photographs. Here are some guidelines:

- Choose the best possible photo reference. This can be a formal portrait photograph or a casual photo that shows the person's facial structure and character clearly.

- Consider having some formal photographs showing the sitter in a variety of lighting environments and in different exposures before starting the drawing process. Although color photographs can give cues as to the subject's complexion, do an in-person color analysis if possible to identify values and nuances of color. If the sitter is not available or is deceased, you will have to create or interpret color based on the available information.

This sketch may just look like a group of caricatures, but likenesses are captured by this simple and direct process of simplification and characterization. Filling sketchbooks with small character sketches is a good way to learn how to get a basic likeness.

Capturing Likenesses

The best way to practice capturing likenesses is to do many, many small sketchbook drawings of people wherever you find them. Use a pencil, a ballpoint pen, or any other convenient drawing tool. The goal is to capture the basic qualities of each subject's head and features in as few lines as possible. Focus on the essential qualities of each head: its shape, its angles, the features, and the person's expression. Likenesses capture these essential qualities first, and details are not necessary.

When doing more studied drawings, you have the opportunity to add to the basic character drawing. For example, in a quick sketchbook drawing, you might draw a person's eyebrows as two quick lines tilted at different angles to capture the basic expression. In a more studied drawing, you can modify the eyebrows to show their real subtlety and complexity. You'll also have the chance to add tonality and varieties of line quality.

Finally, it's important for you to get into the habit of looking at other artists' portrait drawings. Monographs about artists usually include drawings, and museums frequently mount exhibitions of drawings by historical and contemporary artists.

Self-Portraits

Self-portraits are among the most important documents in the history of art. Whether the face of a medieval mason carved among the decorations of a cathedral door, an Italian Renaissance painter including himself in a scene of the Nativity, or a German Expressionist painter looking critically out at the world, self-portraits tell us about the individuals who have created art history. These works say, I was here and this is who I am. The self-portrait can be a regular or an occasional practice, depending on the artist's inclinations. Some artists, like the twentieth-century British painter Stanley Spencer (1891–1959) have done self-portraits frequently; Spencer's tell us of his advancing age and changing appearance.

Doing self-portraits is an excellent way for you to practice portrait drawing. An old joke is that your first attempt at a self-portrait will be a mess; your second will present you as a distraught and grim stranger; and your third will look like a close relative. But don't give up. With enough practice, patience, and wasted paper, you'll finally produce an accurate likeness. Here are some recommendations:

- Choose a mirror large enough for you to view your face, neck, and shoulders.
- Place your easel and drawing pad back far enough that you can view in one glance the whole image you want to draw.

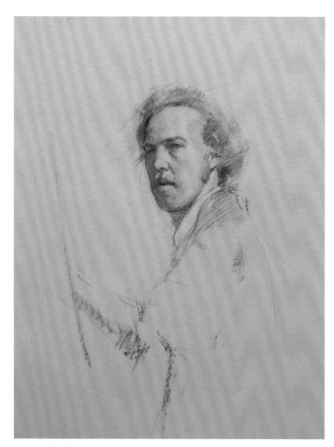

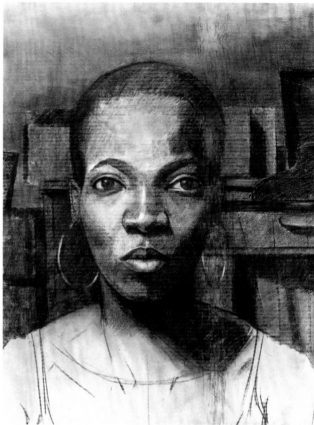

In the tradition of self-portraits from
the seventeenth through nineteenth
centuries, Van Dyke creates a quiet,
reflective, and formal three-quarter view
of himself. This very open-form image
combines line and tone effectively.

The artist looks out at the world in
a direct, uncompromising, and
honest manner. Self-portraits can
take many forms in addressing
the viewer: confrontational, angry,
reflective, shy, and so on.

- Set your easel and drawing pad at a slight diagonal to the mirror
 so that you can look as directly as possible back and forth from the
 paper to the mirror.
- If you use a window as a light source, set up the easel and mirror
 so that the fall of the light over the features suits your study. Make sure
 that enough light falls on your pad to enable you to work comfortably.
- If you use artificial light, you may need a spotlight to light your face
 at the angle chosen for the portrait. Again, make sure sufficient
 light falls on the drawing paper. Some people use one light source;
 others set up two. Overhead fluorescent light will produce an even,
 flattening effect, while a diagonal spotlight will create good contrast
 between light and shade.
- Keep your head still while drawing, allowing only your eyes to
 move. This is difficult at first, but it gets easier over time.

This photo shows the subject of the portrait drawn in the step-by-step that follows.

Demonstration: Drawing a Portrait

When doing a portrait, choose a person whose face interests you. Some people are easier to draw and others harder depending on the clarity or subtlety of their facial structure. Older people whose faces have more character can be easier to draw than younger ones, and drawing children presents special challenges.

As when drawing other subjects, it's helpful to do thumbnail and compositional studies first. The next step is to draw the most important facial shapes and angles—the tilt of the head, forehead, cheek projections, chin, and so on—on the paper broadly and quickly to establish the position of the head and the basic likeness. At this point, don't get involved in any details. Getting a good likeness depends on setting up the general relationships of angles, curves, and projections. These give you a map of the likeness.

Now you can map out light and shadow masses. Wait until the finishing stage before adding the details of values and reflected lights, however.

Then begin placing smaller structures and their angles, tilts, and shapes in relation to each other. The relationships are what matter when capturing a unique likeness. For example, the curves of the eyes, the movement of the line of the mouth, or the character and set of the ears create individuality.

At this point, check all the relationships. The basic likeness should now be evident. Make necessary corrections: an eyebrow may need to be tilted at a sharper angle or the nose may be a bit too long or the chin too short. Editing the drawing is crucial to getting a strong likeness. If all the structures seem solid, proceed to the delineation of particular small forms like the edges of the eyelid line or the planes of the nose.

When finishing the portrait, again check the overall structure for accuracy, and then shave, trim, and tweak small tilts, angles, shapes, and lines. You might find, for example, that the angle of one side of the mouth or the hairline is slightly off. Getting a perfect likeness depends on these minutiae and takes time, close observation, and patience.

The final step in finishing a portrait drawing involves adjusting line quality, textures, and shading. Add the darkest accents last. These may occur in the darks of the nostrils, pupils, along the eyelash lines, and so forth. These dark touches are all relative to the whole face and must be adjusted in their value and clarity accordingly. If you're working in pastel or on toned paper, also add the highlights last. For example, a sharp white highlight may describe the touch of light on an oily nose, while a softer highlight may sit on the forehead.

Portrait Drawing, Step by Step

1 | Lay out basic shapes and planes to secure a primary likeness.

2 | Add a second layer of relationships and correct to create a closer likeness.

3 | Now add details and small modulations to individual features—for example, the planes of the underside of the nose or the arc of one eyelid relative to that of the other.

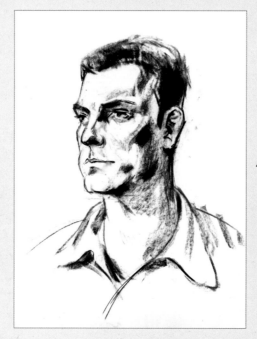

4 | Complete the drawing by adding shading and distinguishing differences in edges and textures. Projecting forms like the nose have clearer, sharper edges and line modulation. Softer areas, such as the underside of the jaw, have blurred and less clear edges. These modulations complete the form and keep the drawing from being flat or stiff.

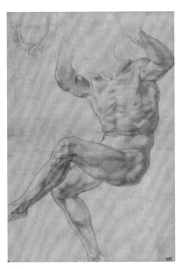

Michelangelo Buonarroti, *Study for the Nude Youth over the Prophet Daniel*, 1510–11, red chalk over black chalk on paper, 13½ x 9½ inches (34.3 x 24.3 cm). The Cleveland Museum of Art (Cleveland, OH). Gift in memory of Henry G. Dalton by his nephews George S. Kendrick and Harry D. Kendrick, 1940.465.

Rooted in classicism but energized by the experience of the soul, Michelangelo's figures exhibit dynamic energy and poetry.

DRAWING THE HUMAN FIGURE

The human body, especially the nude figure, has been a central, unifying image in Western art for thousands of years. The history of the human figure in European and American art exhibits a wide range of approaches, from classical ideals to symbolic iconography to raw physical realism.

Throughout this long history, two major approaches have dominated: Greek classicism and observational reality. The classicist tradition focuses on ideals of beauty and form and modifies the human body to reflect those standards. Observational reality takes the body as it is with all its imperfections and uses the unperfected human image to tell the story of human experience.

The traditions may intertwine, informing each other. Classical canons and structures can be used to give structure and order to a drawing of an otherwise very ordinary human body, while observation of natural human bodies can imbue a classical drawing with greater believability. Education in the two traditions provides a strong, flexible foundation for study and studio practice of figure drawing.

A History of Figure Drawing

Greek classicism, developing in the fifth and fourth centuries BC, presented the nude figure as a pure and balanced personification of ideal beauty. Famous Greek statues like the Venus de Milo and the Apollo Belvedere continue to represent the best of the Classical Greek ideals of beauty. Where, though, did these ideals come from?

For the Greeks, this code of perfection represented the beauty and power of the gods as well as the ideals of an intelligent and well-balanced citizen. Physical beauty and perfection represented goodness, intelligence, and power, which is why the anatomy of figures in Classical Greek sculptures and paintings exhibit idealized descriptions of all forms, from faces to genitalia. Evidence of human imperfection is removed and replaced by beautiful forms appealing and acceptable to both gods and men.

The Classical Greek canons of beauty and proportion have been perennial norms and reference points for artists over the past twenty-five hundred years. These standards are based on geometric structures that the ancient Greeks felt created a sense of perfect organization and rhythm in the body. Regularizing the geometric concepts into strict rules allowed the ancient Greeks to create decidedly clear and strong images of ideal form, and the canons fostered an approach to figure construction based on precise sets of repeated shapes, forms, balances, lines of movement, and physical

types. Following the classical canons produces highly abstracted, perfected
versions of actual human anatomy—for example, the classic Greek aquiline
nose, standard in classical portraits.

Contrapposto, the counterbalance of forms in the body, is likewise
a hallmark of Greek classicism, creating a dynamic set of rhythms and
balances throughout the idealized figure. The late Greek, or Hellenistic,
period of the third through first centuries BC combined classical structures
with the dynamic energy of heightened contrapposto and emotion. The
famous statue *Laocoön and His Sons*, in the Vatican's collection, is a fine
example of later Greek interpretations of the classical ideal.

While aesthetic fashions ebbed and flowed, the classical ideal was the
driving force in the depiction of the human figure for many centuries. The
Romans used it to create idealized depictions of the emperors. Medieval artists
incorporated classical forms into otherwise flat icons of saints. And then the
Italian Renaissance engaged in a broad revitalization of Classical Greek ideals
in everything from art and architecture to literature and education.

Vitruvian Man

Leonardo da Vinci's drawing *Vitruvian Man* depicts an ideal canon of human proportions based on the classical ideals described by the ancient Roman architect Vitruvius. In book three of his treatise *De Architectura*, Vitruvius correlated ideal human proportions with geometry, describing the figure as the principal source of proportion for the Classical orders of architecture. Vitruvius determined that the ideal body should be eight heads high.

Others during the Renaissance interpreted and experimented with the Vitruvian ideals. For instance, Jacopo da Pontormo elongated classical forms to emphasize the poetry and spirituality of his figures. At the beginning of his career, the master sculptor and painter Michelangelo hewed closely to the classical traditions, but his late sculptures exhibit an elongation and naturalism that speak of his spiritual and poetic concerns.

Vitruvian proportions can be summarized as follows:

- The length of the outspread arms is equal to a man's height.
- The distance from just below the chin to the top of the head is one-eighth of the height.
- The distance from the hairline to the bottom of the chin is one-tenth of the height.
- The distance from just above the chest to the top of the head is one-sixth of the height.
- The distance from just above the chest to the hairline is one-seventh of the height.
- The maximum width of the shoulders is a quarter of the height.
- The distance from the breasts to the top of the head is a quarter of the height.
- The distance from the elbow to the tip of the hand is a quarter of the height.
- The distance from the elbow to the armpit is one-eighth of the height.
- The length of the hand is one-tenth of the height.
- The root of the penis is at half the height.
- The length of the foot is one-seventh of the height.
- The distance from below the foot to below the knee is a quarter of the height.
- The distance from below the knee to the root of the penis is a quarter of the height.
- The distances from below the chin to the base of the nose, from the base of the nose to the eyebrows, and from the eyebrows to the hairline divides the skull into thirds.

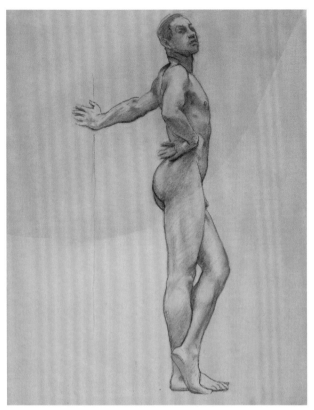

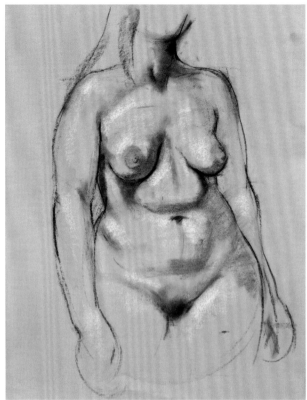

LEFT John Singer Sargent, *Nude Male Standing (Thomas E. McKeller)*, c. 1917–20, charcoal on off-white laid paper, 24¾ x 19¹⁄₁₆ inches (62.9 x 48.4 cm). Philadelphia Museum of Art. (Philadelphia, PA). Gift of Miss Emily Sargent and Mrs. Francis Ormond, 1929.

Sargent did many studies of the nude figure in charcoal as both practice and as preparatory studies for his paintings. Here, strong contrapposto and an S-curving gesture line are enhanced by lightly roughed-in values and exterior contour lines.

RIGHT Al Gury, *Female Figure*, 2014, charcoal and white chalk on tan laid paper, 24 x 18 inches (60.96 x 45.72 cm).

The rounded masses and fluid touch of values and broken contour line accents are unified by the toned brown paper and an underlying geometry of blocks and axial tilts.

By the end of the nineteenth century, art-school drawings of life models had begun to look less like Classical Greek statues and more like nude portraits of individual people. Observational reality had become a strong factor. The Romantic, Impressionist, and Realist movements, together with a conceptual change placing greater value on the individual, all contributed to this greater naturalism in art, especially drawing. Depicting the raw reality of the human body and the unique qualities of each person became a goal for many artists, and the body types artists were now choosing to portray corresponded more to their personal preferences and individual aesthetics than to the dictates of the art academies.

By the end of World War I, interpretations of the human image were as diverse as the artists themselves. The observed figure, filtered through the imagination and taste of the individual artist, began to dominate figurative art. For example, the Austrian artist Egon Schiele (1890–1918) developed an extremely honest and emotional style of describing the human body. His fascination with the body's angularity, imperfections, and sexuality made him a role model for artists pursuing expressive drawing of the figure.

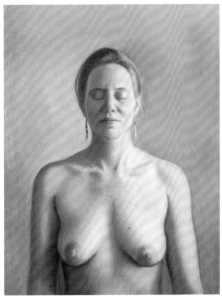

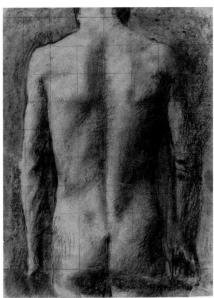

Later, the British painter Lucien Freud focused on the individual characteristics of each of his diverse and quirky models. Modern depictions of the figure share the characteristics of being very personal, individual, natural, even awkward, presenting the body as it is rather than as it "should" be. In the contemporary art world, all the major aesthetic approaches to drawing the figure are in use. Classicism, realism, expressionism, abstraction, and a host of permutations of these styles inform the education and artistic choices of modern artists.

The remainder of this chapter presents a practical guide to the construction of a basic, sound life drawing. My point of view is that combining knowledge of structure gained from observation with learned concepts provides a strong basis for artistic growth and security in drawing the figure. Anatomical structure as well as the essential elements of gesture, balance, proportion, shapes and forms, contrapposto, and foreshortening are explained.

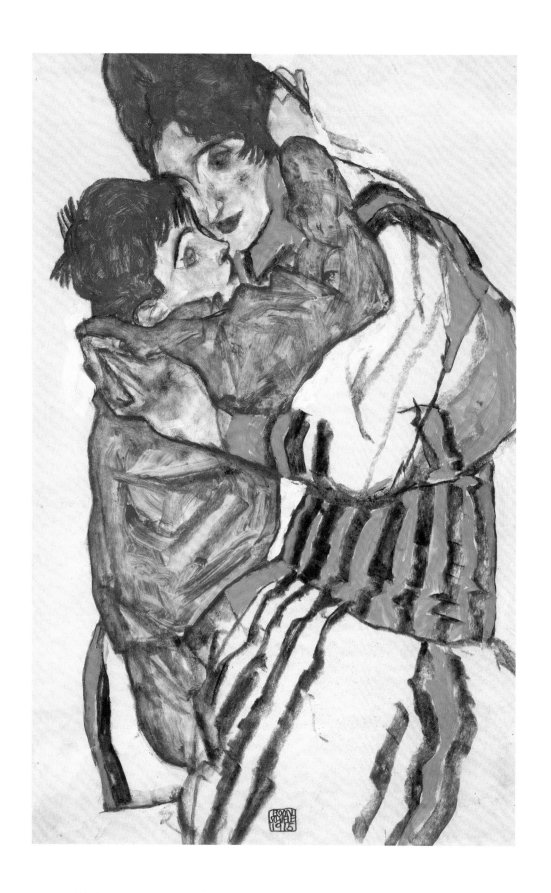

Gesture

Gesture describes the movements and rhythms of the body. It can describe the whole set of rhythms through the body from top to bottom or the small, individual movements of a body part. Gesture drawings are usually thought of as quick studies done as a model moves through a series of poses, but any good figure drawing possesses a clear, strong sense of gesture to create believability, energy, and anatomical correctness.

The most common actions of the human body follow an S curve, as do the shapes of individual bones and muscles in both human bodies and those of other mammals—a design that facilitates smooth and economical movement. Describing these S movements in drawings conveys the energy of the body in dynamic and subtle ways. Lack of gesture can make the image seem stiff and unnatural.

There are two basic senses of gesture that are useful in a life drawing. The first—the simplest but in many ways the more important—describes the whole sweep and movement of the model's pose. Description of this large gestural quality can be done very broadly, expressively, and using a great variety of drawing tools and stylistic approaches. The assessment of the character of the gesture is essential to laying out the figure, whether for a quick gesture sketch, or croquis, or for what will become a highly finished and developed drawing.

The second sense of gesture relates to individual lines of movement in the body. A pose has a large, overall gesture, but the body is also a series of interconnecting visual rhythms. This type of gesture describes smaller relationships within the body—for example, a line of tilt between the shoulders or the line of the muscles' movement from one end of an arm to the other. This smaller gesture is a curved line moving from point to point along the muscles, bones, or body contours.

An axial tilt is a line between two points on a body. For example, in a seated pose, an axial tilt line can describe the relative positions of the knees. Curving gesture lines and axial tilt lines describe every relationship, from the largest to the smallest, throughout the body. The importance of these smaller gesture lines can be underestimated, resulting in a stiff or awkward drawing that inaccurately describes the relationships between points on the body.

Gestural and axial tilt lines are important when laying out a more highly developed drawing. Typically, these lines of movement and relationship are placed very lightly with the drawing tool to guide the later layers of development.

Broad sweep of gesture from top to bottom.

Lines of movement.

Gesture drawings in charcoal.

Lines and blocks of movement.

Weight in the body is aligned evenly through a centerline of balance.

Throw the balance off and the body compensates with balancing movements.

Balance

Balance refers to the distribution of weight in the figure. Visually, a sense of distributed balance is observed in the way the large masses of the figure change direction relative to one another and the way those relationships are aligned within the whole. For example, when a person stands straight and upright, the viewer sees the head, torso, legs, and feet all generally aligned one above the other. When the person shifts weight, the body must compensate by redistributing the masses and angles of the body forms to keep from losing balance and falling over.

In drawing, balance is described by gauging the alignment of shapes and lines of movement in the body and laying them out accordingly. You can accomplish this most easily by using a tool like a pencil, rod, or plumb line, dropping it from a central point on the head to the bottom of the feet and looking at the relative distribution of forms along this line. Observe how far the model's contours project to the left and right of the line, and lay out the drawing of the figure to reflect this distribution. Sometimes, multiple lines must be dropped across the figure and checked from side to side to get everything correct. This process can be used for standing, seated, reclining, and foreshortened poses.

If the figure is not balanced properly, it may look like it is going to fall over. This can be corrected in the layout stage by rechecking the lines of balance and the relative position of the body parts and then making necessary adjustments.

Proportion

Proportion refers to relations of size between and within the parts of the figure. In adult humans, proportions are relatively consistent, although there are variations from individual to individual. Throughout the history of Western art, the proportions of the figure have been a focus of debates over beauty, expression, and content in art.

The Classical Greeks devised a system of ideal proportions that accounted for normal anatomy while maximizing elegance and beauty. These proportion rules were utilized consistently in Greek sculpture and painting, embodying the Classical desire to elevate human beings above our animal nature through ideal characteristics of fitness and beauty. For example, human adults tend to range from as little as six up to seven and a half heads in height; bodies that are eight heads tall are very rare. But a slightly smaller head size in relation to body length can create a sense of elegance and grace in the figure. The Classical system of proportion therefore may describe an eight head figure.

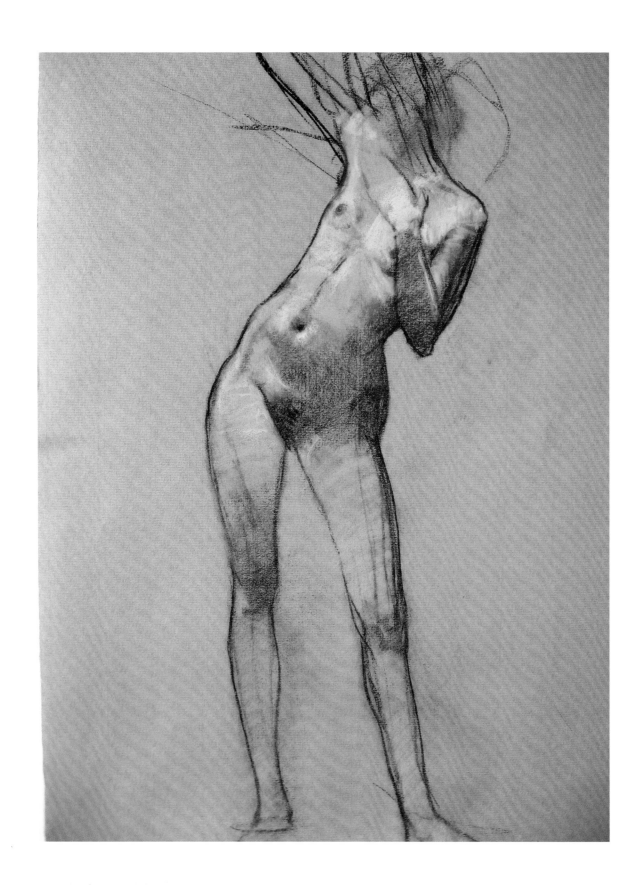

LEFT The visual position of the halfway mark will vary from person to person and according to the nature of the pelvic tilt. A highly tilted pelvis might have a visual halfway mark at the top of the pubic line, while a forward tilting pelvis might have the mark at the bottom of the pubic triangle.

RIGHT Generally, the body can be divided into upper and lower halves through the pubic area.

OPPOSITE Martin Campos, *Nude Figure*, 2014, pastel and charcoal on charcoal paper, 24 x 18 inches (60.96 x 45.72 cm). Courtesy of the artist.

Balance of masses and lines of movement around a perfectly placed plumb line integrate this eerily beautiful figure drawing.

Preferred proportions changed over time as aesthetic requirements and artistic styles changed. While the Classical Greeks utilized relatively natural proportions, Byzantine and medieval European artists often elongated their figures to create a spiritual, otherworldly feeling.

Practical means for understanding proportion in drawing are readily available and easy to learn. Measuring the length of the head and comparing it to the whole length of the body is the starting point. The second important measuring strategy is to compare upper and lower halves of the body. On the front of the figure, the visual halfway point is at the pubic structure. On the side, the halfway point is at the greater trochanter of the femur. The visual halfway point on the back of the figure is the more difficult to visualize because of the variable and fleshy nature of the gluteal structure, but generally the halfway point occurs somewhere from just below the point of the coccyx to halfway down the gluteal furrow.

When working from observation, it is very important to be aware that sizes and positions of body forms vary from person to person. The halfway landmark on one person may be across the top of the pubic triangle, while on another it may be just below it due to the tilt of the pelvis or a variation in the length of the torso. Slight variations from the normative proportions of the head, limbs, hands, and feet and the head also occur. For example, while the hand usually extends to mid-thigh in standing position, the way people stand or carry their shoulders can alter this. So can a person's bone structure; low-set shoulder blades, for example, may cause the hands to extend farther down the body. So while you should be aware of the common standard proportions found in anatomy texts, you should always compare them to the actual person you are drawing.

Drawing Animals

Drawings of animals are among the oldest images in art history. As far back as forty thousand years ago, early humans decorated caves in Europe with drawings of animals. Ancient Egyptian, Greek, and Roman art is filled with exquisite images of all kinds of animals, some serving religious purposes (e.g., as personifications of gods) and some merely decorative. In medieval European book illuminations, drawings of animals commonly appear as decorative elements and as symbols of religious figures and virtues and vices. For example, the lamb is a symbol of Christ; the lizard is a symbol of both wisdom and sin.

From the Renaissance to the present, artists have continued to use animals as subjects. Comparative anatomy—looking at the similarities and differences between animal and human bodies—was an important topic of study in the Renaissance. Great artists from Rembrandt to Delacroix to Picasso were serious students of animal drawing and often used animals as elements in their art. And artists as diverse as the French painter Rosa Bonheur (1822–1899) and the French-born American illustrator John James Audubon (1785–1851) have made animals the primary subject of their art. Today, animals remain a powerful focus in art, particularly in light of concern for the preservation of animal species.

There are several simple and direct ways to make animal drawing accessible and enjoyable. Use a sketchbook to document animals' gestures and forms, starting with your own pets and moving on to the animals at your local zoo. Try using a variety of mediums to explore both the facts of animal anatomy and the expressive nature of their gestures. Copying animal drawings from art books and drawing from animal sculptures, paintings, and illustrations are good ways to develop your skill in animal drawing. The images reproduced here were done by contemporary students in the Pennsylvania Academy of the Fine Arts' animal drawing class, which was begun by Thomas Eakins in the 1880s and thrives in the school's curriculum today.

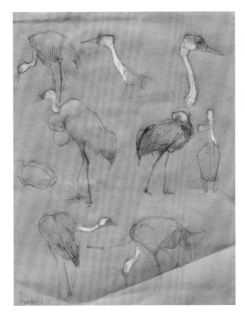
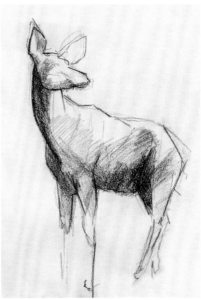

Structural Shapes and Forms

Structural shapes are the contours of the individual body parts and their geometry. These shapes can generally be described as rectangles, ovals, triangles, and other simple shapes. For example, putting aside individual variability, the general shape of an upper arm from shoulder to elbow or a thigh from hip to knee is a tapered rectangle. Regardless of the size or muscular development of the part, the core structure is still very much the same—wide at the top and narrowing at the bottom. The secondary details— amount and definition of muscle, fat deposits, and so on—are what vary.

Understanding and practicing these shapes allow you to correctly visualize the figure's basic anatomical structures. Classical canons of figure drawing and anatomy define relatively consistent shape descriptions; observational approaches account for the many interesting variations. An accurate rendition is a synthesis of the two because there is both consistency and variation.

Structural forms are the three-dimensional masses and volumes of the structural shapes. Artists visualize these volumes using a variety of simple three-dimensional forms: cubes, eggs, cylinders, and so on. The small wooden mannequins for sale in art supply stores can help you with this kind of visualization. In his compositional sketches, the sixteenth-century Italian artist Luca Cambiaso (1527–1585) blocked out the figures as if they were small mannequins. These sketches provided him with a simple, clear visualization of the figures' anatomical forms moving in space. He would then redraw the figures with actual fleshy anatomy before moving on to the painting.

A figure drawing in which structure is the focus begins with the lines of movement from top to bottom and side to side.

Lines suggest the large central forms of head, rib cage, and pelvis.

Identifying high and low points and contrapposto between forms is critical to avoiding stiffness in the drawing.

Here, structural shapes and foreshortening are combined to create believable anatomy in the arm and hand.

Lines of movement created by the bones are balanced by the high and low points of the muscles.

These basic form descriptions are practical devices for creating a figure's solidity. Different artists use different geometric forms—for instance, the French Rococo painter Jean-Honoré Fragonard (1732–1806) tended to use ovals and egg forms—but the underlying principle is one of reliability and truth to basic anatomy.

The human figure has three large central forms: the head, the rib cage, and the pelvis. Secondary forms are those of the limbs, hands, and feet.

Luca Cambiaso, *Study of Cubic Figures*, c. mid-1500s, pen and sepia wash on paper, approx. 17 x 12 inches (43.18 x 30.48 cm). Gabinetto dei Disegni e della Stampe, Uffizi Gallery (Florence). Photo credit: Scala/Art Resource, NY.

Cambiaso invents figures using a block system. The robot-like figures are used to work out compositions and scenes of action for his paintings. This concept is excellent for thinking through structure, structural forms, and gesture.

Tertiary forms comprise the great variety of smaller geometric volumes, such as those of the nose, ears, knees, and so on. All of the body's forms are convex—anatomically, the body has no concave or straight lines. An artist may choose to describe the forms using straight lines or concavities, but this is an artistic choice, not an anatomically correct one. For example, the connection between the rib mass and the pelvic form is actually a series of convex volumes overlapping one another. An artist may draw the waist as a concave curve, but in reality it is not concave.

One common error beginners make when drawing figures is to underdescribe the large central masses (head, rib cage, and pelvis) and secondary forms. When the separations of the forms are not clear enough and the forms are indistinct, the figure can look rubbery or flat.

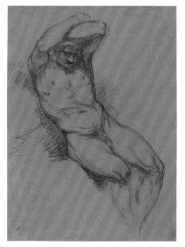

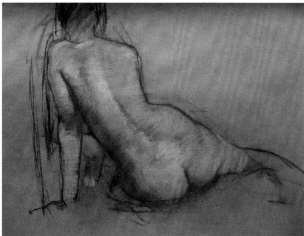

LEFT Raphael Lamar West, *A Seated Male Nude with His Hands Crossed over His Head*, c. 1800, black chalk on blue laid paper, 21^{1}/$_{16}$ x 15^{11}/$_{16}$ inches (53.5 x 39.8 cm). National Gallery of Art (Washington, D.C.). Joseph F. McCrindle Collection, 2009.70.249. Photo credit: Open Access, NGA Images.

West describes strong contrapposto in this figure via the twist of the model's large block-like chest in a diagonal direction away from the pelvis. Additionally, the model's right leg is a good example of foreshortening.

MIDDLE Martin Campos, *Nude Figure*, 2014, pastel on charcoal paper, 18 x 24 inches (45.72 x 60.96 cm). Courtesy of the artist.

In this expressive pastel, the opposition of form between the rib cage and the pelvis defines contrapposto. In addition, the upper and lower arms are moving in contrapposto relative to each other.

RIGHT The rib cage and pelvis are in slight opposition to each other in this drawing. The lines of movement of muscles and creases between forms are also in contrapposto.

Contrapposto

Contrapposto, an Italian Renaissance term meaning "counter-pose," refers to the opposition of forms and movements in the body.

Contrapposto occurs naturally in human anatomy in the curves of the spine and the oppositional curves of joints. The large central forms of the rib cage, pelvis, and head are placed in opposition to one another by the movements of the spine, and the secondary forms respond to the central masses by creating further oppositional movements. The bones and joint sockets create natural contrapposto, enabling balance and effective motion, and the muscles assist in contrapposto through their diagonal movements from attachment to attachment, joint to joint. The whole system of contrapposto throughout the body creates a visual sense of gesture, balance, and proportion in a figure drawing.

The Classical Greeks are credited with introducing contrapposto into figurative art. The Early Classical statue of a young man called Kritios Boy is the earliest surviving example of an artwork incorporating contrapposto and natural movement.

Whether it takes the form of block-like masses moving in opposition through the body, as in the work of Michelangelo, or of fluid S-curved oval forms, as in the figures of the French painter François Boucher (1703–1770), contrapposto is an essential element in describing the functional anatomy of the body and creating an artistic sense of movement in the pose. Successfully conveying contrapposto in a drawing relies on an understanding of shapes and forms, gestural lines of movement, axial tilts, and planes.

The interconnections and internal movements of muscles connecting to each other in this drawing provide an example of normative foreshortening. The side view and position of this figure keep any extreme foreshortening from occurring. If the figure were turned toward the viewer with arms and legs raised, extreme foreshortening would be a major feature of this drawing.

Extreme foreshortening characterizes the drawing of the hand and arm, the bent arm, and the raised leg. Anatomical and structural shapes are shortened and overlap each other at quick intervals to create extreme foreshortening. In addition, darker lines and tones visually bring the upended forms toward the viewer, while softer lines and tones help them recede.

In this lovely drawing, subtle edge lines fade from outside contours toward the inside of the form, creating a gentle description of normative foreshortening. Of special interest are the contour lines at the points where one thigh overlaps the other.

Foreshortening

Foreshortening describes the moving forward or backward in space—relative to the viewer—of the forms of the body. There are two basic types of foreshortening: normative and extreme.

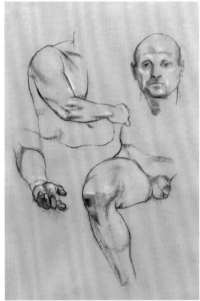

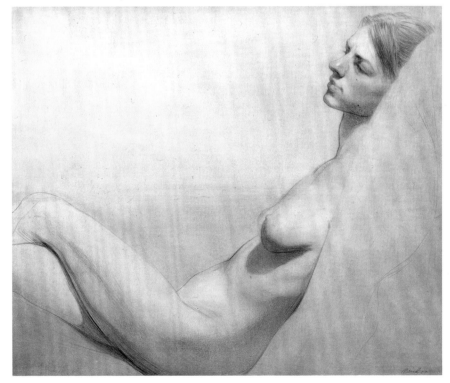

Normative foreshortening occurs where muscles overlap.

The leg's structural shapes overlap each other in a seated pose.

This drawing shows foreshortening of the knee block.

Here you see the fore-shortened foot from several angles. The line from heel to toe provides the correct perspective for the foot on the ground.

In extreme foreshortening, the overlapping shapes are closely packed.

Normative foreshortening refers to the natural way all forms in the body connect and overlap. As one muscle or fleshy form connects with the next, it crosses over the neighboring form. The line contour of one form that passes over and into another form can transition from appearing as a relatively clear edge to a faded wisp. The diagonal movement of forms, one over another, creates an interconnected gestural rhythm throughout the body.

Extreme foreshortening occurs when a limb is extended forward or backward at an acute angle to the viewer. The normative overlaps and their curving lines become more dramatic, and the typical shapes of structural forms change, often shortening or compacting. The visual arrangement of the structural forms—their proportions, measures, and relationships—is radically changed. It can even reach the point where the structural forms in the front (from the viewer's perspective) mostly or totally obscure the ones behind them.

To understand extreme foreshortening in a pose, you need to assess the original forms and overlaps and see how they have changed. For example, the normal structural shapes of a leg in a standing a position are tapered rectangles. When the leg bends in a foreshortened pose, as in a seated figure, the structural shapes and overlaps change: The thigh appears to shorten and widen. The knee block becomes much more pronounced. The whole leg appears shorter than it does in a standing pose, and its position relative to the rest of the body is greatly altered as well.

Martin Campos, *Female Nude*, 2014,
pastel on greenish charcoal paper,
24 x 18 inches (45.72 x 60.96 cm).
Courtesy of the artist.

In this pastel, extreme foreshortening
is conveyed not only by the
overlapping of the shapes of the
body, but also through the compact
overall shape of the whole figure.
The model could easily be contained
within a cube.

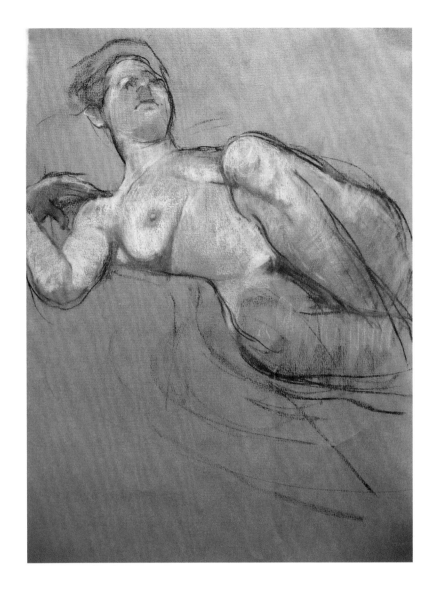

Foreshortening is believably conveyed in a drawing by adjusting the line
and tone. The general rule sharper, darker, clearer comes forward and softer,
grayer, less clear recedes is critical. The edges and tones of an extended knee,
which is closer to the viewer, must be sharper, darker, and clearer compared
to the lines showing the leg's attachment to the pelvis. You should carefully
analyze and lay out such foreshortened relationships before beginning to
finish a drawing.

When learning how to describe foreshortening in the figure, it is advisable
to study the normative shapes, forms, and foreshortening first. For this reason,
it is a good idea to start by drawing only standing poses and then gradually
move on to seated poses and finally to extremely foreshortened poses.

Demonstration: Drawing a Figure

Doing a figure drawing that is strong, both structurally and aesthetically, requires a number of considerations. The gesture must truly evoke the energy and lines of movement of the figure's pose. The proportions and underlying structural geometry must be strongly and clearly designed. Finally, the development process, which uses line, tone, or mixed effects to complete the drawing, must suit the aesthetic goals of the piece. Planning, analysis, and thoughtful critique of the outcome will result in a strong and effective figure drawing.

Figure Drawing, Step by Step

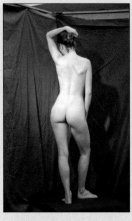 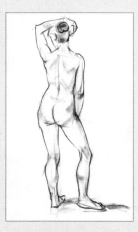

1 | The first step always is to look at the subject and do a visual analysis of the overall figure. Focusing on details should be avoided. It is the relationships of gesture, big proportions, and lines of movement and balance that should first be observed and considered before starting the drawing.

2 | In the next step, the large relationships of gesture, proportion, and balance are laid out with light lines. This is literally the armature of the drawing. The elements must be generally correct from the start, though they can be edited and refined later.

3 | In this step or phase of the drawing, the large structural forms of the torso as well as those of the limbs, hands, feet, and head have been laid in. Focusing on structure, rounded forms have been described with planes to enhance form and mass. Tilts of joints, such as the knee block, and arcs, such as that of the pelvis are described, but still with a light touch. Getting too heavy and dark at this point will impede correcting errors.

4 | To achieve a basic finish, modulate the line quality and the tonal changes around forms. The figure drawing can now be checked for errors. Correct those and then consider the amount of line or tone or both that the figure will receive; this is a stylistic or aesthetic choice.

Copying Master Drawings

Students have been doing copies of works by recognized masters for as long as art training has existed. The Romans studied and copied famous Greek works; medieval masters emulated the works of the Greco-Roman world; Renaissance students copied Classical works and the art of their workshop masters; and the academies of the eighteenth and nineteenth centuries included copying the masters as a regular part of their curricula. In the nineteenth century, it was common for accomplished academy-trained students to augment their incomes by selling their copies of masterworks.

Copying drawings to learn the techniques used by a master artist or as a point of departure for creativity remains recommended practice today. Copying drawings is especially helpful in building beginners' basic skills and confidence.

There are two kinds of copies: sketch copies, which can be done casually for simple practice, and exact copies, which require close observation and planning to produce faithful replicas. You can do either from a good reproduction in a book or a good-quality printout or photocopy. For a sketch copy, choose a master drawing that contains the elements you want to learn—for example, a Michelangelo figure drawing for practice in contrapposto or blocking of forms. Using the drawing as if it were a model posing, sketch the figure's essential structural elements—gesture, masses, planes, structural shapes, and so on. The resulting sketches will look a lot like the croquis drawings you might do when working from a life model. Sketch copies can also be interpretive and expressive, but the primary goal is to learn about the formal and informal qualities of the original.

Drawing an exact copy requires more effort. Choose a masterwork and carefully research the materials used in the drawing, its technical aspects and style, and the period when it was made. The purpose of doing an exact copy is to understand as well as you can the process the artist went through in creating the work and to replicate that process as closely as possible. If you're working from a book or photocopy, you might first trace the work to get a feel for the original structure. Then lay out, develop, and complete your copy, trying to reproduce the line quality, hatching marks, tonal development, and other elements of the original.

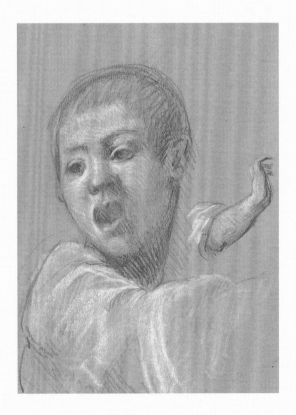

ACKNOWLEDGMENTS

My sincere thanks to my friends for their constant support and patience in listening to me sound out ideas.

My gratitude to my students for inspiring me to do better.

Thanks to Samee Kirk for her excellent proofing skills.

My deepest gratitude to the Pennsylvania Academy of the Fine Arts for its mandate of providing the highest quality of drawing education.

INDEX

213